Film Style and Story

Film Style and Story

A Tribute to Torben Grodal

Edited by
Lennard Højbjerg & Peter Schepelern

MUSEUM TUSCULANUM PRESS
UNIVERSITY OF COPENHAGEN
2003

Cover design by Veronique van der Neut
Set and printed by Narayana Press, Gylling
ISBN 87-7289-851-8

Cover illustration by
Michael Kvium (see note on pp. 251-252)

Editors:
Lennard Højbjerg & Peter Schepelern

The editors wish to thank:
Klaus Bruhn Jensen, Pavel Bunin,
Michael Gregaard, Deborah Kaplan,
and Michael Kvium.

Published with support from
The Danish Film Institute.

Museum Tusculanum Press
Njalsgade 92
DK-2300 Copenhagen S
www.mtp.dk

Contents

Introduction

Style and story are two of the most debated concepts in film studies today. Taking a cognitive perspective, the anthology *Film Style and Story* focuses explicitly on the stylistic portrayal of human behaviour in film, ranging from studies of specific visual patterns to sound montages. Contributions to this volume all share two characteristics: they explore the ways in which styles and stories interact, and they are inspired by the work of Torben Grodal.

The anthology begins with Joseph D. Anderson's "Moving Through the Diegetic World of the Motion Picture". In this article, the differences between a dolly and a zoom are presented as a paradigmatic case of the way in which a viewer's access to different types of information is constrained by different stylistic devices. While in real life, we are free to seek information, in film the chosen style has been pre-selected for the purpose of producing art.

In "Danish Film Noir: Style, Themes, and Narration", Ib Bondebjerg analyses Danish film noir during the early 1940s. He argues that Danish film noir has strong roots in French poetic realism and melodramatic traditions, and, further, that it was only indirectly influenced by American film noir productions.

David Bordwell's "Who Blinked First? How Film Style Streamlines Nonverbal Interaction" analyses the human gaze in film and reality. In contrast to reality, people conversing in films often do not blink. Bordwell claims that film style tends to shape the real patterns they attempt to imitate.

Edward Branigan investigates the different uses of the word (film) frame and he outlines their theoretical implications in "How Frame Lines (and Film Theory) Figure". The discussion addresses a wide range of classic theoretical issues and suggests solutions to many of them.

In "Style: Segmentation and Patterns", Lennard Højbjerg presents a theoretical approach to particular stylistic topics, namely segmentation and articulation. He examines how mainstream stylistic features are replicated in an expressionistic manner in

Dogma films, and demonstrates how this style could be considered a non-linguistic system of articulation with an expressive functionality.

"A Story with a Style: *Nightwatch* and Contemporary Danish Film" by Birger Langkjær explores the ways in which style and story interact in the Danish film *Nattevagten* and shows how these interactions in turn relate to contemporary Danish cinema.

Peter Larsen discusses, in "Urban Legends: Notes on a Theme in Early Film Theory", the concept of the film-form language in early film theories by Balázs, Kracauer and Benjamin, and he relates these theories to urbanization in the beginning of the twentieth century.

Johannes Riis in "Film Acting and the Communication of Emotions" examines perception and expressiveness, offering us a framework for understanding character expressiveness in films. Rejecting the linguistic approach, Riis argues for a functionalist approach in which expressiveness is an integral part of human perception.

In "A Reasonable Guide to Horrible Noise (Part 2): Listening to *Lost Highway*", Murray Smith describes this film's complex use of sound layers and argues that there is a deep affinity between Lynch's style and the fundamental aesthetics of rock music.

Using Carl Th. Dreyer's film *Ordet* as an example, Casper Tybjerg addresses the problem of film interpretation and whether it can be said to produce knowledge. In "The Sense of *The Word*" Tybjerg argues that the theoretical approach to art film proposed by Torben Grodal is capable of producing genuine knowledge and explaining how viewers come to believe that deeper meanings are embedded in the style of art films.

Finally, in "The Documentary Style of Fiction Film in Eastern Europe: Narration and Visual Style", Peter Wuss tackles the subject of 'group style' in Eastern European film and describes the specific documentary style of Miloš Forman's *Black Peter* and Otar Ioseliani's *There Was a Singing Blackbird*.

Torben Grodal (born 1943) is a leading figure in the world of Danish and international film theory. However, he began his career in the late 1960's as a literary scholar, specializing in the innovative

theories of textual analysis then emerging, with a focus on the nineteenth-century classics of Danish literature. In 1988, he left the Department of Comparative Literature to join the Department of Film and Media Studies. Since then he has devoted his enormous diligence and originality to producing groundbreaking theoretical works on film and a wide range of other media, from television to computers. The publication of *Moving Pictures*, his doctoral dissertation (and the first Danish doctoral dissertation on film), stands out as one of Grodal's seminal contributions to consolidating a new way of understanding the film experience and its correspondence with human emotions and cognitions.

Written by leading international scholars in the field, this book is a presentation of cognitive approaches to film theory and analysis. But it is more than a presentation. It is also a present – a birthday present in honour of Torben Grodal – not only in recognition of his scholarly accomplishments and the results of his impressive productivity (see the bibliography), but also as an expression of gratitude for the inspiration he continues to provide to students and colleagues.

Joseph D. Anderson

Moving Through the Diegetic World of the Motion Picture

Motion picture audiences often don't distinguish between zoom and dolly shots, and indeed often *cannot* distinguish between the two types of shots when asked to do so. On the other hand, filmmakers go to considerable lengths to obtain dolly shots on occasion, even when a zoom shot would be easier and cheaper. Two questions arise: What is the difference between a dolly shot and a zoom shot? And if we often can't easily distinguish between them, why might a dolly shot be worth the laying of track and the pushing of a dolly, when a zoom shot could be gotten for a fraction of the price?

A zoom lens is a variable focal-length lens. It is a complex lens composed of several pieces of glass. The elements of the lens can be moved closer or farther away from each other thus varying the effective focal length of the lens over all. By changing the focal length of the lens, one increases or decreases its angle of acceptance. For a zoom-in the lens is converted from a wide-angle lens to a narrow-angle or telephoto lens. The effect on the image is to expand it from the center outward, with the result that the image gets larger and the outer portions of the image disappear off the edges of the frame.

A dolly shot requires the mounting of the camera on a cart with wheels (a dolly). Metal track, reminiscent of railroad track, is laid on the ground to insure the smooth progress of the dolly as it is pushed by hand along the track. For a simple dolly shot, the lens used has a fixed focal length, and therefore always views the profilmic event with the same angle of acceptance. Objects appear larger as the camera gets closer to them. The image produced by dollying is similar in some respects to that produced by zooming. For a dolly-in the central part of the image expands as the camera moves in closer, and the outer portions of the image disappear off the edges of the screen much as in the zoom shot. (And in both if

there is no information to flow off the edges, an object in the center may appear to advance toward the viewer.) A dolly shot contains this information and more. The additional information contained in the dolly shot might be called motion perspective information. It is information for the changing relationship of the camera to objects in the field of view. As the camera is moved, its relationship to all portions of the frame changes, both the angle from which objects are seen and the image size of all objects in the frame change. Perhaps more important, the sizes and positions of the objects change relative to each other, and as sizes and angles change some objects may occlude others. Such occlusion never occurs in a zoom shot. As James Cutting has put it, "Zooming in simply enlarges the focal object, allowing all texture to rush by with equal speed as a function of its image distance from the center of the focal object. No occlusions and disocclusions occur in a zoom. Motion perspective, on the other hand, creates occlusions and disocclusions of far objects by near ones, and the objects and textures rush by at a speed proportional to their physical distance from the camera and their angle from the path of the camera."[1]

Figure 1 presents a comparison of a zoom shot with a dolly shot. A frame from the beginning of each shot shows a little girl holding a puppy and standing in a hallway. The second frame in each sequence is from the midpoint of each shot. One can see that in the zoom shot, though everything is magnified, the girl and puppy bear the same relationship to the square formed by double doors at the end of the hallway, but in the dolly shot the girl and puppy are occluding a large portion of the square. In the last frame of each sequence, the difference becomes even more apparent. In the zoom shot, the relationship of the girl and puppy remains the same with regard to the square formed by the double doors, but in the dolly shot the little girl and her puppy have almost completely occluded the entire end of the hallway. Clearly some of the information contained in a motion picture is different for a zoom and a dolly shot of the same duration and of the same subject.

I have used the term *information* with reference to both the world and to the motion picture, and in general, such usage is appropriate, but let me now be a bit more precise. Information is contained in the often-complex patterns of light that are arrayed

Zoom shot	Dolly shot

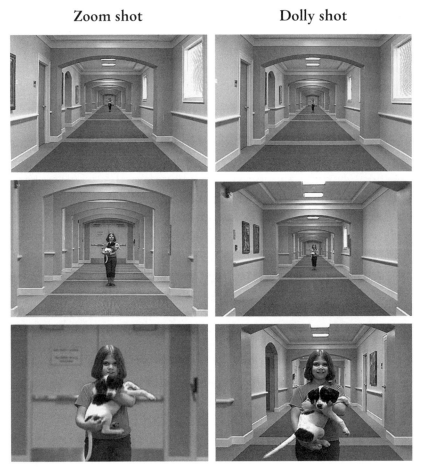

Figure 1: Videography by Steve Cox.

before us in the real world – patterns made up of light of varying wavelengths and brightnesses reflected differentially from surfaces in the world. An almost infinite number of arrays of light are available in the world, but for creatures with eyes like ours, the possible number of arrays of light patterns available to us is constrained by where we are and which direction we are looking. By means of our visual system, the information in the array of light before our eyes at any moment is directly available to us. We do not *read* the array to gain the information; we experience it. More accurately we experience the world specified by the information. (I see the street

outside my window as I write, rather than the array of light itself.)

When viewing a motion picture, the continually changing patterns of light reflected from the screen constitute information about the diegetic world of the film, and through our visual system we experience that world – its people, its places, its events. We do not *read* it; we directly experience it. (An analogous argument can be made for gaining information by means of our auditory system.)

When viewing either the real world or the diegetic world of a motion picture our own retinal image is not available to our inspection. For the motion picture, however, the array of light spread out on the flat screen constitutes a second set of information that *is* available to our inspection. In viewing a motion picture, we alternate between seeing the patterns of light projected on the screen and the diegetic world depicted. We can see either the surface or the scene, but not both at the same time, and most often we attend to the scene.

In perception of the natural world, unless we are dreaming or delusional, the patterns of light and sound that we perceive are actually patterns in the world rather than patterns imposed upon the world by our minds. While we may attend to some patterns and ignore others, the world is not whatever we think it is or want it to be. And just as reality is not whatever we think it is or want it to be, the diegetic world of a motion picture is not whatever we think is or want it to be either. But the two worlds are not the same; reality is the sum of all that exists, including objects, events, and relationships between them; while motion pictures are merely man-made objects, albeit very carefully constructed man-made objects. Though individual viewers may attend to more or less in a film, and relate it to themselves differently, that is, find different personal affordances in the information, they nevertheless all see the same film, and each viewer gathers some of the information that has been carefully placed there.

Given that the patterns at all levels in a fiction film are contrived – very carefully contrived – that contrivance is usually designed to spark insight into ourselves and some aspect of our relationship to our world, rather than to call attention to the cleverness of the contrivance. Indeed, our uninterrupted experience of the diegetic world of a fictional narrative film is dependent upon not picking

up information about filmic construction. This is the experience of realism, the controversial and much maligned illusion of reality presented by the motion picture. The experience of that realism consists in *not* seeing the contrivance. Motion picture realism does not demand that we always take a camera out and photograph the real world. Nor is realism the absence or avoidance of fantasy or creative patterning. The most carefully constructed elements of a film can often seem the most realistic. For example, foleyed sound effects may seem more realistic than the actual location sounds. This is possible because the foleyed sounds are designed to fit perfectly into the fictional world of the film.[2] What realism requires is the construction of a seamless diegetic world. At the level of perception (as opposed to the level of conscious evaluation) realism is the default position. In perceiving motion pictures as in perceiving the real world, things are as they appear to be unless we gain information to the contrary. This is not a tautology or circular reasoning, for as humans we simply have the capacity to gain information from the world directly by looking, listening, touching, smelling, and tasting. The information is what it is, unless we access additional or contrary information.[3]

We can surmise that in our distant past the acquisition of information was crucial to our survival, and that we were able to gain maximum information by moving about on the savanna and along the tree lines of our ancient world. Similarly, we move about the streets and through the corridors of our contemporary world, using the same basic perceptual systems for seeking the information we need for our present survival. Movement is the key to gaining information. Active exploration provides the competitive edge.

In the film, too, movement provides the edge. The very fact that the picture moves, and that the camera has the capacity to move, allows for a vastly greater amount of information to be gained from the viewing of a film than is possible from the viewing of a still image or even a series of still images.

The way that we gain information in the natural world is by moving through the world in search of information we need. The film viewer is obviously constrained in this regard – confined to a seat in the theatre and able to see only those aspects of the diegetic world the director chooses to reveal at any given moment. The

viewer's visual mobility, however, is not as restricted as it might seem.

The kind of information available to a viewer in the natural world was identified by perceptual psychologist J. J. Gibson in his classic study of visually controlled locomotion in animals:

An animal which moves passes through a continuous series of station points. Each eye is therefore presented with a continuous family of transformations, and this family is unique to the particular path of locomotion. With an animal which does not change its position, the eyes are presented with what may be called a continuous non-transformation of the optic array, that is, a static pattern.

The classical geometry of perspective will describe the static pattern of the optic array, that is the projection of an environment to a stationary point. The geometry of "motion perspective" (Gibson, Olum & Rosenblatt, 1955) will describe the "flow pattern" of the optic array, that is, the projection of an environment to a moving point. [4]

In the natural world a stationary observer sees a continuous but non-changing optic array. A moving observer, on the other hand, is presented with a continuously changing optic array, a flow pattern. Gibson identifies these optical flow patterns as the primary source of information about self-movement and visual orientation. Ecological psychologists, following Gibson's lead, have accumulated a significant body of experimental research supporting the idea that it is primarily these optical flow patterns that specify self-movement and visual orientation in the natural world.[5]

When viewing a motion picture with camera movement, an individual confined to one position in a theatre seat is not limited to a static pattern but has access to the flow pattern provided by the moving camera. Optical flow patterns like those that specify self-movement in the natural world are therefore available even to a stationary observer of shots such as dollies and zooms. Those objects that expand in size and systematically move off the edges of the screen provide visual flow patterns similar to those that would occur with one's own movement.

The proprioceptive feedback for self-movement, of course, is not available. We cannot see or feel our legs and feet moving, nor

can we feel our bodies moving forward. However, we are as undisturbed by the absence of this information in film viewing as we are in driving a car, where we similarly experience the flow of information across the periphery of our vision and have a profound sense of moving forward through the world. It is that way with all information available from the world or from the motion picture – we are information seekers, but not detectors of missing information. We are sensitive to corroborating information from any sensory mode; indeed we seek the accompanying sound of an event to confirm what we have seen, and will perceive immediately any disconfirmation or contradiction from another set of information.[6] But we are not syntagmatic/paradigmatic comparison machines. We do not compare what is there to what might have been there but is not. We look for confirmation of those sets of information that are available to our perceptual systems.

In addition to perceiving patterns that *are*, our attention is usually focused upon the objects and events we are perceiving rather than our own movement. The same is true with regard to camera movement when viewing a motion picture. However, if one bothers to identify them, the various moves a camera makes (pans, trucks, dollies, zooms, cranes, aerial, and steadicam shots) are usually easily recognizable, and they are easily distinguishable from each other – except for the dollies and zooms. One might argue that the choice of a dolly or zoom is a matter of physical capacity – that is, whether on any given occasion it is feasible, or even possible, to lay the track needed for a dolly shot, or easier to use a variable focal length lens (zoom), thereby achieving pretty much the same result. No doubt there are occasions on which these are the deciding factors. However, zooms and dollies do not provide *exactly* the same information; they do not allow us *exactly* the same experience of the diegetic world. There are perceptible and significant differences between the two shots that necessitate a stylistic choice on the part of a film director.

There are several factors that affect our experience of zoom and dolly shots. Let us consider screen size, the speed with which the image on the screen moves, and the presence of artifacts or contradictory information in a shot.

Screen size makes a substantial difference in our experience of

self-motion. When actually moving through the real world the visual flow over the periphery of our vision provides us with information for our own movement. Motion pictures provide much of the same information if the screen we are watching is large enough to fill a major portion of our visual field. When sitting in a theater we may at times feel that we are moving through the diegetic space of the movie; when watching a small television screen the motion often appears to be contained in the box.[7]

The speed with which the textures and colors move across and out of our visual field greatly alters our experience of self-motion. A relatively slow zoom, for example, may provide enough optical flow at a perceivable rate to be experienced as self movement, whereas a snap-zoom results in a shift of attention without a sense of self motion. While a dolly shot offers both optic flow information and motion perspective which may be readily experienced by the viewer as self motion, a zoom offers only optic flow information which in many instances may not compel a sense of motion on the part of the viewer though it does effect a shift of attention. This is analogous to normal vision for although the lens in the human eye is incapable of a zoom so dramatic as one effected by a camera lens, both the human eye and the zoom lens are variable focal length lenses, and the eye can perform something like a very fast zoom when we suddenly fix our attention upon one object in our field of vision. Experientially we see the object of our attention to the exclusion of all else. So, while not exactly the same, the zoom-in is analogous to a focusing of attention. A zoom shot may simulate an *involuntary* focusing of attention, as when something in the real world suddenly, by moving or making a noise, causes us to look at it.

Certain artifacts of zooming and dollying are sometimes apparent, and by calling attention to themselves detract from the realism of the shot. For example, as a zoom-in progresses, the increasing focal length of the lens progressively compresses the picture space such that near the end of a long zoom shot one sometimes becomes aware of the flattening of the picture and looses the sense of the three-dimensionality of the diegetic space. On the other hand, if rather than zooming one dollies toward an object, the object tends to grow in size unrealistically relative to the objects around it. In

the real world objects retain their intrinsic sizes. This phenomenon is often referred to as "size constancy," though the term is predicated upon a dubious assumption.[8] Partly because of the artifacts associated with zooming and dollying directors tend to use short shots that cover small distances. In the course of viewing an entire feature length film the viewer remains largely unaware of the many short dollies and zooms that are employed throughout.

Many times directors use dolly and zoom shots to provide conflicting information such as dollying-in and zooming-out at the same time. In such a shot there can be information for motion perspective provided by the dolly while an object in the center, perhaps an actor, remains the same size. Zooming-in while dollying-out would cause the motion perspective to proceed in the opposite direction while the actor again remains the same size.

Zooms and dollies are related to the process of moving through the world seeking information. They are used in films as devices that approximate the experience of information seeking in the world. Zoom-ins are often used to focus attention and zoom-outs to reveal the larger context of an action or situation. A dolly shot is often used when the journey or process itself is the relevant issue, when as viewers we want to physically approach a character, or follow the character moment to moment, or carefully explore the layout of a given space. These shots provide stylistic alternatives to the LS-MS-CU pattern where the exploration is more generalized, and the CU serves as the culmination of a scene or a segment of the action.

The larger point to be made is that just as our experience of the world depends upon an ongoing series of selections that we make from the many patterns of objects and events available to us, so too our experience of a film depends upon our selection from the array of objects and events presented by the filmmaker. A major difference is that the patterns presented in a film have been preselected by the filmmaker. The choice of a zoom or a dolly shot has already been selected for us. The possible meanings are severely constrained. It is in this deliberate constraint of meaning that film artists create the art of the motion picture. And while we may delight in some of the contrivances in the diegetic world of the motion picture that may be impossible in the real world, the ultimate enjoy-

ment from the fiction (or art) comes from experiencing the patterns of the fictional world, which simultaneously allows for some insight into our own world, our involvement in its situations and relationships. At its best the experience of a motion picture is an organic whole, a rich emotional adventure, constrained by story and style.

Notes

1 James E. Cutting, "Perceiving Scenes in Film and in the World." In *Motion Picture Theory: Ecological Considerations*, Joseph D. Anderson and Barbara Fisher Anderson (eds.) Carbondale: Southern Illinois University Press (in press).

2 See Chapter 4 "Acoustic Events" in *Motion Picture Theory: Ecological Considerations*, Joseph D. Anderson and Barbara Fisher Anderson (eds.), Carbondale: Southern Illinois University Press (in press).

3 For further discussion, see Anderson, Joseph D. and Hodgins, Jessica K. "Perceiving Human Motion in Synthesized Images." In Joseph D. Anderson and Barbara Fisher Anderson (eds.) *Motion Picture Theory: Ecological Considerations*. Carbondale: Southern Illinois University Press (in press).

4 James J. Gibson, "Visually Controlled Locomotion and Visual Orientation in Animals," *Ecological Psychology* (Special Issue: Visually Controlled Locomotion and Orientation. William H. Warren, Jr., Guest Editor), Vol. 10, Nos. 3 & 4, 1998, 165. (This article originally appeared in the *British Journal of Psychology*, 1958, 49, 182-194.)

5 See the special issue of *Ecological Psychology* on Visually Controlled Locomotion and Orientation, William H. Warren, Jr., Guest Editor. *Ecological Psychology*, Vol. 10, Nos. 3 & 4, 1998.

6 See Chapter 5: "Sound and Image" in Joseph D. Anderson, *The Reality of Illusion: An Ecological Approach to a Cognitive Film Theory*. Carbondale: Southern Illinois University Press, 1996, 80-89.

7 This and other variables that effect the perception of dollies and zooms should be studied empirically. Some work has already been done in the study of screen size. See, for instance, Matthew Lombard, Robert D. Riech, Maria Elizabeth Grabe, Cheryl Campanella Bracken, and Theresa Bolmarchich Ditton, "Presence and Television: The Role of Screen Size," Human Communication Research, Vol 26, No. 1, January 2000, 75-98.

8 The assumption is that retinal images are often distorted and that this distortion must be corrected by means of a set of mental operations

called "constancies." It is much more likely that perception is an on-going process of gaining information about the world, and that we see the world, not retinal images. The unrealistic enlargement of an object in a dolly shot is an instance where the corollary of the distorted retinal image is recorded on the film and presented to us on the screen. As such it is an image that is never "seen" in natural perception, but only on the screen. Photographed images present us with two sets of information, one for the lensed image (surface) and another for the diegetic world depicted (scene).

Ib Bondebjerg

Danish Film Noir
Style, Themes, and Narration

During the German Occupation of Denmark, between April 1940 and May 1945, Danish cinema went into a production mode that transformed basic generic formulas and boosted Danish film culture as a whole. This period could be defined as a kind of isolated laboratory for films in which cinema became more popular than ever, and domestic films especially were greeted as being part of a symbolic, cultural resistance. Danish film culture was cut off from mainstream European film as the Germans, during the first years of the occupation, gradually banned the import of American, English and French films, leaving the Danes with only their own films, Italian and German films or films from neutral powers like Sweden. The outcome of this was that, in order to make up for the loss of international films, Danish film culture suddenly had to widen its scope, volume, production quality and generic mix.

Danish cinema in the 1930s was characterised by a massive dominance of popular and European inspired romantic or social comedies, often with clear elements of European musical influence containing songs woven into a thin narrative fabric. These comedies often employed narrative elements such as role switching and mistaken identities that allowed the film to explore social roles and gender conflicts. Two tendencies were dominant: the first tendency was characterised by comedies that were set in a nostalgically romantic Danish countryside, such as the romantic comedy *Bolettes Brudefærd* (1938, "Bolette's Wedding") or the musical comedy *Barken Margrethe* (1934, "The Bark Margrethe"); the second tendency was characterised by contemporary, urban comedies, presenting modern gender roles and other social class structures. The most popular film of this period, *Mille, Marie og mig* (1937, "Mille, Marie and Me": see Bondebjerg, 1996), is the prototypical modern romantic comedy, closely resembling an American screwball comedy, featuring a female lead posing as three different roles,

mirroring emerging possibilities available to the urban women. The film ends with the potential unification of these three roles, so that she gets both her education, her career and her professor.

This social and gender-related mediation in both traditional rural comedies and modern urban comedies, where both social and psychological conflicts are overcome in happy endings, is of course a prototypical comedy-element. But it is a significant historical fact that Danish cinema in the 1930s is generally dominated by these 'genres of integration' (Schatz, 1981) and that the more violent and tragic genres, or even the melodramatic forms, are almost completely absent from Danish cinema. As the Danish film historian Eva Jørholt (2001) has said, it is as if the sun always shines in Danish films from this period. Other types of films, speaking to other cognitive and emotional structures of the Danish audience, came from America, Great Britain or continental Europe – a sort of division of labour between domestic and foreign films in the classical Danish film culture between 1930 and 1960.

Internationalisation and Generic Diversity:
the Birth of Melodrama and Film Noir

Film noir is traditionally described as an American type of film from the period 1940–1955, combining a crime plot (often based on the hard-boiled detective novels of the 1930s) and a characteristic expressive style. The first of these films, according to most film historical presentations (Naremore, 1998, Silver & Ursini, 1996, Tuska, 1984), is *The Maltese Falcon* (1941), with *Double Indemnity* (1944) or *The Big Sleep* (1946) as two other early, seminal films. There is little doubt though that also stylistic elements of German expressionism from the late 20s and French poetic realism from the late 30s and early 40s influenced the film noir tradition. As Danish cinema was cut off from American and most European films during the Occupation, one can speculate on the sources of inspiration for a Danish noir tradition.

There is not much research data to verify this with great certainty. However, among the films shown in Denmark during the years 1940–1945, we clearly find no American film noir classics.

The first of the seminal American film noir films to be shown in Denmark are *The Maltese Falcon*, in 1946, *Phantom Lady*, in 1947 and *Double Indemnity*, in 1948. Therefore, no direct influence is likely. In contrast to American film noir, French poetic realism was shown almost immediately in Danish Cinemas – for instance, Marcel Carné's films *Quai des brumes*, in 1938, and *Le jour se lève*, in 1939. Furthermore, French Films were allowed in Danish cinemas until 1944.

There is, therefore, no doubt that French poetic realism is the most important source of inspiration for Danish film noir and has strongly influenced the new international style and themes in Danish film culture between 1940 and 1945. We encounter significantly more elements of French fatalism and melodramatic emotional structure in Danish film noir than the hard-boiled tendencies of American film. It is also most certain that British films, for instance Hitchcock's British crime-thriller period, with films like *Blackmail* (1929), *The Man Who Knew Too Much* (1934) or *The 39 Steps* (1935), influenced the general rise of crime-thriller films during the years 1940-45, although they cannot be said to be part of the film noir tradition as such.

But even if Danish film directors were not able to view the real American film noir tradition before 1945, knowledge of American films may have come through information or first hand experience from abroad, for instance nearby Sweden, where no restrictions were enforced. Just a few years after the end of the occupation, American film noir finally reached Danish screens. Thus, post-war Danish film noir was most certainly directly inspired by the American film noir, as also documented in Danish newspaper reviews of these films.

In Danish cinema before 1940, both melodrama and crime or other types of action genres were quite rare and therefore there was almost no national tradition to build on. A very early film, *Hotel Paradis* (1931, "Hotel Paradise", George Schnéevoigt), has elements of expressive style, fatal melodramatic structures and a crime plot, and *Kirke og Orgel* (1932, "Church and Organ", George Schnéevoigt) has the same sombre, tragic and melodramatic tone and expressive use of shadow and light but is without the crime element. In one of the three largely unsuccessful films of Paul Fejos[1] *Det gyldne Smil* (1935, "The Golden Smile"), we also

find strong melodramatic structures. But apart from these few examples, melodrama, crime and a more excessive style were not common in Danish cinema. Danish cinema in the 1930s was – as already indicated – dominated by rural or romantic domestic comedies and musicals, with the presence of a few more modern comedies by the end of the 1930s.

However, this all changed with the Occupation and, between 1940 and 1945 alone, we find quite elegant, heavily Hollywood-inspired screwball comedies, a number of both romantic and social melodramas as well as a number of film noir, crime films and thrillers. Also a much more developed, genuine and American musical tradition was born (see Bondebjerg, 2000 a & b). Of the 95 films produced in Denmark between 1940 and 1945, genres like melodrama or crime were not exactly dominant, but at least 11 films belonged to the crime-thriller format and of those at least 6 have clear film noir elements: *En Forbryder* (1941, "A Criminal", Arne Weel), *Afsporet* (1942, "Derailed", Bodil Ipsen & Lau Lauritzen Jr), *Natekspressen P 903* (1942, "The Night Express P 903", Svend Methling), *Jeg mødte en Morder* (1943, "I Met a Murderer", Lau Lauritzen Jr), *Mordets Melodi* (1944, "Murder Tune", Bodil Ipsen) and *Besættelse* (1944, "Obsession", Bodil Ipsen).

Between 1945 and 1955, when Danish film culture returned to more normal circumstances of production, the film noir tendency continued, but not in the same quantity as before, although some of the finest films in the Danish film noir tradition were made in this period: *Kristinus Bergman* (1948, "Kristinus Bergman", Astrid & Bjarne Henning-Jensen), *Hr. Petit* (1948, "Mr Petit", Alice O'Fredericks) and *John og Irene* (1949, "John and Irene", Asbjørn Andersen). In the same period, crime films with some noir influences also continue, though often with more emphasis on the structural problems of urban crime and police work. This is the case in films like *Unge piger forsvinder i København* (1951, "Young Girls Disappearing in Copenhagen", Aage Wiltrup), *Lyntoget* (1951, "The Express Train", Aage Wiltrup) and *Kriminalsagen Tove Andersen* (1953, "The Criminal Case Tove Andersen", Sven Methling Jr & Aage Wiltrup).

So despite the fact that post-war Danish cinema developed new

and largely serial mainstream film forms and became more national in orientation, the international 'turn' taken by Danish film culture during this period was lasting and permanent. But taken as a whole, there is no doubt that the rural sunshine of the 1930s returned to popular, national mainstream cinema. Some elements introduced by the French and American-inspired noir melodrama tradition did, however, continue in other formats, mostly in the form of more social melodramas, often referred to in Danish film history as 'realistic debate films' (Jørholt, 2001 and Villadsen, 2001). The social melodrama focusing mostly on juvenile delinquency, alcoholism, sexuality and single mothers, or even political cold-war ideologies, continued after 1945 to the end of the 1950s, until a new form of realism, influenced by British and French new wave, replaced them (see Bondebjerg, 2000).[2]

Film Noir: Melodrama with a Tone and Mood

Film noir is not a genre in the basic, cognitive-narrative sense of the word: a fundamental narrative and emotional structure. As Torben Grodal has already argued (Grodal, 1999), melodrama is a basic narrative and emotional genre and film noir is a stylistic and emotional *modality* within melodrama, often with a specific thematic focus on moral decay, crime, destructive passion and most often a modern, urban setting. If we think of *Gone with the Wind* as the all time prototypical melodrama of the romantic type before 1940, it becomes quite clear, however, that the film noir mode is not just a melodramatic structure but has a clear tendency to mix melodrama with the normally more action-oriented crime-sub-genre. But as it will also become clear in the following analysis of some of the most important examples of Danish film noir, action and the establishing of order through violence is not the typical form of film noir. In film noir, criminal acts are often tragic results of fatal coincidences and lives that have gone awry, and we do not often see things through the eyes of a hard-boiled detective figure, emotionally entangled with a femme fatale. In Danish film noir, the melodramatic structure is

stronger than the crime structure, as is also the case in French poetic realism.

Sexuality and sudden erotic passion with catastrophic consequences play a crucial role in the noir tradition as such, as well as in Danish film noir. Not surprisingly though, given the socio-historical development of Danish society in the 1940s, this erotic theme is not always imbedded in an urban and modern milieu. One of the early films in the noir tradition, Lau Lauritzen's *Jeg mødte en Morder* (I Met a Murderer), based on a script by James Mason and a remake of the British film with the same title (1939), revolves almost completely around a triangular erotic relationship between two women and a farmer and lacks the characteristic urban noir style.

But the film clearly illustrates a long tradition for rural melodramas in Danish film culture that expose and burst any notion of rural romanticism and nostalgic idyll[3]. However it clearly possesses another of the noir elements; the flashback structure in which the 'murderer' in this crime of passion tells her story and confess as the story unfolds. The photographer (Rudolf Frederiksen) also worked the year before on the other more seminal erotic film noir *Afsporet*, a film that definitely has the gloomy urban atmosphere of decay, so characteristic of French poetic realism and later American film noir.

The first of the 'real' Danish film noir films, *En Forbryder* ("A Criminal"), is a typical Danish version of the film noir, telling the story of quite prosaic people caught by a cruel social fate, and was inspired directly by the films of Marcel Carné. The film is shot mainly inside a studio, as was also the case with French poetic realism. Thus, except for a few establishing shots of typical 1930s flats, the gloomy, rainy and dark central Copenhagen is a visual construction. But the mise-en-scène and photographic style of the film constantly employs low-key lighting, mist and darkness, particularly in the dramatic scenes that take place at the house of the loan shark, where the main character, Erik, at the end of the film, commits the murder that sends him to jail after he has turned himself in. The conflict and basic theme in this film is not erotic obsession or greed but the social force of money. The film tells the tragic love story of an ordinary Danish couple. He is a clerk, hoping and waiting for promotion; she is a shop assistant. They meet and

marry but, in order to make a start, have to borrow money to rent a flat and buy furniture. After having tried in vain to borrow the money from both his family and hers, he is finally forced to borrow them from a loan shark.

The thematic conflict is based on the contrast between two different family prototypes, sharply drawn but not unrealistic: on the one side, we have Erik and his family (his widowed mother and his sister Maria, a teacher) as representatives of the honest, hardworking but not very fortunate Danes and, on the other, we have his wife Edith's family, dominated by her unscrupulous brother Willy, driven solely by profit and power. Willy refuses to help Erik unless he takes part in his schemes and ruthless plans and, when Erik declines, Willy gets nasty, interfering with the loan shark to put more pressure on Erik.

It is modest, classical virtue against the decay of capitalist modernity, and Erik is caught in the middle and gradually driven to despair as the loan shark puts the screws on him more and more, to get his money. As the narrative unfolds Erik is finally driven to kill the loan shark in an act of temporary anger and despair. At first, it seems that Erik will avoid being charged with murder, as the loan shark's housekeeper is accused and, in her terror, actually admits to the murder. But by coincidence, Willy finds a crucial piece of evidence on Erik's blanket, an unusually painted Joker from a pack of cards belonging to the loan shark and he threatens to tell everything unless Erik allows Willy to take control of his personal finances and his life. Faced with this, Erik turns himself in.

The opening scene of the film sets the tone of poetic realism and noir fatalism perfectly, and also uses the flashback technique. This technique, used in many noir films – as already pointed out in numerous articles and books on film noir – is not just a technical device. By removing some of the narrative suspense, it makes the viewer focus more on the inevitable and fatal course of events rather than on events themselves. This technique underlines the fact that people in film noir and melodrama are merely pawns in a big power game of social forces and are passive victims of fate. This is further underlined by the visual noir style in which the world is seen as dangerously dark, where it is difficult to act with determination and clear sight.

Both these elements are present in the opening scenes of *En Forbryder*. First we see empty city streets in rain and darkness. During the announcement and credits, the music swells with emotion and drama, then the street comes to life and we see Erik's legs pacing up and down the street in front of the police station. We follow him inside a typical café and at a table he reads about the murder of the loan shark and the confession of his housekeeper. He asks for a drink and some paper and starts writing a letter to his wife explaining everything. We do not hear an actual voiceover and we do not return to this opening scene until the last shot of the film, when Erik leaves the pub and enters the police station. Although the voiceover is not as developed as in the later American film noir tradition, the framing of the narrative and the whole set up is there. As spectators, we are emotionally and cognitively cued from the beginning to read this film as the story of a man caught in a web of social forces beyond his control. He is not a bad guy, just unlucky. To quote Erik's sister in the film: "You're no more criminal than all the rest of us. You were just pushed by circumstances to commit your crime."

By presenting the issues as it does, the film highlights the conflict between selfishness as a symptom of modern, urban decay and the altruism or social, collective morality, which are at the core of both French poetic realism and the American film noir tradition (Grodal, 1999: 57f). But in this particular film, sexuality is not the key to the conflict as much as the longing for normal family life, hence we see a stronger influence from the social realism and lower-class focus in French poetic realism than that found in the hard-boiled American version. Sexuality, of course, is not absent from the film's central plot. Erik's wife Edith is a far cry from the femme fatales of hardboiled films; she is a more innocent, naïve type of woman who just wants a nice home, nice clothes and the fun in life she can get. But their situation does not even fulfil these basic desires, making her an easy target for her evil brother's plotting. In one of the scenes, she is clearly portrayed as the tempting femme fatale promising Erik sexual rewards if he plays his card the way she and her brother want. When he fails to do so, the door is slammed in his face.

The dramatic climax of the film, approximately 50 minutes into

the film (total length 83 minutes), is of course the scene where Erik visits the loan shark and kills him. The social milieu of the loan shark has all the visual and symbolic trappings of moral and sexual decay: prostitutes eyeing Erik temptingly from the back of the stage, the obvious love-hate relation of the loan shark and his housekeeper, the miserly and morally corrupted attitude of the loan shark etc. The whole scene is filmed with sombre noir mise-en-scène and with a focus on Erik caught in a social, psychological and emotionally blind alley. But besides this dense poetic realism and the fatal noir style in this particular scene, which signals a new modern film style, the cross cutting used here is also particularly modern, compared to the general 1930 standard in Danish cinema.

Just after the murder we have a match cut directly from Erik's panic stricken face and dark clothes to a man in a completely white suit, surrounded by female dancers in white. The shot is from a nearby nightclub where Erik and his wife had their first date, and the theme of the song is just as much in contrast to the murder scene as the cut from black to white of the two men. The theme of the song is about being on good terms with happiness that is waiting just outside the door, a sharp contrast to the fatal reality of the film's story. This contrast is however also directly commented on in the figure of a sad clown, clearly a visual representation of Erik and used as match cut several times, as the editing shifts between the night club and the events at the murder scene, where first the householder arrives and finds the body and after that the police. There seems to be a clear inspiration from both German expressionism and the Fritz Lang tradition in the montage of these dramatic sequences – at least it is an unusually modern style in Danish cinema from this period.

No Danish crime films from this period have a main character or quite the narrative structure of the American film noir. The films mostly focus on ordinary people caught by social forces or sheer bad luck (see also Michael Braa, 1999), or they are the victims of an erotic obsession that causes social and moral deroute. The figure of the lone detective wolf is not a realistic one in a Danish context and the urban setting does not resemble Los Angeles, New York or London. The Danish noir-characters are victims of fatal developments in everyday life, like the characters in French poetic

realism, not tough guys caught in the cross fire of big crime and dangerous women, as in American film noir. *En Forbryder* launches this theme in Danish film noir very distinctly since the main character is a nice, very naïve and gentle fellow and yet still he ends up as a convicted criminal.

Erotic Melodrama and Noir Tendencies

The other main type of Danish film noir deals with direct sexual obsession, as in the film *Besættelse* (1944), a classical noir-story in which an older man (Steen), of high social standing, quite randomly meets a young women (Else) and they spend the weekend together in a remote summer cottage. She turns out to be the prototypical femme fatale. Recently dumped by her last boyfriend, she takes advantage of him and drives him mad with jealousy. In the end he is caught between his own desire and the fear of undermining his social position. Although he does not directly become a murderer, his fear of being exposed to public light leads him to try to get rid of the body of a young rival, killed by accident when he fell from a steep ladder outside the house, while attempting to force his way into Else's bedroom. The theme of this type of film is not, as in *En Forbryder,* the lack of a social position and power leading to disaster and crime, but rather social and sexual deroute caused by instincts overpowering social status, which expose the contrast between surface and underlying structure or individual instincts and social codes.

The reverse gender versions of this narrative, but with a much more complicated plot, can be found in another Occupation noir-melodrama, *Afsporet*, the film debut by the director of *Besættelse*, Bodil Ipsen. Just as in *Besættelse*, the story of erotic obsession is not just a moral story of decay and deroute, but also a story of a social critique of conventions; the social contrast in *Afsporet* between the academic upper class milieu of the main character Esther and the criminal underworld she is absorbed in, as Lily, when she loses memory of her former identity, is also a contrast between emotional coldness and the worst sort of depraved humanity. Late in the film, when Lily is confronted with a newspaper article on

her disappearance and regains her memory, her words characterise the theme of the film: "I feel like I have been raped in a state of intoxication and ecstasy. But I never imagined there could be that much poetry in the gutter."

The contrast is also a contrast in the visual space of the film. The first part of the film, where we, by means of a flashback, follow the first 24 hours of Esther's mysterious disappearance, is shot partly on location in Copenhagen (outdoor scenes and interiors of flats and hotels) and partly in a studio, with emphasis on space, light and white colours. But this enlightened social space is at the same time conventional and completely void of life and sensuality. Esther, in this part of the film, is diagnosed by her father – a famous medical professor – as both anaemic and always cold. While the father's cure is to send her to the cold mountains of Switzerland, she sees her potentially deadly disease (the name of which we are never told directly) as a result of her unhappy life and sterile marriage to a ministerial civil servant.

It is heavily implied that this was a forced marriage and, in her despair, she seeks out her true love, an adventurer just returned from abroad. She then leaves her husband in rebellion but, when she is rejected by her former love, who has married in the meantime, she loses her memory and social identity and begins her descent into the Copenhagen underworld. The shift in visual style is pronounced and spectacular. As in German expressionism and French poetic realism, we enter a studio recreated world of strange neighbourhoods (supposedly representing the 'Nyhavn' quarter of central Copenhagen) and quaint characters, crooks, pimps, criminals and lost souls, played by some of the best actors of Danish cinema: Ebbe Rode as Janus, her new love and the jewel thief "Stenmåren", Johannes Meyer as the 'lost genius' "Organisten" (the organist) reciting philosophy and playing Chopin, Ib Schønberg as the dangerous and slimy "Jammerherren" and Sigrid Horne-Rasmussen as Janus's betrayed, revengeful former girlfriend.

The sombre universe is generally portrayed in dark, low-key lit pictures with sharp shadows but, also in certain scenes, with a nostalgic touch of a warm, lively community. Especially in the last part of the film, the intensity is strong in the psychological and

erotic scenes between Lily and Janus, a relationship where an erotic, emotional and social power play is ongoing and in the end fatal. The film has some of the most sensual love scenes in early Danish cinema, with hints of sado-masochism, where social and sexual dominance change places in this unequal and, in the end, impossible relationship between high society and the gutter. As an erotic melodrama, the film is merciless in its tragic end and is unusually violent for a Danish film. There is a shoot out between the couple and the police, when both Esther's father and the police find the couple and try to arrest Janus. Esther sticks to her new identity as Lily and, in trying to protect it, she shoots herself, choosing death rather than return to her upper class family.

In both the film's press-release material from the ASA production company and in the reviews of the film in the Danish press, it is referred to as a film in the "genre of the French masters" and *Quai des brumes* is mentioned, but *Le jour se lève*, with its violent shoot-outs, is just as relevant a source of inspiration. Although it was a new kind of Danish film with a tragic, melodramatic narrative and sombre style, it was seen by almost 500,000 Danes and it was represented at the Film Festival in Venice in 1942 (Source: Wiinblad, *Socialdemokraten*, August 2, 1942). The film is seen as a successful translation of French poetic realism and the camera work on location is seen as a result of a new realism, based on a more filmic style than usual in the often rather theatrical Danish cinema of the early 1940s.

Clearly the film was perceived as setting a new international standard for Danish cinema. However, in the Danish Nazi newspaper *Fædrelandet* (February 20, 1942), it is heavily criticised as decadent art and not as French inspired but based on American gangster films! The conservative *Nationaltidende* also talks about the romantic, unrealistic portrait of the 'Nyhavn' quarter and its decadent and criminal residents. But despite this, there is also clear recognition of the international photographic qualities of the film, influenced according to this newspaper by both French and Russian films. Some of the newspapers find the genre difficult to describe. Although both of the leading Copenhagen newspapers *Berlingske Tidende* and *Politiken* follow the French inspiration, the social democratic newspaper *Socialdemokraten* describes the film

as melodramatic folk comedy. However also here, the dramatic scenes from 'Nyhavn' are mentioned as elements in this Danish *Quai des brumes.*

Bodil Ipsen's other erotic melodrama, *Besættelse*, has, as already mentioned above, a much simpler narrative plot and fewer characters. The emphasis is therefore more on the individual psychology and the triangle between the young femme fatale (Else, played by Berthe Quistgaard), the derailed old 'pillar of society' (the draper Jens Steen, played by Johannes Meyer) and the young, hotheaded rival (Aage, played by Poul Reichhardt). The newspapers also clearly see the film as inspired by French poetic realism and they all mention the melodramatic role of chance and fate. Like *En Forbryder*, it is a melodrama about ordinary people caught in a web of fate by sheer bad luck, confronted with an erotic power that transcends and destroys social norms and cynically uses other people. But the reception of the film was, however, more reserved than that for other films by Ipsen; the film was seen as too un-dramatic and static in narrative structure.

The film has the classical flashback structure of film noir, but the crime-element is quite secondary compared to the psychological dimension. The film lacks the urban atmosphere of both French poetic realism and American film noir and is therefore not central to the Danish noir wave. However from a stylistic point of view, it has some interesting elements often found in Ipsen's melodramas and the work of her photographer, Valdemar Christensen, who is also credited as co-director. To begin with, the film has a very symptomatic use of sharp light and dark colours, already noticeable from the first scene of the film where Jens Steen is paving the floor of his prison cell, telling his story. This expressive visual style continues throughout the film's interior scenes, and as a contrast to on-location scenes shot in the nature surrounding the summer cottage, where most of the story takes place. In this sense, the noir style is used as a key element in the portrayal of the psychological conflicts, caught between the powerful open nature and the narrow social space.

The psychological drama and the dangerous erotic undercurrents are heightened further by the rather dramatic use of facial light in many of the car and seduction scenes, or the repeated use

of point-of-view editing, especially underlining the male gaze on naked body parts. Especially in a scene late in the film, where Jens briefly returns to his office, the male gaze is directly visualised and commented on at the same time by the voiceover. The individualised psychology of the film (which is seen from the male point of view and told in flashback by Jens) is also underlined by the voiceover employed throughout the film, through which Jens comments on his state of mind.

In addition, the film at times uses dissolves in a very demonstrative and psychological way. The most powerful of these slightly extended dissolves takes place in the car and has the form of a visual flashback to Else's story and her last relationship. But instead of just using this dissolve as a technical device signalling subjective memory, the dissolve is kept just long enough to give the visual structure a more symbolic function: the dissolves point to the conflict between front stage and back stage of the characters, or the public persona and the hidden persona. The film's general use of dissolves gives a very smooth and soft montage between scenes and often links elements from one scene to another by symbolic contrast or match cuts, for instance faces and expressions, as well as landscapes and sunsets. The melodramatic and psychological quality of the film is therefore strongly underlined and created by visual cues and effects that use some of the international tendencies found in French films, Hollywood noir films and melodramas from the same period.

Post-War Film Noir

As already pointed out, melodrama as a whole remained a strong genre after 1945, still very much inspired by a European tradition (French, British) but also with a stronger influence from American hard-boiled genres and film noir. The crime genres developed and were more directly American in form and theme. Especially two post-war films represent the new tendencies in the Danish noir style melodrama. The first one is the often overlooked film *Kristinus Bergman* (1948), by the director-couple Astrid and Bjarne Henning-Jensen – the latter internationally most known for his

film *Ditte Menneskebarn* (1946), based on Martin Andersen Nexø's classic novel by the same name. Like Bille August's later film *Pelle the Conqeuror*, based on a novel by the same author, this 1946 film was a major international success during this period. The second one is perhaps the most prototypical Danish film noir, the tense and stylistically very carefully crafted melodrama of every-day life *John og Irene* (Asbjørn Andersen, 1949).[4]

Kristinus Bergman is a masterpiece of film noir photography, filmed by the later well-known female director Annelise Reenberg, an artistic performance that gave her the Danish 'Bodil' film prize in 1948, the year it was established. From the first images of a dark, rainy night in a provincial Danish town, through the powerful vi-sual portrayal of the remote, scary orphanage, haunted by memo-ries of social injustice, and the powerful images of a nature almost at the point of apocalypse, to the images of urban space and the crime theme unfolded there, the film develops a strong, expressive noir style. The theme and narrative structure of the film is both close to French poetic realism and the new documentary style in American police-crime stories. But first of all it is – not surprising-ly given the two directors previous films – a strong social melo-drama with a high degree of social criticism, combined with a fine psychological and tragic double love story.

The narrative structure uses the well-known flashback tech-nique, but not in the usual fashion. We do not see the story from the point of view of a main character already caught after a fatal crime or incident. The narrative suspense is kept throughout the film and therefore we do not know for certain, until the last scenes of the film, whether or not the two main characters will succeed in breaking free of their social destiny and long criminal career, and finally free themselves from their past. Of course everything goes wrong and the end is tragic, with only a dim light at the end of the tunnel. But the flashback structure is quite important after all, be-cause the film systematically moves between the social humiliation and injustice inflicted upon the two male leading characters in the orphanage when they were children and the present, where they return to revenge the past.

The visual style and montage technique, especially used in the childhood narrative, is again masterly. The shift from present to

past is always done through a point-of-view shot on a concrete object that links past and present together, and the fatal mental and social deadlock of the past is strikingly underlined by two long montage sequences with important symbolic dimensions. The first montage sequence concludes an incident that explains how the destiny of the four boys is deeply connected, also in the present. The first flashback focuses on a cruel incident, where one of the boys, Emanuel Volten (played as grown-up by Olaf Ussing), ends up getting crippled, and where two of the other boys, Kristinus Sandersen (played as grown-up by Ebbe Rode) and Jacob Lund (played as grown-up by Preben Neergaard), try to rebel and defend him but eventually have to run away. The montage sequence shows them struggling for food, shelter and survival, and how they are finally caught and sent on an endless journey from one institution and prison after another.

The second montage sequence is almost at the end of the film where Kristinus, on his way to the city, after their clever bank robbery has almost been disclosed, is hospitalised after a car accident. He is delirious in his bed and, while he shouts "I am not guilty", the montage sequence illustrates his social destiny in a collage of images, almost as complicated as montage sequences in Russian films, surrealism or some of Hitchcock's films, such as *Vertigo*. The photographic style and the montage style in *Kristinus Bergman*, thus, in a very original and modern way, combine film noir elements and avant-garde techniques that are also found in postwar American film noir.

In this sense, the film is definitely more modern and international in visual style than the Danish noir tradition of the early 40s. But at the same time, it is unique in its strong social, melodramatic theme and social critique. However, the noir style and the extremely non-emotional and non-ideological tone clearly separate the film from the more straightforward realistic and problem oriented films dominating Danish post-war social melodrama. There is no moral preaching or elaborated ideological messages: the film allows the tragedy to unfold without any use of false emotional tones. The film is a hard-boiled psychological and social drama, accentuated by the clear stylistic, expressive noir style.

The social melodrama structure also contains erotic themes and

tragic love-story elements. But we do not find the femme fatale figure so often in these films. Whereas the social destiny of the two main characters is almost without mercy, the never really fulfilled love stories Kristinus and Jakob get involved in actually point to a possible atonement and a new future. At least the film ends on an open note. Jakob is involved with a girl that he marries and gets pregnant, but from whom he is separated after he is caught. But perhaps she will wait for him. Kristinus develops a more complicated relationship with Maria Tange, who is married to the fourth of the boys (Ulrik Tange) from the orphanage. He is killed in a car accident late in the film, after having left Maria, and he is generally described as the most socially and psychologically handicapped person – weak and with a drinking problem. But Maria (played with a glowing but sad beauty by a very young Lily Weiding) is, as the name almost indicates, a rescuing heroine and it is she that makes Kristinus stay and confront his crime instead of being on the run, as he has been all his life. The erotic and emotional tone of the film is not without tenderness and passion, but it is more resigned than hopeful and romantic. Still, as Kristinus disappears in the night in the police car to yet another incarceration, a woman is standing in the doorway watching. Again, the momentous noir fatalism dominates the tone, mood and narrative structure of the film, but a faint glimmer of hope is indicated.

The reviews and general reception of the film in Denmark were extremely positive, and the reviews refer to both the French tradition of poetic realism and the new American and Danish documentary realism (in both film and literature) with its social critique. The film was considered such a valuable artistic and social contribution to Danish film culture that it was given DKK 75,000 in public support, a large sum in those days. Some of the reviews were a bit sceptical regarding the mixing of two genres, the social melodrama and the psychological crime story (for instance *Information*, August 26, 1948), but generally the film was praised for both its visual, narrative and psychological intensity and qualities.

The same positive reception and reviews characterise the second masterpiece of the Danish post-war noir-tradition, *John og Irene*. In this film we are back in the classical flashback narrative structure of film noir. The film is told by John, after he is caught for having

killed a parasitic, rich business man. The murder happens accidentally while he is attempting to get money, so that he and Irene can get out of their social misery, get married, have their baby and live a normal family life. Again a clear-cut melodrama with both erotic-psychological and social dimensions, portraying two people on their path to social decline. The film was received as an example of the international quality of Danish film and, perhaps as a result of the post-war climate, references to Hollywood are frequent.

The film is based on a novel by the Danish author Johannes Allen and, in the novel, the story takes places in the US. However, in the film, the narrative geography is moved to Scandinavia and it is actually a truly Scandinavian co-production featuring both Swedish and Norwegian actors. The film is shot partly on location in Copenhagen, Stockholm and Oslo but mostly in a studio. Frequently mentioned in the reviews is the authenticity of the psychological portrayals and the social milieu. Especially the resigned and disillusioned nature of the female character Irene, played by Bodil Kjer, evoke references to the hard-boiled American tradition, although of course film noir is not mentioned since this term is only later constructed. But also the comments on the fatal, melodramatic narrative and Aage Wiltrups masterful visual style point in the same direction. All reference to French poetic realism has vanished. What is stressed is that this is a story about human beings in a modern urban setting; a sharp, authentic and realistic portrait of contemporary life with all its hardships and troublesome aspects; a modern life, which is cast in the tradition of American and not European film.[5]

The opening of the film, which takes place in Stockholm, contains all the classic noir characteristics: beautiful, dark shots of Stockholm by night, sombre music, a man walking up the stairs to a police station in very expressive dark and light. The man is John, on his way to tell his story to a policeman. The film has the classical noir style with flashback and voiceover structure. John and Irene are a dance act trying to get jobs in varieties, restaurants, etc, but clearly on their way down the social ladder. And this miserable life of moving from city to city, from hotel to hotel, and the desperate fight to find jobs in such unsavoury places is tearing the couple apart and putting their love, and their whole relationship,

40

under terrible pressure. When Irene realises that she is pregnant, John wants to have the baby. But Irene is realistic enough to see that this is unfeasible and has an illegal abortion, without John's consent or knowledge. However, before John gets knowledge of this, he has already committed his crime – desperate to save the baby and their relationship.

Fundamentally, the film's strength lies in its fine visual style, which underlines both the melodramatic and the realistic quality of the film, and the dramatic, psychological intensity of the relationship between John and Irene. The narrative structure and editing and the visual use of space and framing are important elements in the noir mood and style that permeates every scene of the film. The continuous shift between long distance shots of urban landscapes and close up shots of John and Irene in emotional crisis in their cramped and anonymous hotel rooms creates an atmosphere of contemporary man as a lonely individual in a modern mass society.

The intense psychological quarrel scenes between John and Irene indicate the intrusion of the urban law of the jungle in an otherwise long and loving relationship. Irene is certainly not a femme fatale and John not the hard-boiled type. They have been kicked around by bad luck and tough conditions and have had to develop a tough surface. But underneath, love and tenderness is still there. This is clearly demonstrated by the parallel visual structure at the end of the film. Here they are first seen together in an ambulance taking Irene to hospital after a half botched and dangerous illegal abortion, promising to wait for each other. Irene is disappearing down a long corridor and, shortly after, John is seen walking down a long corridor to his imprisonment. These shifts in visual space, long distance and close up, between dramatic narrative turns and between quite opposite emotions is what makes the film great to watch and what gives it a more American noir film dimension than seen before in Danish film noir.

The return of Hollywood and the beginning of the general Americanization of society is clearly reflected in this film. But at the same time, the film combines an authentic and realistic Scandinavian dimension in its portrayal of urban space and everyday life in big cities. The film is an important milestone in the modernisation of Danish mainstream film culture in the classical period.

Notes

1 Paul Fejos was originally Hungarian but was brought by Nordisk Film from Hollywood to raise the international standard of early Danish film.

2 Social melodramas from this period are, just to mention the most important, *Soldaten og Jenny* (1947, "The Soldier and Jenny", Johan Jacobsen), *Café Paradis* (1950, "Café Paradise", Bodil Ipsen), *Farlig ungdom* (1953, "Dangerous Youth", Lau Lauritzen) and *Blændværk* (1955, "Delusion", Johan Jacobsen). They were not just internationally inspired but were also a result of public support for artistic films with a social agenda.

3 Examples of this are not just the already mentioned films from the 1930s, but also the film *Møllen* (1943, "The Mill", Arne Weel) where an erotic femme fatale undermines and in the end lead to the decline of religion, family and tradition. The director Arne Weel also directed the first real Danish film noir *En Forbryder* (1941), which indicates the connection between melodrama as such and film noir.

4 Some very straightforward Danish crime films are sometimes falsely labelled film noir in writings on Danish film. For instance Michael Braa (1999) promotes Peer Guldbrandsens *2 minutter for sent* (1952, "Two minutes late") not only to a film noir but also the most outstanding example of film noir in Denmark. The film however completely lacks the noir style.

5 There is in fact only one reference to European film, namely Frederik Schybergs reference to the German silent movie *Varieté* (1925, Ewald André Dupont, photo Karl Freund).

References

Bondebjerg, Ib (1996): Film Comedy, Modernization and Gender Roles. Aspects of Romantic Comedy in Danish Cinema (in Tybjerg & Schepelern, eds: *A Century of Cinema*. Sekvens Filmvidenskabelig årbog, 1995/96, pp. 65-103).

Bondebjerg, Ib (2000): Film and Modernity.Realism and the Aesthetics of Scandinavian New Wave Cinema (in Bondebjerg, ed.: *Moving Images, Culture and the Mind*. University of Luton Press, pp.117–133.

Bondebjerg, Ib (2000 a): Singing and Dancing in Copenhagen: Hollywood et la construction du film musical danois (in Jean-Pierre Bertin-Maghit, ed.: *Les cinémas européennes dans les années cinquante*. Paris, AFRHC, pp. 199–215).

Bondebjerg, Ib (2000 b): When Hollywood doesn't come to Copenhagen – Copenhagen must come to Hollywood: the construction of a national film musical in Denmark (in *De Nieuwste Tijd*, no. 13/14, 2000, pp. 55-67).

Braa, Michael (1999): Skæbne og forbrydelse. På sporet efter dansk film noir (in *Kosmorama*, no. 223, summer 1999).

Buss, Robin (2001): *French Film Noir*. London, Marion Boyars.

Chipnal, Steve & Robert Murphy, eds. (1999): *British Crime Cinema*. London, Routledge.

Grodal, Torben (1999): Melodrama, seksualitet og altruisme. Stil og følelser i film noir (in *Kosmorama*, no. 223, summer 1999).

Jerslev, Anne (1999): Film noir. Et netværk af familieligheder (in *Kosmorama*, no. 223, summer 1999).

Jørholt, Eva (2001): Sol over Danmark (in Peter Schepelern, ed.: *100 års dansk film*. København, Rosinante, pp. 121-165).

Jørholt, Eva (2001 a): Voksen, følsom og elegant (in Peter Schepelern, ed.: *100 års dansk film*. København, Rosinante, pp. 90–121).

Langkjær, Birger (1999): Mysteriet om film noir. Stil stemming og følelser (in *Kosmorama*, no. 223, summer 1999).

Naremore, James (1998): *More Than Night. Film Noir in its Context*. Los Angeles, University of California Press.

Silver, Akain & James Ursini, eds. (1996): *Film Noir Reader*. Limelight Editions, New York.

Tuska, John (1984): *Dark Cinema. American Film Noir in a Cultural Perspective*. Westport Connecticut, Greenwood Press.

Schatz, Thomas (1981): *Hollywood Genres*. New York, Random House.

Villadsen, Ebbe (2001): Familiehyggens årti (in Peter Schepelern, ed.: *100 års dansk film*. København, Rosinante, pp. 165–199).

David Bordwell

Who Blinked First?
How Film Style Streamlines Nonverbal Interaction

According to one tradition, if you're a scholar you make progress by learning more and more about less and less, until you know everything about nothing. I'm happy to report that this essay fits firmly into that tradition. If it makes some progress toward understanding how films work, it does so by focusing on some fairly minute matters. Blink and you might miss them.

Not that the general problem is trivial. Despite decades of discussion of The Gaze and "visuality," it seems to me that we know very little about eye behavior in cinema. How do characters gaze or glance or stare or just look at each other? What patterns of looking can we find in films, and what functions can we assign them? How do these patterns shape performance and how might they accord with broader stylistic strategies employed by filmmakers? How do we as viewers respond to these patterns? Such issues are quite important, since eye behavior is central to understanding human activities, both on screen and off. As an effort toward answering these questions, I want to consider some aspects of eye behavior in mainstream narrative films. Before that, though, we need to consider how looking works in everyday situations.

Although novels and poems portray eyes as fierce, piercing, or dreamy, by themselves eyes can express very little. As social signals, they normally function as part of the face. Features, particularly the eyebrows and the mouth, work together with the eyes to create what Ekman has called the "facial action" system.[1]

Anger is prototypically signaled less by the eyes than by the knitted brows, the tense mouth, and the set of the jaw, perhaps aided by a flushed complexion or a loud tone of voice. A Fan-

tômas-style cagoule shows in a disquieting way how the eyes alone are rather uncommunicative.

Nonetheless, the eyes do have some locally significant features. The color of the iris is distinctive, and the degree to which the eyes are closed is informative. (The drooping eyelids of my students don't express quite the sensuality seen in portraits of Italian Renaissance ladies.) The size of the pupil was presumably an important cue in our evolutionary heritage, for a dilated pupil can be a sexual signal.[2] Particularly significant is the direction of a person's gaze, a cue to which we (and perhaps other primates) are highly sensitive. When a person is looking off at something, this "deictic gaze" triggers an interest from other parties, who tend to follow the direction of the look. This tendency has been discussed by Noël Carroll as an important cue in point-of-view editing.[3]

Eye direction is not, however, a snapshot affair; our glance is constantly shifting, and sometimes in quite patterned ways. A natural place to study longer-term eye behavior is in conversations, both in real life and on film. To keep things simple at the start, I assume a two-person dialogue.

Researchers in interpersonal communication have discovered that in western societies, talk between two parties displays patterns of looking and looking away. These patterns are regulated by turn-taking, as the conversants switch the roles of speaker and listener. In the most common situation, the speaker looks away from the listener more frequently than the listener looks away from the speaker. Perhaps surprisingly, the two parties seldom share a look for very long. It appears that stretches of mutual gaze, with eyes locked, are infrequent and brief. Michael Argyle found, with two people conversing, the listener typically gazes at the speaker 75% of the time, the speaker gazes at the listener 40% of the time, and the two make eye contact 30% of the time. Argyle also found that both people's eye directions changed often, with the typical one-sided glance lasting only 3.0 seconds and the mutual gaze a mere 1.5 seconds.[4] In sum, mutual looks alternate constantly with "gaze avoidance" or other eye movements, such as looking upward to recall something or glancing to the side to monitor the environment.

What creates these patterns of interaction? The usual explanation is that the speaker is expending more cognitive resources and

needs to concentrate on formulating speech, but she or he still must return at intervals to check the listener's uptake. The listener, on the other hand, concentrates not only on what the speaker says but also on other cues which carry meaning, such as facial expression. So naturally the listener pays more attention to the stream of information. In addition, to look away too often might suggest boredom, inattentiveness, or disagreement.

Imagine by contrast a situation displaying more prolonged staring between parties, with sustained mutual eye contact. This is rare in ordinary exchanges because, depending on context, the mutual stare typically signals either aggression (very salient in nonhuman primates) or deep affinity. We have on the one hand Travis Bickle's "Are you looking at me?" and on the other the rapture of lovers lost in each other's eyes. Here's another reason why in ordinary life people don't look at each other more often: locking onto the partner's eyes too frequently can send a signal which could be interpreted as hostility or erotic interest.

So much for everyday conversation. What do we find when we turn to film? A few surprises, I think. Take a scene from *L.A. Confidential* (1997). (For reasons that will become clear shortly, I've picked one in which the parties are in basic agreement, displaying neither hostility nor affection.) Sergeant Edmond Exley has been summoned by his superiors, who ask him to testify that policemen beat prisoners. The officials want to make a public-relations effort to clean up the Los Angeles police image (always in need of repair), and they need officers willing to snitch on their colleagues. Exley immediately agrees (in exchange for a promotion to lieutenant) and offers suggestions on how they can force another cop, Jack Vincennes, to testify as well.

The dialogue portion of the scene lasts about two minutes and four seconds. Exley is standing at attention before a desk, with his superiors seated around it. The scene is broken up into several shots, setting medium-shots of Exley against group shots and individual shots of his superiors. The officials take turns talking with him, occasionally talking with each other, while he addresses himself to the police commissioner, the most powerful man in the room. In the course of the scene, individuals look intently at each other, either when they are speaking or when they are listening.

If we time the intervals in which any man listening is *not* looking at the speaker and any man speaking is *not* looking at his addressee, they add up to very little – no more than ten seconds. And during many of these intervals, when one man is not looking at the speaker or his own listener, he is exchanging glances with another listener. For example, the officials glance at one another when they realize that Exley has devised a plan for his benefit.

This passage appears to invert the default case. The scene presents a world in which a speaker looks far more frequently and fixedly at a listener, and the listener concentrates on the speaker even more intently, than in the normal case. Why this result? After examining several scenes like this, I'd argue that the standard cinematic case indeed alters the ordinary scenario. Characters look away from one another rarely, not frequently, and they are often making mutual eye contact. Indeed, they often seem to be staring at one another. Yet the stare doesn't necessarily signal either hostility or love.

By contrast, a movie scene which presents something like the normal real-life case risks sending the wrong signals. In a film conversation, when a character avoids looking back at her or his partner, gaze avoidance takes on an expressive tint. A viewer might construe it as evasiveness, furtiveness, lack of interest, or the like (the very attributions made in real life when someone looks from a speaker too long or too frequently). Gaze avoidance, far from being a normal part of the rhythm of conversational interaction, is in films rare and highly informative about the character's psychological state.[5]

We can see this condition in an early scene in *Chinatown* (1974). Detective Jim Gittes is visited by a woman claiming to be the wife of Hollis Mulwray, an official in the Los Angeles Power and Light Commission. She sits at his associate's desk and explains that she suspects that her husband is having an affair. She occasionally looks away from Gittes, and he frequently looks away from her, glancing at his colleagues or frowning at the floor. By my count, a total of 45 seconds of the 118-second scene consists of gazes not focused on either speaker or listener.

If we examine these moments, however, we find that the deflected glance is psychologically revealing. At times, Gittes shares

a glance with his assistants, as did the officials in the *L.A. Confidential* scene. More important, Mrs. Mulwray looks away when she is flustered, as when she voices her suspicion that her husband is seeing another woman. At this Gittes lowers his eyes and looks to the ceiling before returning her gaze. We know from the previous scene that he's a cynic, and so we tend to read his exaggerated gravity as a sign that (a) he is simply pretending to be shocked by a man's peccadillo; and (b) he is not surprised that her husband has strayed from such an unattractive wife. As the conversation goes on, it is clear that Gittes is reluctant to take such a banal case, and this is expressed in fairly frequent glances to the side and to the floor, as if he's searching for a way out. In later scenes, though, once Gittes gets caught up in the investigation and starts to believe he is unravelling a scandal, his gaze at others becomes much more unwavering.

Certainly the contrast between the real case and the filmic case is revealing, but if we look a little further, the inversion isn't perfect. For one thing, aggression and affinity – the feelings which promote prolonged looking on the part of the speaker in normal life – are common bases of dramatic action in movies. So one could argue that most scenes in fact conform to the rule that mutual looking depends on these emotional circumstances. In fact, I had to search fairly hard to locate neutral scenes like the ones in *L.A. Confidential* and *Chinatown*, for most scenes I found had at least the hint of mutual hostility or mutual attraction. This may suggest that these feelings are at the emotional center of most scenes in mainstream movies, while more neutral encounters are fairly uncommon. At the very least, scenes of confrontation and enthrallment are far more frequent in fiction films than in life, so a greater degree of shared looking is to be expected.

Secondly, I'd argue that the cinematic default isn't a true inversion of the normal case because the prototypical cinematic conversation takes the characters' basic attitude to be *mutual attentiveness to the story situation*. The norm is that the speaker is paying strict attention to the listener's response because (unlike most conversations in real life) something of consequence hangs upon it. In effect, the eye behavior characteristic of the *listener*'s role in ordinary interaction is mapped onto the *speaker*'s role as well. The fic-

tion film presents a world in which speakers are constantly monitoring the effects of their self-presentation on listeners, searching for the slightest reactions. It would not be too great an exaggeration to say that one sign of drama is people looking intently at one another.

"What we do," says Michael Caine in his instructive tape on acting technique, "we actors who are in the movie, is: We hang onto each other's eyes. That's the most important thing." Since the characters pay constant attention to one another, we're encouraged to do so as well. The drama, after all, is about them. The filmic conversation deletes the fluctuating eyelines we'd find in life, in order to highlight the ongoing mutuality of interest–that is, the dramatic issue of the scene.

This possibility nicely reinforces Ed Tan's theory that the ground of our emotional engagement with films is the attitude of interest.[6] But is there a way to detect mutual interest among the characters more precisely? We might think of cases when the mutual interest isn't present. If a listener is oblivious to what a speaker is saying, as in the case of the TV-watching husband or a bored theater audience, the listener is usually shown looking away from the speaker. But I think there's another way to chart mutual interest in conversation scenes, one which brings out some unexplored aspects of acting technique as well.

In the 1970s I became fascinated watching Judy Garland films, not just because I found her a captivating performer but also because I noticed that she seemed almost never to blink. At the time I put this down to her having been fed pharmaceuticals as a child star. Years later I began to notice that she wasn't the only non-blinker; indeed, in most scenes actors seldom blinked. This issue didn't exactly rocket to the top of my research agenda, but it continued to intrigue me.

Only after reading a pop biography of Michael Caine did I get a hunch about the process. Caine claims that as a youth he read Pudovkin's treatise on film acting and learned that he should never blink.[7] Caine then practiced staring without blinking until he could do so for minutes on end.[8] In his tape on acting, produced many years later, he explains why. "If I keep blinking, it weakens

me. But if I'm talking to you and I don't blink [stares at camera] and I keep on going and I don't blink [continues to stare at camera], you start to listen to what I'm saying. And it makes me a very strong person, as opposed to someone who is sitting there going [blinks several times], which is someone who's completely flustered." General thespian lore appears to hold that strength, menace, or some other intense quality is best conveyed by the rocklike look.[9] Antony Hopkins maintains that in playing Hannibal Lecter he strives never to blink: "If you don't blink, you can keep the audience mesmerized."[10] Likewise, Samuel L. Jackson credits his success at playing disturbing roles to winning the no-blinking game as a child. "I have this habit of being able to stare unblinkingly at you until you break."[11]

Now playing a strong, determined person might seem to call for unblinking eyes, and there's no doubt that Caine, Hopkins, and Jackson excell in such parts. But I think that the absence of blinking is far more widespread than these reports indicate; remember Judy Garland. Moreover, we have evidence that filmmakers want to control blinking behavior whenever it occurs. According to a friend of mine, when he was directing a film, his editor felt he had to make a cut in order to eliminate an actor's blink.[12] George Lucas, pointing out the postproduction advantages of digital video, employs a telling example: "If someone blinks right where I'm making the cut and I can't make the cut because it doesn't work with the blink, I just get rid of the blink."[13] It seems likely, then, that the suppression of blinking occurs fairly often and fulfills cinematic purposes beyond the enhancement of Michael Caine's career.

In ordinary life we blink to lubricate our eyes, and we do so between fourteen and twenty times per minute. A blink lasts about ⅓ or ¼ of a second. Interestingly, in conversation, playing the role of speaker tends to raise the blink rate, while playing the role of listener lowers it.[14] Once more, in film, aspects of the listener's role – here, fewer blinks – are transferred to the speaker, and the speaker becomes less of a blinker, just as his or her gaze wanders much less. And Caine is right about looking flustered. We blink faster when we are excited or in other states of arousal (anxiety, addressing a large crowd, telling falsehoods). One study found that people

rated a frequently blinking person as more nervous and less intelligent than one who blinks rarely.[15]

When do we not blink? It seems that absorption in a visual task creates longer intervals between blinks. Several Japanese researchers have found that blink rates slow down when people are engrossed in television watching.[16] In movie dialogue scenes, the absence of blinking is a very direct way to convey each partner's attentiveness and mutual interest. If my *L.A. Confidential* scene were an everyday conversation, we should find a minimum of 96 blinks in total (twelve blinks a minute times two minutes times four men). Yet I can find only 34 blinks shown onscreen. Each man seldom blinks when he is speaking, especially when he is the subject of a "single," or a shot showing one alone. Actors whom I've asked seldom report that they decide to avoid blinking, but they do invoke the common actor's advice that credible performance involves watching and listening to the other actors. When actors concentrate on what the other players are doing, it may yield fewer blinks as a byproduct.

Yet Lucas' remark also indicates that blinking is not to be outlawed altogether. The movie blink can be very useful and can fulfill a range of purposes. Consider that in ordinary contexts, a blink often is read as a signal of surprise, concern, or bafflement. This tendency seems to have become a convention of fictional narrative generally. No novel reports all a character's blinks, but when the narration does, it is important.

"I don't understand," Meyer said, puzzled. "Did she *look* thirty, or did she ...?"
"Well, how would I know *how* she looked, man?"
Meyer blinked. "What do you mean?" he said.
"She was wearing a mask," Bones said.
"A mask?" Meyer said, and blinked again. "At a wedding?"
"Oh," Bones said. "Yeah." He blinked, too. "Maybe I got something mixed up, huh?" he said.[17]

The *L.A. Confidential* policemen blink very little. They blink most when they change the angle of their gaze, and occasionally they blink to register a reaction to what is said; Exley, for example,

keeps his face composed but blinks in response to chastisement from his captain. In the *Chinatown* example, where only Gittes' and the purported Mrs. Mulwray's faces are discernible, I find at least 53 blinks in 118 seconds (about the same amount of time as the *L.A. Confidential* scene consumes). Here the average (about twelve or thirteen blinks per minute) is close to the real-life norm. But again the blinks tend to be significant. Mrs Mulwray blinks when she talks of her husband's infidelity; as with Exley, her facial expression appears unconcerned, but her blinking shows her to be agitated. Similarly, Gittes' efforts to avoid taking the case are registered by several blinks which convey not only hesitation and avoidance but also an elaborate effort to be polite. At one point, as Gittes strains to charm Mrs. Mulwray, Jack Nicholson's performance makes him positively flutter his eyelashes.

Thus the demands of film acting build upon normal patterns of blinking but functionalize them: actors strive to make this spontaneous act a tool of their craft. One study has indicated that in ordinary life blinks occur with greater frequency at the start of an utterance or word.[18] But actors tend to blink when they want to *punctuate* an utterance, often after a meaningful phrase. More frequent blinking, as we would expect, is a tool of expressive performance, with implications shaped by context. Just as a change of eye direction will not be read onscreen as the gaze drift characteristic of normal conversation, a series of blinks is likely to be taken not as natural lubrication of the eye but rather as betraying a particular emotional state – all those variants of Caine's "weakness" we can call apprehensiveness, anxiety, remorse, fatigue, or sadness (blinking back tears). In *The Guns of Navarone*, when the David Niven character confronts a member of the demolition team with damning evidence that she is a spy, he holds the screen with unblinking force. The other team members watch her warily, and their vigilance is expressed through a pronounced absence of blinks. By contrast, the suspected spy blinks – an indication that her façade is cracking. Yet in the next scene, waiting for the moment to launch the raid on the guns, Niven is the one who blinks mightily: he's afraid.

A little observation of screen performances shows that there are blinking-related tricks of the acting trade. For example, it's easier

to keep from blinking if you're not fixating on something (so all praise to Caine and Jackson for managing a fixed stare). Actors therefore find ways to motivate changes of glance. Even slight shifts of eye direction can help hold back a blink, as when two actors looking at one another seem to search each other's faces. Actors also find ways to conceal their blinks. A performer can sneak a blink by turning the head (the *L.A. Confidential* tactic) or by lowering the eyes, as if in modesty or deep thought (one of Nicholson's tactics in the *Chinatown* scene). Some actors squint, in the process making themselves look more adorable (e.g. Renée Zellweger) or implacable (Charles Bronson). And certain directors slow down the blink so that it becomes a dramatic event in itself; Robert Bresson's players lower their eyelids with such deliberation that they seem to be shutting down an electrical circuit.

We might expect cultural variations in the eyeblink repertory, but my preliminary searches don't reveal them. In films from various countries and periods, it seems that actors avoid blinking, just as they watch each other as fixedly as Hollywood performers do. This uniformity seems to occur despite a culture's rules about eye behavior.[19] Japanese etiquette discourages people from looking fixedly at their conversational partner, but in films they do so frequently, and they seldom blink. Ozu films are remarkable repositories of non-blinking conversations.[20] Did actors in other cultures learn from US films to restrain their blinking? Or did they independently rework some transcultural norms of eye behavior?

In any event, it would be worth studying different films from different traditions and periods to plot the ways in which actors conceal or manifest the simple act of blinking. Similarly, we might consider how various shooting and staging techniques have made blinks more or less salient. (Today's insistence on "singles," particularly close-ups, would seem to demand actors who can hold back blinks.[21]) But now you see why I began by saying that I'm approaching the academic ideal of knowing more and more about less and less. Fortunately, though, this exercise harbors some more general, if somewhat speculative, implications.

How may we best understand cinematic conventions? They are often built out of ordinary-life behaviors; but not just any behav-

iors. The ones favored would appear to involve interpersonal interactions which put people's social intelligence on display. One important function of art may well be the opportunity it affords for us to test, refine, and expand our knowledge of how and why others do what they do. To this end, for example, faces in films become of particular interest because they're informative on many levels – they provide information about attention and interest, as well as mental and emotional states. To take a more concrete case: it's important for us to detect deceivers, and we have evolved many mechanisms to help us. Films presenting evasive, blinking liars may reinforce and fine-tune our sensitivities.

In narrative cinema, it's important to keep the viewer fastened on the flow of information, especially in character encounters. The shared gaze and the absence of blinking are two well-defined social signals for mutual attentiveness, and filmmakers marshall them often. They signal to an outside party, the audience, that the characters are participating in a significant exchange of story information. The situation becomes defined as dramatic by very basic indications that the characters are deeply engaged in consequential action. These signals of mutual engagement also stabilize the viewer's attention from moment to moment, an important consideration in a time-bound medium like film.

If cinema, like other artistic media, often models social intelligence, it doesn't simply copy the relevant behaviors. Like all representations, it simplifies what is represented according to a principle of purpose-based relevance. Accordingly, many devices of film style rework social acts for clarity and expressive effect. Elsewhere I've suggested that one function of shot/reverse-shot cutting is to accentuate the patterns of face-to-face interaction and turn-taking typical of conversational exchanges.[22] Acting as a practice already stylizes normal human interactions, and when the performance is subjected to other cinematic techniques – framing, lighting, color, cutting, and the like – further simplification takes place. Thus a close-up can make eye direction unambiguous, and cutting can delete blinks.

Once more, I think, we're led to a moderate constructivism, something akin to what Torben Grodal calls "ecological conventionalism."[23] Historically, filmmakers have taken as their material

ordinary behaviors, often of transculturally readable sorts. But the filmmakers have processed those behaviors, usually for the sake of greater clarity and force. Cinematic style often streamlines ordinary human activity, smoothing the rough edges away, reweighting it for the purposes of creating representations which are densely and redundantly informative, as well as emotionally arousing.

Thanks to Joe Anderson, Noël Carroll, Jim Dillard, Dirk Eitzen, Mary Anne Fitzpatrick, and Kristin Thompson for their comments on ideas presented in this paper.

Notes

1 Paul Ekman and Maureen O'Sullivan, "Facial Expression: Methods, Means, and Moues," in *Fundamentals of Nonverbal Behavior*, ed. Robert S. Felderman and Bernard Rime (Cambridge: Cambridge University Press, 1991), p. 185.
2 For a useful review of these factors, see Alain Brossard, *La psychologie du regard: De la perception visuelle aux regards* (Lausanne: Delachaux et Niestlé, 1992), pp. 185-191.
3 Noël Carroll, "Toward a Theory of Point-of-View Editing: Communication, Emotion, and the Movies," in *Theorizing the Moving Image* (Cambridge: Cambridge University Press, 1996), pp. 127-129.
4 Michael Argyle, *Bodily Communication*, 2nd ed. (London: Methuen, 1975), p. 159. For a more complete treatment of the subject, see Michael Argyle and Mark Cook, *Gaze and Mutual Gaze* (Cambridge: Cambridge University Press, 1976), Chapters 3-5.
5 I except the case of two characters conversing while engaged in a common task, such as working on a machine or riding in a vehicle. Even in car dialogues, however, I suspect that the person who isn't driving will look at the driver far often than we'd expect in real life.
6 Ed S. Tan, *Emotion and the Structure of Narrative Film: Film as an Emotion Machine* (Mahwah, NJ: Erlbaum, 1996), pp. 85-119.
7 I cannot find any passage in Pudovkin's *Film Acting* (New York: Grove, 1960; orig. English edition, 1937) which alludes to blinking.
8 Michael Freedland, *Michael Caine* (London: Orion, 1999), pp. 37-38.
9 This may be the source of the sense of strength conveyed by dark glasses; they seem to present an unbroken stare.
10 Antony Hopkins interview with Barbara Walters, *Arts and Entertainment Mundo*, broadcast 8 March 2001 in Buenos Aires.

11 Quoted in Celebrity News, Internet Movie Database, 30 November 2001. Thanks to Jonathan Frome for the reference.

12 Joe Anderson, personal communication.

13 Quoted in Benjamin Bogery, "Digital Cinema, By George," *American Cinematographer* 82, 9 (September 2001): 71.

14 Daniel McNeil, *The Face: A Natural History* (Boston: Little, Brown, 1998), p. 29. See also Argyle and Cook, *Gaze and Mutual Gaze*, p. 26.

15 Yasuko Omori and Yo Miyata, "Eyeblinks in the Formation of Impressions," *Perceptual and Motor Skills* 83, 2 (October 1996): 591-598.

16 Hideoki Tada, "Eyeblink Rates as a Function of the Interest Value of Video Stimuli," *Tohoku Psychologica Folia* 45 (1986): 107-113; Kenroku Tsuda and Naoto Suzuki, "Effects of Subjective Interest on Eyeblink Rates and Occurrences of Body Movements," *Japanese Journal of Physiological Psychology and Psychophysiology* 8, 1 (June 1990): 31-37; Niina Kobayashi et al., "The Effect of Appreciating Music Videos on Spontaneous Eyeblink," *Japanese Journal for Physiological Psychology and Psychophysiology* 17, 3 (1999): p. 183-191.

17 Ed McBain, *Calypso* (New York: Avon, 1988; orig. 1979), p. 73.

18 W. S. Condon and W. D. Ogston, "A Segmentation of Behavior," *Journal of Psychiatric Research* 5 (1967): p.229.

19 A few such culture-specific rules are listed in Argyle and Cook, *Gaze and Mutual Gaze*, pp. 27-32.

20 See my *Ozu and the Poetics of Cinema* (Princeton: Princeton University Press, 1988), p. 173.

21 On today's film style, see my "Intensified Continuity: Visual Style in Contemporary American Film," *Film Quarterly* 55, 3 (Spring 2002):p. 16-28.

22 "Convention, Construction, and Cinematic Vision," in Post Theory: Reconstructing Film Studies, ed. David Bordwell and Noël Carroll (Madison: University of Wisconsin Press, 1996), pp. 87-107.

23 Torben Grodal, *Moving Pictures: A New Theory of Film Genres, Feelings, and Cognition* (Oxford: Oxford University Press, 1997), p. 21.

Edward Branigan

How Frame Lines (and Film Theory) Figure

"I am not saying [that the word 'good'] has four or five different meanings. It is used in different contexts because there is a transition between similar things called 'good,' a transition which continues, it may be, to things which bear no similarity to earlier members of the series. We *cannot* say 'If we want to find out the meaning of "good" let's find what all cases of good have in common.' They may not have anything in common. The reason for using the word 'good' is that there is a continuous transition from one group of things called good to another."[1]

Wittgenstein

"[T]he current interest [of scholars in the humanities is] in cultural locations, practices, identities and objects that are hybrid, mixed, marginal, Creole, transcultural, postcolonial, liminal, meta-, para-, quasi-, or otherwise impure and ambiguous. It is not an exaggeration, I think, to say that the majority of essays in the humanities have as their primary methodological orientation an interest in complexity and ambiguity. Perhaps the commonest rhetorical strategy in current scholarship is to demonstrate a state of unexpected complexity or a pitch of ambiguity that cannot be reduced to simpler schemata."[2]

James Elkins

"[A] realist aesthetic and an expressionist aesthetic are hard to merge. …The art cinema seeks to solve the problem [of merging the two aesthetics] in a sophisticated way: by the device of *ambiguity*. The art film is nonclassical in that it foregrounds deviations from the classical norm – there are certain gaps and problems. But these very deviations are *placed*, resituated as realism (in life things happen this way) or authorial commentary (the ambiguity is symbolic). Thus the art film solicits a particular reading procedure: Whenever confronted with a problem in causation, temporality, or spatiality, we first seek realistic motivation. (Is a character's mental state causing the uncertainty? Is life just leaving loose ends?)

If we're thwarted, we next seek authorial motivation. (What is being 'said' here? What significance justifies the violation of the norm?) Ideally, the film hesitates, suggesting character subjectivity, life's untidiness, and author's vision. Whatever is excessive in one category must belong to another. Uncertainties persist but are understood as such, as *obvious* uncertainties, so to speak. Put crudely, the slogan of the art cinema might be, 'When in doubt, read for maximum ambiguity.'"[3]

David Bordwell

World, Language, Ambiguity

Does the world dictate language or does language dictate a world? Does the real world existence of a cat and mat motivate the words "the cat is on the mat"? Or, instead, does a human conceptual scheme bring into existence (express) a specific sort of world, making prominent only certain kinds of actions, qualities, categories, resemblances, and relations? Consider, for example, the worlds that might be produced through conceptual schemes that contain such words as "beauty," "number," "permission," "value," "ennui," "unicorn," "absence," "freedom," "fairness," "balance," "possibility," "combustible," "phlogiston," "irony," and "time wasted." Posed in this manner, the basic question does not have an answer. The alternatives, as it were, are too far apart. To make progress on this question one needs to explore the causal interactions that *mediate* between a strict realism and a strong relativism. One needs to examine in greater detail the cognitive systems and mental representations that are intermediate between world and comprehension.

A similar quandary arises concerning the relationship of "story" and "style." Does a particular story naturally give rise to a form of expression or does expression alone create a vision that defines a unique story world? Other aesthetic oppositions that seem to be intractable in the same way include story/discourse, content/form, and material/meaning.[4] F. Elizabeth Hart has argued persuasively that there is a vast middle ground of methodologies between the extremes of realism and relativism that can illuminate aesthetic issues.[5] She argues that a second-generation cognitive sci-

ence based not on logical computation but on figural, embodied, emotive, and ecological processes is able to address some of the intricacies of how a person thinks about self and environment in mediated ways through language. In the field of film and media studies, Torben Grodal has employed this kind of approach, which he calls "ecological conventionalism," to systematically reconfigure basic problems of theory and analysis.[6] Grodal's admirable work has begun to fill in the gaps between the extremes of realism and relativism.

One aspect of "realism" is its use by critics as a *concept* for isolating a particular experience of a spectator. In a careful analysis Grodal identifies eleven types of "realism" said to be prevalent in audiovisual representations. He finds that the term realism is "used in many different ways, causing ambiguity or inconsistency in [its] meaning."[7] He also considers the relationship of realism to a postmodern skepticism and relativism. It is in this spirit that I would like to examine another term used by critics – the "frame." The word "frame" is central to our vocabulary of viewing. It is, however, an ambiguous word and may be used in many inconsistent ways. Grodal declares, "'Frame' is a word with many meanings and functions." He reviews five main cognitive processes implicated in the word "frame."[8] This multiplicity will pose a problem for persons writing about film or those reading film criticism. Nevertheless, what I wish to concentrate on is a different side of "ambiguity": the fact that ambiguity may be convenient, disguised, and deeply constitutive of the way we are able to think and use language, and of the way we live in the world.[9]

I believe that the more closely one looks at film, the more closely one is looking at *why* one watches film and how one *talks about* the memory of what has been experienced.[10] A spectator's experience of film is much more than what is seen and heard on the screen. Watching a film requires a spectator to make judgments moment by moment and to actively construct models of locale and agency using folk knowledge, expectations, inferences, heuristics, scripts, metaphors, social schemata, and numerous forms of memory. Because film plays within the mind, and not simply on the screen, the analyst must attend to the way a spectator uses language to encode his or her responses. With what vocabulary do we

watch and to what purpose? I suggest that the critical vocabulary, even when systematized, is not always designed to be exact and unequivocal (a "realist" language) but sometimes is meant to be ambiguous and flexible in order to better fit the desire to watch, participate, shape, speak, commend, and transform (a "relativist" language).[11]

In what follows I want to demonstrate the ambiguity of the concept of "frame" as it appears in critical discourse.[12] What are the sources of its ambiguity? How is the concept of frame made to function? What are the implications for constructing a film theory? But first, the notion of "ambiguity" is ambiguous! Linguists have distinguished several kinds of ambiguity, two of which are homonymy and polysemy.[13] In the case of homonymy, two words spelled in the same way possess unrelated, or at least very distant, meanings (thus separate lexical entries):

1. She was fishing in the river from the *bank*.
2. She deposited money in the *bank*.

1. He heard a dog *bark*.
2. The tree in the forest has *bark*.

By contrast, in polysemy a word has distinct, though related meanings, or at least meanings that are fairly close (thus a single lexical entry):

1. She bought a *newspaper*.
2. The editor was fired by the *newspaper*.

1. He broke the *bottle* [container].
2. The baby finished the *bottle* [contents].

1. The man *ran* into the woods.
2. The road *ran* into the woods.
3. The voice-over *ran* into the next scene.

In this essay I will discuss only polysemy and will treat a polysemous word as opening onto a special type of category that George

Lakoff calls a "radial" category, i.e. a category where ambiguous meanings of a word are linked, creating, as Wittgenstein says, "a continuous transition."[14] Incidentally, the word "open" just used is dazzling in its polysemy as is the word "figure" in the title of my essay as well as the word "good" mentioned by Wittgenstein in the epigraph (i.e., "good" may describe a film, a breeze, a concept, a friend, a car, a memory, a meal, a conversation, a scolding, a color, a generalization, a time, the middle part of an essay, a pencil, a hand …).

Radial meanings are important to analyze because they are intimately connected to the way in which we confront familiar, everyday situations and solve ordinary problems. Radial meanings help organize our memory and are part of imagination, that is, "visualization" in the broadest sense. Although any given situation is unique, the links among radial meanings provide "a continuous transition" from one group of things to another based on a set of preexisting analogies. This allows a given situation to be part of a series of past and possible future events. As Lakoff emphasizes, however, radial meanings are neither predictable from a core meaning (because as a whole they fail to have relevant common properties, a collective essence) nor are they the result of a series of arbitrary conventions, but something in between – a *motivated* convention based on living within a community and sharing a way of life. Radial meanings are an embarrassment to Objectivist (nonembodied, "realist") theories of meaning and rationality as well as an embarrassment to certain philosophical beliefs. According to Mark Johnson, polysemy is one of seven fundamental challenges to 'metaphysical and epistemological' realism.[15]

Some Radial Meanings of "Frame"

I will now list and briefly discuss fifteen different, though related, ways of employing the word "frame" in discussions about film. Although typical, these ways do not exhaust the possibilities.

1. The frame is the *real edge* of an image on the screen that has resulted from limits imposed on celluloid inside a physical camera

and projector so that, for example, a projected image can be said to be "in frame" or "out of frame" on screen. The spectator, however, is not really seeing an actual edge. The edge of an image on screen is not the edge of an individual exposed frame from inside a film camera but, at least, a composite edge that is made up of a number of exposed frames since in watching a film the spectator does not see each of the individual frames halted on the screen as if a series of slides were being shown.

2. The frame is the *subjective contour* or illusory border of an image that is projected by a spectator. A subjective contour is not inferred or imaginary, but is an *explicit* visual feature to which specialized neurons respond in a particular cortical area of the visual system. Thus when a dark object appears on the screen, but far from the center of an image, the spectator will see the dark object as being partially cut off at a certain point by a "straight line" which will be seen to be continuous with other, brighter straight line segments, the sum of which will form a luminous rectangle that will be said to "frame" the entire image. That is, there need not be an actual line through the dark object; the spectator's perceptual system will fill in the "line" and make it "straight" so that the dark object will be seen to be separated from the equally dark surround. Notice in this case that the "frame" is experienced as being *overlaid* on the image so that the image is being cut off at the sides. From this conception of framing comes the expectation that at a later time we may be able to see *more* of what was blocked.

3. The frame is the *gestalt form* of an image that makes it appear as a rectangular whole because of principles of good continuation and closure. The "outer" frame acts to bias such internal relations as figure-ground organization and proximity groupings.

4. The frame is the *shape* of an object or group of objects seen outlined inside an image. For example, a "vase" on a table will be seen as framed by a distinctive shape as well as by the top of the table and background curtains. Note that a framing "edge" is defined simply by an abrupt perceptual change – a difference or contrast – in either the illumination or the colors of adjacent regions, where-

as a framing "line," in addition to having two "edges," possesses extension (length) and thus can be used to build a figure within an image (e.g., a vase). Furthermore, since *contrast* between edges is at its greatest intensity when edges occur in the same plane, a series of frame lines that are composed on the flat screen of a film or on the canvas of a painting offer more striking contrasts than do frames dispersed in multiple planes (i.e., dispersed in three dimensions) on a theater stage or in real life.[16]

5. The frame is the overall *composition* of an image, its disposition and balance of figures, forms, colors, lighting, angle, perspective, focus, movements, and sub-spaces (i.e., the "framing" or "misframing" of a shot with respect to a convention or expectation). A simple example would be a shot that frames a doorway that frames a view. Much study has been devoted to various "principles" of composition in the belief that the arrangement of shape, color, and movement can clarify and intensify the meaning of an element (e.g., a facial expression).[17] The composition is then said to "frame" or bracket the element.

6. The frame is the *totality* of the two-dimensional *area* of an image as well as the totality of the *three-dimensional space* represented by an image (e.g., a storyboard panel or a film frame that depicts a locale).

7. The frame is the *physicality* of what surrounds an image, i.e. the materiality of a screen and perhaps the auditorium itself, like the wooden frame that holds a painting.

8. The frame is the *implicit rationale* for the seeing of an image. When the rationale for the presence of an image is stated metaphorically in terms of everyday situations of viewing, then one might think not of an auditorium, but of a window in a house or train or the view from an amusement park ride. If the observer is imagined to be walking, then one might think of a strolling, nineteenth-century *flâneur* who encounters transient and haphazard, everyday situations[18]; or one might think of someone walking toward a destination with a definite purpose in mind which would

produce impressions of the journey quite different from those of a *flâneur*. Moreover, if one were to replace the "glass" in the metaphorical window with other kinds of optics, one would be able to construct additional rationales for the seeing of film (as film theorists have done) based on analogies with such instruments as the microscope, camera lucida, camera obscura, telescope, and periscope.

To elaborate a few variations of the standard metaphor of a viewer in front of a window, framing in film might be likened to (I) what is seen *through* the frame of the "window," or to (II) what is seen to be constrained and *shaped* by the frame of the "window," or – when the window becomes partially fogged or else light wanes with the coming of "twilight" – to (III) what is *reflected* in the window as a "mirror," namely, the person who tries to look and/or the world of the person who tries to look.[19] In all three cases, keen judgment may be required to separate what is seen through the glass (perhaps darkly) from the influence of whatever lies unseen beyond the frame as well as from what is "partly reflected" *on* the window. That is, a critic's judgment may be required to interpret various "hidden and mixed traces" within the visible display in order to discover an appropriate rationale for seeing what should be seen. The significance of what should be seen may appear initially to be ambiguous, implicit, suppressed, or involuntarily repressed within the (merely) visible.

Not all film theories develop analogies based on everyday situations of viewing. Sergei Eisenstein insists that a spectator will experience successive images in a film as appearing not *next to* each other in a linear flow on the screen, but *on top of* each other in a dialectical collision.[20] This illustrates how Eisenstein's film theory is not built upon analogies with ordinary situations of looking at (framing) something while standing, riding, walking, or using an optical instrument.

9. The frame is the *view* that is given on a fictive action from within the diegesis. Examples: a point-of-view shot that frames a character's view; an eyeline match; a dream sequence; an expressive angle (revealing a character's "frame" of mind); and a camera reframe. Gerald Mast analyzes how the dynamic flux of a character's

changing state of mind is conveyed in Chaplin's *Easy Street* by a character's movements toward and away from the frame edges and concludes that "the cinema frame, like the fun house mirror, achieves its magical fun because it has edges and borders that are not so much physical boundaries as psychological limits and barriers to visual perception."[21] Jean Mitry argues that characters' movements, camera movements, and continual changes of shot tend to make the spectator "forget the 'frame.'" Mitry adds, "Thus if everything contrives to make us forget the frame as such, everything contrives at the same time to make us feel its effects."[22] Mitry has it both ways, whereas Bazin would have us forget the frame in favor of a photographic and phenomenal "realism" (e.g., through continuous sweeping camera movements that create a "lateral depth of field"[23]) while Eisenstein, Arnheim, and Burch would have us remember the frame as an antidote to "realism."[24]

Briefly, I would like to explore a special case of framing a character's view. If the identity of the character who has the view becomes problematic in some way, or the character somehow becomes "absent" from his or her point-of-view shot, then what remains of the "view" is merely its framing which becomes enigmatic, fragmented, de-centered, alienated, uncanny, liminal, or empty in some measure (as in films by Antonioni, Resnais, Bergman, Herzog, and Tarkovsky). This produces a partially unanchored framing or "semi-disconnected" point of view within the film. The "art cinema" – as discussed by Bordwell in the epigraph – is one type of film practice that focuses precisely on these sorts of ambiguous and uncertain states of being in a world.[25] These states are at a remove from everyday actions that exist in a present and immediate, but fleeting time. Torben Grodal has argued that the art cinema strives for an effect of "high art" by seeking to represent that which seems permanent and permanently out of ordinary time. Grodal shows how art cinema depicts abstraction, oblique meaning, possibility, recurrent memory, unusual mental states, disembodiment, and transcendence in conjunction with unmotivated dissections of perceptual flux through "difficult" stylistic exercises and *temps mort*. In addition, Grodal argues that the art cinema aims to evoke negatively-colored emotions cut off from familiar objects and specific situations, such as euphoric and lyrical experi-

ences, the sublime, melancholia, nostalgia, and estrangement.[26] The various effects of such metaphysical "high art" are valued by scholars in the humanities, as Elkins contends in the epigraph. It may be that scholars are drawn to ambiguity and difficulty, even when weighing the products of visual culture generally, because of their search for a middle ground between realism and relativism where seeing the value of an artwork demands special skills and sensibilities that lie between an uninformative realism and a self-indulgent relativism.

10. The frame is the *rhetorical figure* that interprets or bears upon a situation. Examples: a metaphorical image (for example, in the metaphor, "man is a wolf," "wolf" frames "man"); a musical cue used as foreshadowing; a repeated shot used for emphasis; an eccentric camera position; and an unmotivated, wandering camera.

11. The frame is the *scene* that provides an overall context for describing or encapsulating various separate actions that together make up an unfolding event. A scene represents knowledge that is always more than what appears on the screen at a given moment, and more even than the sum of all the shot-fragments relating to the event since there are always elements "off-screen" that are presupposed by the action. Here are some examples of how a scene frames an event for a plot: an establishing shot (frames the location of the event); a reaction shot (frames a character with an attitude toward a series of actions); and a detail shot (highlights an important object within a causal chain). Characters, too, may create "scenes"; for example, a character who "frames" a person for a crime that he or she did not commit (as in *Who Framed Roger Rabbit*).

12. The frame is the *narrative structure* (narrative framework) that contains or embeds various parts of a story. Examples: a prologue (frames the story to come); a frame story (a story about the story); foreshadowing (frames a future event); implied authorial commentary (frames an attitude to the story); a non-subjective flashback (the past as a frame for the present); closure (reframes the beginning of the story); and voice-over (frames one or more scenes).

13. The frame is the *narration* or discourse that produces a story (i.e., produces a series of linked events as "evidence" for an argument). In general, narration is a *set of principles* (which may be implicit or inconsistent) that act, for example, to select, organize, restrict, obstruct, fragment, censor, abstract, condense, revise, correct, substitute, emphasize, link, and/or confer duration on elements of a plot in relation to a story. Several "levels" of narration may be operating simultaneously where each level acts to regulate (frame) the spectator's access to a kind of information.

14. The frame is the general *psychic state* or disposition that underlies a spectator's emotions while watching a film. Examples: deframing (Metz); disframing (Heath); identification (i.e., not just "looking at" a character, but "looking after" him or her); misrecognition (*méconnaissance*); self-conscious or reflexive framing; dream processes (e.g., Tarkovsky's "elimination of the image's borders" to fashion an "obfuscated peripheral vision" characteristic of dream); emotional buffer frames (Grodal); and the double framing of the blot (Zizek).[27]

15. The frame is the relevant subset of our *world knowledge* that is presupposed by a story and/or applied to a story by a spectator. World knowledge provides a context or set of background assumptions used for comprehension and interpretation. In general, a spectator is confronted at every moment by the problem of deciding *which few ones* of the countless inferences that may be drawn from an image are *relevant* for the occasion.[28] The total number of such inferences is enormous because the number of *categories* and *aspects* that may be attributed to an image, and to its placement within a sequence and context, is enormous.

From the "realism" of the first definition of frame, we have now arrived at a definition that is amenable to a version of "relativism." Consider, for example, Richard Rorty's account of how multiple contexts may be put to use by Western intellectuals:

"From an ethico-political angle, however, one can say that what is characteristic, not of the human species but merely of its most advanced, sophisticated subspecies–the well-read, tolerant, conversable inhabitant of a

free society–is the desire to dream up as many new contexts as possible. This is the desire to be as polymorphous in our adjustments as possible, to recontextualize for the hell of it. This desire is manifested in art and literature more than in the natural sciences, and so I find it tempting to think of our culture as an increasingly poeticized one, and to say that we are gradually emerging from the scientism which Taylor dislikes into something else, something better."[29]

How Do We Think in the Cinema?

How do we make judgments while watching a film? Where is "interpretation" to be located? What defines the uniqueness of the film medium: is it a material? an expression? Is the "three-dimensional" space of an image illusory? (What is real, what is not, in film?) When a critic settles on a particular radial meaning of "frame" as the most important and "literal" meaning, he or she will discover already in place a theory of film that addresses these questions along with a special rhetoric for employing the word "frame." For this reason I believe that a "theory of film" may be thought of generally as the grammar of an ensemble of words, such as frame, shot, camera, editing, style, realism, auteur, performance, spectatorship, and medium specificity, accompanied by selected radial extensions of these words.[30] I believe that a film theory is not simply a set of objective propositions about film because "film" – – that is, the grammar of the words that describe film – is not fixed but tied to culture, value, and a consensus about, for example, the present boundaries of the medium and the present ideas that are used to "clarify our experience of film."

As an illustration, consider the role of *intentionality* in film; that is, questions about which agents are responsible for which acts in a film (an author, narrator, character, spectator ...). It will be found that the acts attributed to an agent depend on which of the radial meanings is chosen as a frame of reference. Consider, for example, the first meaning of frame above (i.e., where the frame is defined relative to the *real edge* of an image on the screen resulting from limits imposed on celluloid inside a physical camera). Thinking in this way, the primary agent will be the cameraman (standing

70

in for the auteur) while the spectator plays little or no role. Similarly, in the second meaning of frame above (i.e., where the frame is experienced as superimposed onto the image, blocking out parts of what can be seen), it seems natural to think that someone (an auteur) has made a decision to show one particular thing while excluding all else. These two ways of thinking emphasize the material reality of film production (a realism, a historical fact) while connecting the frame to ideas of "planning" and "contrivance." However, in other uses of the word "frame," the spectator will assume a more significant role, ranging from ordinary ways of looking and moving (e.g., 7-9 above) to forms of narrative reasoning (e.g., 12-13) to non-conscious perceiving (a relativism, e.g., 14-15).

One shouldn't think that the act of framing is confined to visible and/or visual aspects of imagery. Sound can frame. The sound track can make an object visible by directing our attention to it; a sound can portray the extent and qualities of a locale; a sound can express an aural point of view; a sound can refer to an object off screen; a sound can summon visual experiences; a sound can rhetorically frame meanings; a sound can invoke a motive, an emotion, and world knowledge; and so forth. Furthermore, all films (including silent films) must embody *an aural rationale* that frames how each sound *can be heard*.[31]

Roughly speaking, I would say that uses of the word "frame" in ways 1-7 draw mostly upon processes of "bottom-up" perception while ways 8-15 draw mostly upon processes of "top-down" perception.[32] Uses of the word frame falling in the middle of the list (7, 8, 9) reflect so-called "basic-level categories" as opposed to "subordinate" and "superordinate" categories (lower- and higher-numbered definitions, respectively). Basic-level categories reflect phenomena that are experienced as concrete and "real" through bodily-based processes (e.g., gestalt perception, mental imagery, and motor interaction). A basic-level category is the highest level at which a single mental image can represent an entire category. For example, an expert will be able to visualize the subordinate category, "brown-capped chickadee," but even an expert cannot visualize the superordinate category, "vertebrate," which includes birds, mammals, reptiles, and fishes. One may easily visualize such basic-level categories as "chair" and "car," but not the superordi-

nate categories, "furniture" and "vehicle." Basic-level categorization of objects, actions, emotions, social groups, etc., is one of the far-reaching discoveries of a second-generation cognitive science.[33] It is also a key concept in Torben Grodal's fundamental rethinking of the nature of art cinema. Grodal argues that art cinema works to transcend online, transient body states (basic-level) in favor of permanent, higher meanings (superordinate emotions and meanings). Art cinema utilizes ambiguity and uncertainty in order to challenge basic embodied existence and point toward higher "truths".[34]

It is important to realize that when the frame is conceived as a *top-down principle* (in ways 8-15), the frame will not at all be *visible* in the same manner as an edge or subjective contour of an image since cognitive activities beyond the visual system will be required in order to make the effects of the frame appear on screen. Thinking bottom-up (in ways 1-7) makes what appears on the screen seem "concrete" and distinct (suggesting a kind of "realism" composed of subordinate categorization) while at the same time making acts of interpretation seem abstract and secondary. By contrast, thinking top-down frames a type of viewing or intelligibility for a spectator that is neither directly on the screen in the form of "cues" nor tied to the time of presentation (projector time). What actually appears on the screen in thinking top-down will seem "abstract" and secondary, merely an illusion, imitation, form, description, or symptom of some *other*, more concrete though invisible, reality in the world. Thus thinking top-down suggests a kind of "relativism" composed of superordinate categorization. The art cinema, in particular, strives to make what is on the screen seem ambiguous, uncertain, incomplete, empty, and/or illusory so as to provoke (top-down) thought about unseen, deeper, and felt realities.

Sergei Eisenstein developed ideas about film by thinking both bottom-up and top-down, though he is most famous for advocating a "language" of film that is primarily a top-down procedure. Eisenstein urged that to understand cinema, one should avoid analogies with the visual arts, like theater and painting, and instead think carefully about mental processes that are non-visual like language and emotion.[35] In the present age where each new form of digital media provokes a frantic search for its unique features, I believe that the lessons of Eisenstein remain pertinent. One should be

cautious about focusing too quickly on physical characteristics, technology, and typical operations of a medium at the expense of radial sorts of connections to other media – connections based on higher-order mental functions and tasks that may be selectively performed by a great many "older" media. The reality of a new medium is relative.

It would be well to recall Wittgenstein's admonition: "One thinks that one is tracing the outline of the thing's nature over and over again, and one is merely tracing round the frame through which we look at it."[36]

The Container Schema

I would now like to trace the notion of "frame" in terms of how we look at it as a mental procedure. A "frame" may be understood through the cognitive psychological concept of the *container* image schema. An "image" schema is much more "diagrammatic" and abstract than the "image" one encounters in film studies which tends to be a detailed sort of mental picture with quasi-photographic features. An image schema in cognitive psychology represents only general structural features of a thing, not a particular thing or memory of a thing. The container schema is a mental procedure that divides something into a diagrammatic "inside-boundary-outside." It is one of the most powerful and pervasive *embodied* schemas used in recognizing patterns, solving problems, reasoning, explaining, and planning. An "embodied" schema is a non-conscious kinesthetic structure arising from physical and bodily existence (e.g., arising from our percepts, movements, and manipulation of objects). The range of bodily experiences also includes social norms that impinge on behavior and thought.[37] Thus embodied schemas are neither "universal" nor "arbitrary," but are based on typical actions and feelings of the body in typical situations. Most importantly, embodied schemas may be extended by metaphors and metonymies into other realms. Indeed the reason that polysemous meanings are radial (are related to one another) is because the meanings have been projected from a specific image schema through metaphor or metonymy.[38]

The container schema (embodied, kinesthetic, non-conscious, imagistic) underlies, for example, the way in which we imagine that objects are inside space, parts and qualities are inside objects, beliefs and memories are inside the mind, examples are inside categories, meanings are inside films, and ideas are conveyed in words. Moreover, we imagine a chair to be in the corner in a view, a glass in our hand, and orange juice both inside a glass and inside our body as we are in our clothes and in a mood inside a room, a car, a marriage, Denmark, and the Society for Cinema Studies. Consider also this sentence: "Tell me a story to figure *out*, but leave *out* the minor details." That is, a given container encloses and excludes, and may be framed by other containers. Moreover, a container may be metaphorically expanded to produce new, more abstract containers. For example, our view of framing in film may be expanded through analogies that make new sorts of containers out of Plato's cave, unconscious subterranean tunnels, and the womb.

Figure 1

As a summary, I offer figure 1 which is a graphic representation of an *image schema* for the notion of "radial meaning" where each of the individual boxes frames a single category of meaning based on a container schema while the set of boxes taken as a whole represents a single lexical entry (a set of related meanings) for a polysemous word. I have been arguing, of course, that the word "frame," as used in film studies, is radial in meaning and, moreover, that each meaning of "frame" may itself have radial components (e.g., 8 above). The container schema variously structures our thinking within the 15 domains of framing in film. Although every frame

encloses like a "container," what is "inside" – the contents – and the nature of the "enclosure" – the criteria for the containing thing – is different for each of the 15 domains. How the container schema is applied to a domain will determine how inferences are drawn and conjectures made about what is framed, including what it will take to "break the frame."

To illustrate how the container schema may be applied to the act of framing, consider the "frame" when it is defined in terms of a "narration" (see 13 above). Figure 1 may then be interpreted as a distribution of narrations in a text in the form of a heterarchy rather than a hierarchy.[39] "Breaking the frame" of an individual subjective narration might then be accomplished through certain strategies of the art cinema (see discussion in 9 above). To take another example: when the "frame" is defined in terms of a "scene" composed of an edited sequence of shots (see 11 above), figure 1 may be interpreted as an unusual editing pattern that refuses to develop the scene as a simple hierarchy of spaces illuminating an event at assorted scales. Non-analytical editing schemes that generate heterarchies have often been explored by the art cinema and demonstrate that editing, in general, need not be conceived as merely a series of embedded, local juxtapositions, but may include, for example, matches between shots 1 and 3, 5 and 2, 4 and 12. To imagine editing as merely an immediate juxtaposition is to imagine that we have no memories other than the most recent and no schemata to frame our sight.

A final example: when the "frame" is defined in terms of an "implicit (basic-level) rationale" derived from ordinary situations of looking at objects during daily life (see 8 above), the situations will become connected in a radial manner and may be metaphorically projected to create a set of linked film theories. The resulting film theories, however, will not probe all possible differences among spectators and situations, but rather will assume that all spectators share certain abilities (e.g., the ability to be alert, to look through a window, ride in a vehicle, walk, or use an optical instrument). What counts as "framing" or "breaking the frame" will be determined by the metaphor that governs the prototypical viewing situation. This raises a deeper question: can a single, unified theory of film be constructed? Could there be, for example, a single,

unified theory of "frame lines"? Perhaps a film theory, like a poly-semous word, can only be constructed of dispersed but linked "pieces," each with a distinct logical structure defined by ecologi-cal conventions (Grodal) or motivated conventions (Lakoff).

A more complete description of framing in film from a cogni-tive standpoint (i.e., from *within* a cognitive frame …) would in-volve, besides the container schema, such schemas as the source-path-goal schema which addresses the framing of a *time* span (i.e., a time frame) as well as such judgment heuristics as "anchoring and adjustment" and the movement of a person's attention. This larger perspective on "framing" is a reminder that framing cannot be lim-ited to the "aesthetics" of film or to "general aesthetics" since schemas and reasoning procedures play a vital role in many areas of community life. Thus Figure 1 may also be interpreted as a dis-tribution of mental models in a population that taken as a whole characterize a culture. Particular mental models, of course, may appear in several cultures.

Envoi: the Indefinite Boundary

Finally, Wittgenstein reminds us that there are limits to thinking in a frame, and even to thinking in a sequence of frames. Meanings that are indefinite, blurred, or porous may have a use.

"The sense of a sentence – one would like to say – may, of course, leave this or that open, but the sentence must nevertheless have *a* definite sense. An indefinite sense–that would really not be a sense *at all*. – This is like: An indefinite boundary is not really a boundary at all. Here one thinks perhaps: if I say 'I have locked the man up fast in the room – there is on-ly one door left open' – then I simply haven't locked him in at all; his be-ing locked in is a sham. One would be inclined to say here: 'You haven't done anything at all.' An enclosure with a hole in it is as good as *none.*–But is that true?"[40]

If we adopt for a moment "basic-level categories" for thinking about philosophical issues (as Wittgenstein frequently does), we can imagine some analogues to the situation of the man who has

been locked in a room with only one door left open. For example, consider the plot of a classical film as it moves along a trajectory from one point through an open door to the next point (to a new room and scene); or, consider the tiny hole ("open door") in an hourglass through which sand drains away, measuring one kind of time found often in plots; or, finally, consider that there may be a point that is being communicated to the man in the room through the "sham" of being locked inside with an open door, just as narrative "fictions" (and fictions within fictions[41]) may well have a point and not be simply false.[42] If a few more doors and windows had been left open (but not *all* the doors and windows, producing a sieve), then one might have uncovered parallels with the methods of art cinema; indeed "the man" in the room might not have been able to decide whether or how to leave. In this analogy, the art cinema may be seen as approaching how we think generally in the cinema, neither bottom-up nor top-down, neither basic-level nor subordinate/superordinate, neither completely inside nor completely outside the film, but rather somewhere between the extremes of realism and relativism in an area where time runs in both directions.

Coda: the Camera

Now what shall we say about the entity that we call THE CAMERA? Doesn't the camera *cause* the framing to be on the screen in each of the 15 senses of frame listed above? That is, the camera may be said to cause the framing after one has specified in a suitable manner what it means to be "on the screen."

Perhaps we should turn the question around – let the tail wag the dog for once. Since there are many ways of seeing the act of framing, perhaps there are many ways for the camera to be seen ... or to be. For example, the camera that we see "moving" in animation is not the physical camera on the animation stand (even if that camera were to move). Nor is the camera that is moving around Group Captain Mandrake, President Muffley, and Dr. Strangelove the same camera that moves around Peter Sellers. (Peter Sellers, but not the others, could be seen performing on a set in front of a

camera.) Perhaps, then, there are many ways for the word "camera" to function in our discourse when we undertake to describe how we have experienced a film. That is, there may be many cameras (some incompatible) in our talk about cinema depending upon our goals.

I believe that the word "camera" is a radial concept that extends far beyond the properties of a (definite) physical apparatus able to record the real world and having a weight and serial number. I believe that the camera extends beyond – dare I say? – photographicity, beyond pictured-ness, beyond even the visible and visual, and instead extends into the schematic and abstract wherein lies language and the language of film, where there is no genuine and exact description proper for all occasions,[43] where a camera is created to point out, and where getting the point means imagining a camera.

I wish to thank Henry Bacon, Warren Buckland, John Kurten, Melinda Szaloky, and Charles Wolfe for their perceptive comments. Preliminary versions of some of the ideas in this essay may be found in "*Quand* y a-t-il caméra?," *Champs Visuels* 12-13 (Janvier 1999), pp. 18-32 (special issue edited by Guillaume Soulez on "Penser, cadrer: le *projet* du cadre") and in "How Frame Lines Figure," a paper presented at the Society for Cinema Studies conference, May 2002.

Notes

1 *Wittgenstein's Lectures: Cambridge, 1932-1935*, From the Notes of Alice Ambrose and Margaret Macdonald, ed. by Alice Ambrose (New York: Prometheus Books, 2001), Part I, §29 (original emphasis). See also §28 and Part II (The Yellow Book), §§2-3 (on the complicated grammar of such words as "good," "game," "kind," "concrete," "abstract," "mind," "thought," "soul," and "God"). Part of the problem, Wittgenstein says, is that we tend to "think of anything we mention as falling under one genus only; and we look on the qualities of things as comparable to the ingredients of a mixture." (§2) These issues are extensively discussed in Wittgenstein's *Philosophical Investigations*, trans. by G.E.M. Anscombe (Oxford: Blackwell, 3rd ed. 1967; orig. 1953).

2 James Elkins, "Preface to the book *A Skeptical Introduction to Visual*

Culture," *Journal of Visual Culture* 1, 1 (April 2002), p. 96; see also pp. 94-95.

3 David Bordwell, "The Art Cinema as a Mode of Film Practice," *Film Criticism* 4, 1 (Fall 1979), p. 60 (original emphases).

4 A worthy effort to overcome such distinctions as story/discourse and content/form in theorizing narrative may be found in David A. Black, "*Homo Confabulans*: A Study in Film, Narrative, and Compensation," *Literature and Psychology* 47, 3 (2001), pp. 25-37. See also Black, *Law in Film: Resonance and Representation* (Urbana: University of Illinois Press, 1999).

5 F. Elizabeth Hart, "The Epistemology of Cognitive Literary Studies," *Philosophy and Literature* 25, 2 (October 2001), esp. pp. 319-325. Mark Johnson argues strongly for a middle ground position between "Objectivism" or "foundationalism" and "relativism" in *The Body in the Mind: The Bodily Basis of Meaning, Imagination, and Reason* (Chicago: University of Chicago Press, 1987), pp. 194-212. See generally Norman N. Holland, "Where is a Text? A Neurological View," *New Literary History* 33, 1 (Winter 2002), pp. 21-38; and Paul Hernadi, "Why Is Literature: A Coevolutionary Perspective on Imaginative Worldmaking," *Poetics Today* 23, 1 (Spring 2002), pp. 21-42 (special issue on "Literature and the Cognitive Revolution").

6 On "ecological conventionalism," see Torben Grodal, *Moving Pictures: A New Theory of Film Genres, Feelings, and Cognition* (Oxford: Oxford University Press, 1997), index entry, p. 299; cf. "psychomimetic" representations of time, pp. 139, 145. See also David Bordwell's middle ground position between "sheer naturalism" and "radical conventionalism" which he terms a "moderate constructivism" based on "contingent cultural universals"; "Convention, Construction, and Cinematic Vision" in *Post-Theory: Reconstructing Film Studies*, ed. by David Bordwell and Noël Carroll (Madison: University of Wisconsin Press, 1996), pp. 87-107. For two recent appraisals of cognitive film theory, see the special issue on "cinema and cognition" of CiNéMAS 12, 2 (Winter 2002) and Laurent Jullier, *Cinéma et cognition* (Paris: L'Harmattan, 2002).

7 Torben Grodal, "The Experience of Realism in Audiovisual Representation" in Northern Lights Film and Media Studies Yearbook 2002, *Realism and "Reality" in Film and Media*, ed. by Anne Jerslev (Copenhagen: Museum Tusculanum Press, University of Copenhagen, 2002), pp. 67-68.

8 Grodal, *Moving Pictures*, pp. 209-210; and see index entry on "frame," p. 300. The five main cognitive processes of framing that are discussed by Grodal are as follows: picture-frame as container; window/camera as both mask and source of vision; focus of attention; frame-system for organizing hypotheses; and emotional filter.

9 See, e.g., Ellen Spolsky, "Darwin and Derrida: Cognitive Literary Theory As a Species of Post-Structuralism," *Poetics Today* 23, 1 (Spring 2002), pp. 43-62. Spolsky asserts, "Since the study of just about everything is conducted in words, these inherent instabilities or ambiguities [in language], previously described as 'literary' phenomena parasitic on 'normal' language ..., [are] now understood as a general condition of language use, including language used to conduct scholarly debate." (p. 50) Bryan Vescio goes even further by arguing that there is no important distinction between image and word, perceiving and reading; "Reading in the Dark: Cognitivism, Film Theory, and Radical Interpretation," *Style* 35, 4 (Winter 2001), pp. 572-591.

10 See generally David Bordwell, *Making Meaning: Inference and Rhetoric in the Interpretation of Cinema* (Cambridge, Mass.: Harvard University Press, 1989), and James Elkins, *Our Beautiful, Dry, and Distant Texts: Art History as Writing* (New York: Routledge, 2000).

11 On the advantages of ambiguity in film theory, see Edward Branigan, "To Zero and Beyond: Noël Burch's *Theory of Film Practice*" in *Defining Cinema*, ed. by Peter Lehman (New Brunswick, N.J.: Rutgers University Press, 1997), pp. 149-168.

12 In this essay I will concentrate on the "frame" as it is used in critical discourse in film studies. For works that consider the "frame" in painting, see, e.g., *The Rhetoric of the Frame: Essays on the Boundaries of the Artwork*, ed. by Paul Duro (Cambridge: Cambridge University Press, 1996); Jacques Derrida, *The Truth in Painting*, trans. by Geoff Bennington and Ian McLeod (Chicago: University of Chicago Press, 1987); and Barbara E. Savedoff, "Frames," *The Journal of Aesthetics and Art Criticism* 57, 3 (Summer 1999), pp. 345-356.

13 I am setting aside the considerable, and still unresolved, theoretical difficulties that arise in attempting to make distinctions among homonymy, polysemy, and univocality. See, e.g., Michael V. Antony, "Is 'Consciousness' Ambiguous?," *Journal of Consciousness Studies* 8, 2 (February 2001), pp. 19-44.

14 See esp. George Lakoff, *Women, Fire, and Dangerous Things: What Categories Reveal about the Mind* (Chicago: University of Chicago Press, 1987), chap. 6, "Radial Categories," pp. 91-114, 146-147, 346-348, 537-540, passim. For Wittgenstein, see the epigraph.

15 See Johnson, *The Body in the Mind*, "Preface," pp. ix-xvi. The seven challenges to Objectivism discussed in Johnson's book are categorization, the framing of concepts, metaphor, polysemy, historical semantic change, non-Western conceptual systems, and the growth of knowledge.

16 On the frame as a line that produces edge contrast, see Jacques Aumont, *The Image*, trans. by Claire Pajackowska (London: British Film Institute, 1997), pp. 14-16, 40-44; on framing, pp. 106-118.

17 A few interesting books on the principles of composition: Arthur Wesley Dow, *Composition; a series of exercises in art structure for the use of students and teachers* (Berkeley and Los Angeles: University of California Press, 13th ed. 1997; orig. 1899); Victor Oscar Freeburg, *Pictorial Beauty on the Screen* (New York: Arno Press, 1970; orig. 1923); Vladimir Nilsen, *The Cinema as a Graphic Art (On a Theory of Representation in the Cinema)*, trans. by Stephen Garry (New York: Hill and Wang, 1959; orig. 1937); Gyorgy Kepes, *Language of Vision* (Chicago: Paul Theobald, 1944); Rudolf Arnheim, *Art and Visual Perception: A Psychology of the Creative Eye – The New Version* (Berkeley and Los Angeles: University of California Press, rev. ed. 1974); Rudolf Arnheim, *The Power of the Center: A Study of Composition in the Visual Arts – The New Version* (Berkeley and Los Angeles: University of California Press, 1988), and see chap 4, "Limits and Frames," pp. 51-71.

18 On metaphors involving film framing and the *flâneur*, see, e.g., Siegfried Kracauer, *Theory of Film: The Redemption of Physical Reality* (Princeton, N.J.: Princeton University Press, 1997; orig. 1960), pp. 170-171; and *Cinema and the Invention of Modern Life*, ed. by Leo Charney and Vanessa R. Schwartz (Berkeley and Los Angeles: University of California Press, 1995), "Introduction," pp. 5-6. On metaphors involving film framing and the train window, see Lynne Kirby, *Parallel Tracks: The Railroad and Silent Cinema* (Durham, N.C.: Duke University Press, 1996). On metaphors for film framing derived from trains and amusement park rides, see, e.g., Peter Wollen, "*Rope*: Three Hypotheses" in *Alfred Hitchcock: Centenary Essays*, ed. by Richard Allen and S. Ishii-Gonzalès (London: British Film Institute, 1999), esp. sect. "Mobility and claustrophobia," pp. 81-83.

19 On the three standard metaphors of "window," "window frame," and "mirror," see, e.g., Dudley Andrew, *Concepts in Film Theory* (Oxford: Oxford University Press, 1984), pp. 134-135, and Vivian Sobchack, *The Address of the Eye: A Phenomenology of Film Experience* (Princeton, N.J.: Princeton University Press, 1992), pp. 14-20. One might wonder about the status of film sound in the standard metaphors: is it unheard, muffled, secondary? Sobchack avoids the standard metaphors while still using everyday, embodied perception to create a radically new conception of the frame and the activity of framing. She *denies* the usual distinction between animate and inanimate and argues that film itself is a conscious and experiencing entity, not merely an inanimate thing that is subject to anthropomorphism. "Along with its objective existence for us as its spectators, a film possesses its own being. That is, it *has being* in the sense that it *behaves*." (p. 61, original emphases) The result is that the frame acquires a special role: "The frame provides the *synoptic center* of the *film's experience* of the world

it sees; it functions for the film as the field of our bodies does for us."
(p. 134, my emphasis of the second pair of words; see also pp. 131, 135, 211)

20 *S. M. Eisenstein: Selected Works, Vol. I, Writings, 1922-34*, ed. and trans. by Richard Taylor (London: BFI Publishing; Bloomington and Indianapolis: Indiana University Press, 1988; orig. 1929), "The Dramaturgy of Film Form (The Dialectical Approach to Film Form)," p. 164; Sergei Eisenstein, *Film Form: Essays in Film Theory*, ed. and trans. by Jay Leyda (New York: Harcourt, Brace & World, 1949), "A Dialectic Approach to Film Form," p. 49. Though Eisenstein does not mention the stereoscope, he does draw a parallel between images in dialectical collision and stereoscopy. See also *S. M. Eisenstein: Selected Works, Vol. II, Towards a Theory of Montage*, ed. and trans. by Michael Glenny and Richard Taylor (London: BFI Publishing, 1991; orig. 1940), "Vertical Montage," pp. 332, 392-393, translated as "Synchronization of Senses" and "Form and Content: Practice" in Sergei M. Eisenstein, *The Film Sense*, ed. and trans. by Jay Leyda (New York: Harcourt, Brace & World, 1942), pp. 78-80, 201-205.

21 Gerald Mast, "On Framing," *Critical Inquiry* 11, 1 (September 1984), p. 109. Note that Mast's comparison of the cinema frame to the "fun house mirror" merges two rationales for seeing an image, namely, the 'view from an amusement park ride' and the 'window as a mirror.' See preceding discussion of the word "frame" (8) in the text above.

22 Jean Mitry, *The Aesthetics and Psychology of the Cinema*, trans. by Christopher King (Bloomington and Indianapolis: Indiana University Press, 1997; orig. 1963), p. 190.

23 André Bazin, *Jean Renoir*, trans. by W. W. Halsey II and William H. Simon (New York: Simon & Schuster, 1973; orig. ms.1958), "The French Renoir," p. 89. See also Bazin's famous contrast between the theater's self-sufficient and brilliant "crystal chandelier" which "holds us prisoners" and the cinema's "little flashlight of the usher, moving like an uncertain comet across the night of our waking dream, the diffuse space without shape or frontiers that surrounds the screen." "Theater and Cinema: Part Two" from *What is Cinema?*, trans. by Hugh Gray (Berkeley and Los Angeles: University of California Press, 1971; orig. 1951), p. 107. Cf. Kracauer, *Theory of Film*, "Affinities," pp. 18-20 (i.e., the inherent affinities of photography with reality); see also pp. 37-39, 60-74.

24 See, e.g., *Eisenstein: Selected Works, Vol. I* (orig. 1929), "Beyond the Shot," pp. 146-148. In a different translation of this passage, framing is described as "Hewing out a piece of actuality with the ax of the lens." Eisenstein, *Film Form*, "The Cinematographic Principle and the Ideogram," p. 41. See also Noël Burch, *Theory of Film Practice*, trans. by Helen R. Lane (New York: Praeger, 1973; orig. 1969), chap. 2,

"*Nana*, or the Two Kinds of Space," pp. 17-31; reprinted by Princeton University Press, Princeton, N.J., 1981. See also Rudolf Arnheim, *Film as Art* (Berkeley and Los Angeles: University of California Press, 1957; orig. 1933), "Selections Adapted from *Film*," sect. 1 "Film and Reality," subsect. "Delimitation of the Image and Distance from the Object," pp. 16-20 and esp. "Artistic Use of the Delimitation of the Picture and of the Distance from the Object," pp. 73-87. Arnheim asserts that "[t]he limitations of the picture are felt immediately. The pictured space is visible to a certain extent, but then comes the edge which cuts off what lies beyond. It is a mistake to deplore this restriction as a drawback. I shall show later that on the contrary it is just such restrictions which give film its right to be called an art." (p. 17) The topic of "framing" was usually discussed by early film theorists in terms of the "close-up" shot.

25 See Bordwell's "The Art Cinema," pp. 56-64, and his *Narration in the Fiction Film* (Madison: University of Wisconsin Press, 1985), chap. 10, "Art-Cinema Narration," pp. 205-233.

26 See Torben Grodal, "Art Film, the Transient Body, and the Permanent Soul," *Aura* 6, 3 (2000), pp. 33-53.

27 On "emotional buffer frames," see Grodal, *Moving Pictures*, pp. 178-179. On dream framing, see Vlada Petric, "Tarkovsky's Dream Imagery," *Film Quarterly* 43, 2 (Winter 1989-90), p. 29. An example of "disframing" in Hitchcock's *Suspicion* is analyzed at length by Stephen Heath, *Questions of Cinema* (New York: Macmillan, 1981; orig. 1976), chap. 2, "Narrative Space," pp. 19-24; see also, "On Screen, in Frame: Film and Ideology," pp. 1-18. "Disframing" involves a return of unconscious and repressed "excess" textual material that must be repressed anew by the narrative. For Slavoj Zizek the phallic blot functions as a "double framing": the blot frames a "hole" in the fabric of the "real" world, of normality, but only after it has been recognized and "removed" as anomalous (leaving behind the "hole" as a 'window'); however, the newly-created "hole," in its turn, acts to frame the "whole," the rest of the "real," from the inside out(ward). Zizek, "The Hitchcockian Blot" in *Alfred Hitchcock: Centenary Essays*, pp. 127-128. On the fetishistic pleasure of framing-deframing, see Christian Metz, "Photography and Fetish," *October* 34 (Fall 1985), pp. 86, 89. He states, "More generally, the play of framings and the play with framings, in all sorts of films, work like a striptease of the space itself … The moving camera caresses the space, and the whole of cinematic fetishism consists in the constant and teasing displacement of the cutting line which separates the seen from the unseen. But this game has no end." (p. 88) See also Metz, "The Imaginary Signifier" from *The Imaginary Signifier: Psychoanalysis and the Cinema*, trans. by Celia Britton, Annwyl Williams, Ben Brewster and Alfred Guzzetti

(Bloomington: Indiana University Press, 1982; orig. 1975), sect. "Fetish and Frame," pp. 77-78.

28 See, e.g., Daniel Dennett, "Cognitive Wheels: The Frame Problem of AI" in *The Robot's Dilemma: The Frame Problem in Artificial Intelligence*, ed. by Zenon W. Pylyshyn (Norwood, N.J.: Ablex Publishing, 1987), pp. 41-64.

29 Richard Rorty, "Inquiry as Recontextualization: An Anti-Dualist Account of Interpretation" from *Objectivity, Relativism, and Truth* (Cambridge: Cambridge University Press, 1991), p. 110; quoted in Vescio, "Reading in the Dark," p. 589.

30 Cf. *Wittgenstein's Lectures*, Part I, § 28 ("Luther said that theology is the grammar of the word 'God.'").

31 I apply such concepts as schema, top-down and bottom-up perception, the pragmatics of a middle world, and basic-level categorization to a theory of film sound in "Sound, Epistemology, Film" in *Film Theory and Philosophy*, ed. by Richard Allen and Murray Smith (New York: Oxford University Press, 1997), pp. 95-125. Even a silent film will provide a rationale to justify how a sound can be heard since a spectator does not presume characters to be deaf nor the world mute. See, e.g., Melinda Szaloky, "Sounding Images in Silent Film: Visual Acoustics in Murnau's *Sunrise*," *Cinema Journal* 41, 2 (Winter 2002), pp. 109-131.

32 Separating "bottom-up" from "top-down" perception has theoretical implications for the existence of "computational algorithms" in the mind as opposed to more flexible, "context-sensitive" processes. See, e.g., the "Dialogue" between John Tooby & Leda Cosmides and Ellen Spolsky, *SubStance* 94/95, v. 30, nos. 1/2 (2001), pp. 199-202 (special issue "On the Origin of Fictions: Interdisciplinary Perspectives"). The distinction between bottom-up and top-down perception is not based on the presence or not of visual illusions and constancies, which are usually thought of as bottom-up phenomena. Top-down perception is subject to many kinds of cognitive illusions, biases, and fallible heuristics (e.g., the fundamental attribution error, belief perseverance, and dilution). Bottom-up perception is involuntary, serial, rapid, atomistic, computational, highly specialized, and inaccessible to memory and consciousness. Bottom-up perception operates directly upon the visible and audible data of film by organizing it automatically into such features as aural pitch, loudness, timbre, edge, slant, corner, depth, volume, orientation, motion, speed, direction, size, shape, surface, color, and texture. By contrast, top-down perception enables one to perceive narrative patterns and to construct a cognitive map of a locale on the basis of seeing a few shots. Top-down perception is based on acquired knowledge, memory, predisposition, inference, practical postulates, and schemata, and hence is "context-sensitive." Top-down

perception is not constrained by stimulus time and operates indirectly, often abductively, on the visible and audible data of film using a spectator's expectations and goals as principles by which to organize knowledge, and especially to project hypotheses. As the Queen remarks to Alice in Lewis Carroll's *Through the Looking-Glass* (chap. 5), "It's a poor sort of memory that only works backwards."

33 On the philosophical significance of embodied basic-level categories and their relation to imagery, knowledge structure, and "realism," see esp. George Lakoff and Mark Johnson, *Philosophy in the Flesh: The Embodied Mind and its Challenge to Western Thought* (New York: Basic Books, 1999), pp. 26-30. In this connection, see also the importance of the "person schema" in understanding the embodiment of characters within a basic-level fictional world; Murray Smith, *Engaging Characters: Fiction, Emotion, and the Cinema* (Oxford: Oxford University Press, 1995), pp. 17-39, 113-116.

34 See Grodal, "Art Film, the Transient Body, and the Permanent Soul," pp. 35-38, 46-50.

35 Eisenstein asks, "Now why should the cinema follow the forms of theater and painting rather than the methodology of language, which allows wholly new concepts of ideas to arise from the combination of two concrete denotations of two concrete objects? Language is much closer to film than painting is." Eisenstein, "A Dialectic Approach to Film Form" in *Film Form*, p. 60; *Eisenstein: Selected Works, Vol. I*, "The Dramaturgy of Film Form (The Dialectical Approach to Film Form)," p.178.

36 Wittgenstein, *Philosophical Investigations*, § 114; cf. §§ 104, 122.

37 See, e.g., Johnson, *The Body in the Mind*, pp. 205-212.

38 On the container schema and other embodied image schemata, see, e.g., Johnson, *The Body in the Mind*, chap. 2, "The Emergence of Meaning through Schematic Structure," pp. 18-40, and chap. 4, "Metaphorical Projections of Image Schemata," pp. 65-100; on schematic constraints, pp. 112-126; on polysemy and schemata, p. 107. See also Lakoff, *Women, Fire, and Dangerous Things*, pp. 269-278. Warren Buckland discusses the container schema and other embodied schemata in *The Cognitive Semiotics of Film* (Cambridge: Cambridge University Press, 2000), chap. 2, "The Body on Screen and in Frame: Film and Cognitive Semantics," esp. pp. 39-51. See also Maureen Turim, "Postmodern Metaphors and the Images of Thought," *Polygraph* 13 (2001), pp. 112-119.

Embodied image schemata are similar to so-called "mental models" which are diagrammatic pictures in working memory that are connected to perception and imagination as well as to an interpretation of the propositional content of a sentence. Also, there exist alternative ways to conceptualize a schema besides as an embodied image

schema; notably an approach in which a schema is seen as a "frame" for procedural and generic knowledge that contains "slots" that can accept a limited range of "values," including "default values," e.g. a schema for a "living room" or a "birthday party." In addition, there are other important kinds of knowledge structures besides schemata, e.g. folk models and judgment heuristics. On various methods and concepts of cognitive science, see generally *The MIT Encyclopedia of the Cognitive Sciences*, ed. by Robert A. Wilson and Frank C. Keil (Cambridge, Mass.: MIT Press, 1999).

39 On levels of narration and their organization in terms of dependency or relative autonomy, see Edward Branigan, *Narrative Comprehension and Film* (London and New York: Routledge, 1992), chap. 4, "Levels of Narration," esp. pp. 113-114. The term "heterarchy" comes from Marvin Minsky's classic study of intelligence, *The Society of Mind* (New York: Simon and Schuster, 1985), p. 35. Figure 1 in the text above may also be used to represent dynamic framings in a film, for example, temporal articulations and camera movements; cf. *Narrative Comprehension and Film*, figure 3, p. 41.

40 Wittgenstein, *Philosophical Investigations* § 99 (original emphases); cf. §§ 71, 76-77, 98, 100-101. I am reminded of film viewing when Wittgenstein says, "I look at the landscape, my gaze ranges over it, I see all sorts of distinct and indistinct movement; *this* impresses itself sharply on me, *that* is quite hazy. After all, how completely ragged what we see can appear! And now look at all that can be meant by 'description of what is seen.'–But this just is what is called description of what is seen. There is not *one genuine* proper case of such description–the rest being just vague, something which awaits clarification, or which must just be swept aside as rubbish." Part II, xi, p. 200 (original emphases).

41 See Edward Branigan, "Nearly True: Forking Plots, Forking Interpretations – A Response to David Bordwell's 'Film Futures,'" *SubStance* 97, v. 31, n. 1 (2002), pp. 105-114.

42 The following are additional real and embodied situations that may be metaphorically linked to Wittgenstein's room with an open door (thereby creating new images for the activity of framing): a birdcage, insect trap, and the "glass ceiling" encountered by women in the business and professional worlds. Furthermore, Wittgenstein's "open door" may be interpreted as a convenient illusion as in the case of a subjective contour (cf. definition 2 of the frame); or, the "open door" may be turned inside out to create a "room" in the form of a Möbius strip (cf. definition 14 which invokes contradiction, ambivalence, and unconscious processes).

43 See notes 36 and 40 above.

Lennard Højbjerg

Style
Segmentation and Patterns

The first transmission of *The Kingdom* (*Riget*), which took place on Danish television in 1994, marked the broader acceptance of a new and more expressive visual style, both in film and television. Lars von Trier and Thomas Vinterberg subsequently formulated the Dogma document (1995) declaring certain aspects of filmmaking as more authentic (e.g. the absence of optical tricks, filter setting, extra lighting etc.), and opposing mainstream aesthetics. The film historian Peter Schepelern remarked (1997) that the creation of the Dogma 95 document was inspired by the style of *The Kingdom,* and it seems obvious, in many ways, that *The Breaking the Waves* (1996) and *Celebration* (1998) present the same type of style. The Dogma style appears so overwhelmingly different from earlier art-narration styles that many consider it to be a radically new stylistic departure with few similarities to mainstream and art-narration style whatsoever. In this article, I will describe how on the one hand, the Dogma style bears many resemblances to the principal characteristics of mainstream style, and yet on the other hand, applies certain of these mainstream techniques in less recognizable ways. I will investigate the ways in which this new style diverges from mainstream stylistic practices and how it also remains consistent with mainstream stylistic practices. In conclusion, I will point out those areas of visual expression, which are common to all cinematic styles, and suggest some additional concepts to the theory of visual style.

The Concept of Style

Before we move on, we need to understand the concept of style. I will apply Bordwell's theory of narration and concept of style as described in his books: *Narration in the Fiction Film* (1985), *The*

Classical Hollywood Cinema (1985) and *On the History of Film Style* (1997) – and supplement this with my own contribution to the concept of visual style in "The New Television Style" (Bondebjerg, 2000).

Inspired by the Russian formalists, David Bordwell proposed his poetic of film in the early 80's. In contrast to semiotic theory, Bordwell's theory is based on the viewer's reception. Bordwell's theory conceives the spectator as the creator of the meaning of any given film. Confronted with the information of the syuzhet – a succession of events – the spectator constructs the story (the fabula). The succession of events can be constructed in many different ways. The means of presenting syuzhet information are called tactics and strategies. These encompass the whole way in which a narrative is constructed, e.g. range of knowledge, degree of knowledge, point of view, suspense, and mystery. The spectator experiences the narrative through the form of the style. Roughly speaking, the style is an integral part of the medium and syuzhet and style each treat different aspects of the reception process. While the syuzhet fabula relation cuts across media, style embodies the film as a technical process. The style is a combination of cinematic techniques: mise-en-scène, cinematography, editing and sound. Mise-en-scène is staging, acting style, decoration, lighting and costumes. Cinematography consists of all the photographic aspects of a film: camera movement, lens aperture, composition of the shot, point of view, close up, medium shot, long shot and so on, while editing is the montage of the film, and sound is comprised of music, dialogue and different types of noise. Style is what influential critics preceding Bordwell have called film aesthetics. In contrast to this view on style, Bordwell considers style to be a pattern – a systematic use of cinematic devices – and not an aspect of the film's composition (which he calls syuzhet tactics or strategies). For example, crosscutting is a type of composition, which creates meaning, but at the same time it is a particular style of editing. According to Bordwell's approach, these are two different aspects of the reception process but are also interrelated textual functions. It is a syuzhet strategy – the information is constructed in a sequence, propagating the viewer's expectations, and it is also a stylistic pattern of close-ups, medium shots that are formed in a special

rhythm. The stylistic pattern can support the points of the syuzhet, or it can be self-conscious in relation to the syuzhet. Though the viewer may not always detect the pattern of style, it is nevertheless identifiable from an analytical position. For example, the close-ups of Dreyer's *Jeanne d'Arc* constitute a pattern of systematically applied cinematic devices. In more classical films we can describe the stylistic pattern as the fundamental approach to the information of the syuzhet, even though the classical style is allegedly "invisible".

The point of Bordwell's theory is that style supports the syuzhet in a manner that leads the spectator to construct the fabula. In formalist terms, the syuzhet is dominant – i.e. the style is a function of syuzhet demands. Systematically used stylistic parameters create patterns supporting syuzhet information – leading the spectator to make inferences on the fabula-level. However, when examining style as a function of the syuzhet in Dogma films, we must ask the question: Does the style support the syuzhet?

The Kingdom

The satirical *The Kingdom* was made as television series in 4 episodes (later released as a feature film), followed by 4 more episodes in 1997, *The Kingdom II*. The story is set at the Copenhagen University Hospital – called *Rigshospitalet* in Danish, and nicknamed "Riget" (The Kingdom). It tells the story of an old clair voyant woman, Mrs. Drusse, who persistently forces her way into the hospital's neurological department, which is populated by ambitious doctors who compete and fight with each other, attend infantile lodge meetings in the hospital basement and who perform questionable medical experiments on themselves. Here Mrs. Drusse undertakes the task of finding out what happened to the wandering spirit of little Mary, a little girl who had been abused in the name of medical progress by a deceased chief surgeon.

In most of the sequences in *The Kingdom*, the style could be characterized as dysfunctional: for example, the dialogue between Professor Moesgaard and Chief Surgeon Stig Helmer in Moesgaard's office in the first episode of the serial. Stig Helmer demands

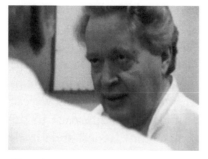
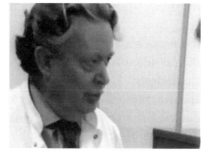

Shot A *Shot B*

that the resident doctor Krogshøj be brought before a disciplinary committee because he admitted a patient to a CT-scanning without proper authorisation. Moesgaard rebuffs Stig Helmer's allegations against Krogshøj in a friendly manner, and instead presents Helmer with his new idea *Operation Morning Air* – a plan to give the Neurology Department a new and more service-minded image through the use of 'happy face' stickers (!). The dialogue is shot in one-shots and two-shots (close-ups and extreme close-ups), using a hand-held camera, and edited without respect for the 180-degree rule. The 180-degree rule is frequently transgressed, thereby creating the intended jagged rhythm. In mainstream style, the same type of dialogue would have been edited in the classical manner of shot/reverse-shot.

Most of the scenes and sequences in *The Kingdom* are shot and edited in a similar fashion, with the exception of a few scenes featuring Mrs. Drusse and those scenes featuring the two mentally retarded dishwashers at work in the basement. These dialogue scenes are edited in shot/reverse-shot, with static camera and entirely as one-shots (close-ups). The style is in one respect radically different from the style of the scenes and sequences with doctors and nurses, and in another respect consistent. Some of the photographic qualities are consistent: the colour filtration (with brown and yellow colours dominating) and the relatively rough texture – both characteristics created during the digital editing process. As already mentioned, the format (one shots as opposed to two shots) and the rule of editing differ, with perceptible emphasis on breaking the 180 degrees rule. But why is this so?

That the *overall style*, often characterized by selected photo-graphic qualities (of colours and texture), is identical from scene to scene in the serial is not surprising. These predominant features indicate that all the scenes, in spite of other stylistic differences, are within the same narrative framework. Differences in *specific style* between scenes are often used to create changes in pace, various moods, feelings, and so on – but they can also serve as a narrational explication of differences in story meaning. In *The Kingdom* an obvious point is made of the fact that the doctors' self-esteem exceeds their sense of reality, as does their extremely prestigious projects such as their declared goal of defining life itself. Watching them fumbling around, attending their childish lodge meetings and generally behaving in a neurotic and undignified fashion, all give an impression of insanity that is in contrast to their purported profession. The doctors residing on the upper floors are portrayed as the "abnormal" ones, while the mentally retarded dishwashers in the basement represent the "normal" – a contrast clearly implied by differently applied rules of editing. Moreover, this theme can be observed in all of Lars von Trier's films, where despite their low social status, the abnormal, the outcasts, nevertheless express humanity and sensibility.

Although the style of *The Kingdom* is radically different than that of mainstream style, it is clear that the contrast between specific stylistic patterns is used for narrative emphasis. In this respect, this particular stylistic characteristic is functional – in Bordwell's sense – and here style is used to support the syuzhet.

A New Style

As previously stated, style supports syuzhet, because it leads the way for the spectator to construct coherent space, time and action. But if style transgresses its classical function, how then can the spectator construct coherent space and time? In most of the scenes in *The Kingdom* the hand-held camera and the breaking of the 180-degree rule of editing do not support the syuzhet. On the contrary, it seems as if the director and the editor have intentionally attempted to break the norms of mainstream style. In *Narration in*

the Fiction Film (chapter 12), Bordwell deals with this phenomenon and describes it as *parametric* narration. Parametric narration occurs where style, in contrast to its normative role of supporting the syuzhet, dominates the syuzhet or is seemingly equal in importance to it. Is *The Kingdom* a parametric TV serial/film? No doubt, the visual style of *The Kingdom* is so norm breaking that it is possible to conceive of it as being parametric. On the other hand, the style is no more parametric than that it still continues to enable the viewer to construct time and space. I propose a concept of style that relies on the documental and nominal functions of the photographic representation of moving images (Carroll 1996). The documental function (the photographic capability of presenting objects in a "realistic" way) and the nominal function, the use of the moving images (here in a narrative context) produces the necessary conditions for the coherence of the moving images. I would argue that no matter how excessive the style of a film or TV production is, it is always possible for the spectator to create a coherent space in which the character action takes place. In another important chapter of *Narration in the Fiction Film* entitled *Narration and Space*, Bordwell states that: "We can start out our analysis of spatial representation by assuming that the spectator works upon cues supplied by the medium and by stylistic conventions" (p. 101, 1985). If this is true, then it follows that this will have consequences for the way in which we understand style. We might consider Bordwell's point about stylistic conventions as being related to the construction of *narrational* space – that type of space, which is a consequence of the spectator's inferences about characters, their intentions and actions.

In the above-mentioned sequence of *The Kingdom*, the action takes place in an office. The scene is chaotic and the viewer may well become confused regarding the continuity of time and space. Nevertheless, there is so much realistic information in the medium (the photographic representation) that we are still able to construct a coherent idea of the space in which the action takes place. Parts of the style are, therefore, redundant. In other words, certain selected stylistic parameters provide the viewer with sufficient realistic information to construct time and space in order to form a coherent picture of the action taking place, while others no longer

carry out the classical syuzhet-supporting function. The point is that some components of the visual style that have been freed from convention, now have opportunities available to explore other matters. Moreover, the narrative logic (the nominal re-presentation) in many scenes is so coherent that the viewer is able to retrospectively construct time and space. This is what we often witness in many films and TV productions, where style is used purely as ornamentation and decoration and serves no other purpose than bringing attention to itself or the purely aesthetic.

Segmentation

If we look closer at the scene with Moesgaard and Helmer, we find a special structure of editing where the first and the last cuts of the scene are traditional shot/reverse-shots, and in the middle of the scene there is also a cut which respects the 180-degree-rule:

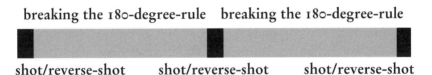

Comparing this structure with the story being told during the scene, one notices that the first and last cuts "frame" the scene. But what about the shot/reverse-shot edit in the middle of the scene? This particular cut appears when Moesgaard refuses Helmer's demand to instigate an investigation by the hospital review into Krogsgaard's use of CT scanning, and then introduces his own topic of conversation – *Operation Morning Air*. The cut represents a break in the stream of otherwise norm breaking cuts. It segments the scene into two story lines: Helmer's allegation against Krogshøj, and Moesgaard's introduction of *Operation Morning Air*. The concept of segmentation as defined by Raymond Bellour ("Segmenting/Analyzing", 1986) refers to the way that a story is split into different shots, in order to present a deeper meaning, common

to all stories, for example, the Oedipus myth. My use of the concept of segmentation is not psychoanalytic but rather founded in cognitive film theory. For the purposes of this article, segmentation entails any kind of stylistic device serving the purpose of dividing scenes and sequences into smaller segments in order to direct the viewer's attention to changes in the story. Segmentation is a feature found in many classical Hollywood films, but this technique is more visible in the Dogma style, and more importantly, is an integral part of *The Kingdom's* story structure.

Segmentation – A Feature of Mainstream Style?

The type of segmentation used in *The Kingdom* is not an isolated example. We can find other interesting examples of differently applied forms of segmentation in films and television. As pointed out, segmentation is a feature that is used in quite an artistic manner in several Dogma films.

We can make one important inference of the way segmentation manifests itself in *The Kingdom*: segmentation means changes in the dominant stylistic pattern. As previously seen, a stylistic pattern is established (breaking the 180-degree-rule), then broken briefly by a short segment with shot/reverse-shot, after which there is a return to the former stylistic pattern. In my opinion, *the pattern of stylistic patterns* is a very significant aspect of visual style. In fact, we find the same form of segmentation in many mainstream films. The question is therefore: How is segmentation used and does this complex stylistic figure have specific functions? Let us examine two examples – one a scene from *When Harry Met Sally* (1989), and the other a scene from *The Benny Goodman Story* (1955).

When Harry Met Sally

The scene in question is the memorable one in which Harry and Sally are sitting in a diner and the topic arises of whether men know when a woman is faking an orgasm. Harry claims that he is perfectly capable of telling the difference. Then Sally begins to howl and

moan, simulating an orgasm, and the reactions of the other guests are seen. When Sally is finished faking her orgasm, Harry admits that she made her point. The climax of the scene is a subsequent shot followed by another comical climax, when an older woman gives the waitress her order – "I'll have what she's having."

The scene is visualized in classical Hollywood style. The first, part, or segment, is the dialogue between Sally and Harry. The style of this segment is the traditional shot/reverse-shot. Sally talking, Harry replying, and so on. When Harry then confidently tells Sally that he is able to differentiate between a fake and a real orgasm, the stylistic pattern changes. In a single shot (a two-shot) we see the two characters in profile. After a few seconds the scene returns to shot/reverse-shot, and Sally begins simulating a fake orgasm. The structure of the scene looks like this:

Harry and Sally: dialogue **Sally simulating an orgasm**

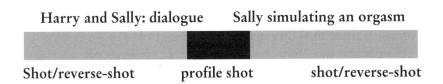

Shot/reverse-shot **profile shot** **shot/reverse-shot**

Looking at this structure, it is obvious that there are two ways of explaining the segmentation. First, the profile shot is a kind of explicit narrational comment. We do not conceive a traditional narrator telling the story, but here we find a way of expressing a comment or marking a specific change in the flow, with the express purpose of making the viewer conscious of a change in the narration. Secondly, the profile shot is a subjective expression of the decision taken by Sally. Her mental state shifts as she moves from being engaged in chatty dialogue to emphatically demonstrating her point. In a so-called objective shot, we are informed of a change in character subjectivity (Sally has made a decision), and decisions are difficult to visualize using the usual narrational techniques: point of view, perception shot, projection, subjective flashback, dreams etc. (Branigan, 1984). Therefore, segmentation is a vehicle that can be used to show mental processes taking place in the mind of a character.

Torben Grodal (1997, 2000) describes how objective shots can be subjective by representing actions and processes which deviate in some ways from normal "objective" actions and processes. When Elliot and his friend in *E.T.* (1982) are cycling through the air to avoid the adults and the authorities, the sequence takes place in slow motion. That stylistic feature makes the viewer experience the sequence as a subjective expression. Lyrical and associative scenes and sequences can also generate subjectivity. But there is an important difference between the subjectivity of the bicycle sequence in *E.T.* and the diner sequence from *When Harry Met Sally.* According to Grodal's arguments, 'objective' subjectivity is an experience generated by the viewer, an experience caused by the stylistic changes in the film's 'realism'.

In the case of *When Harry Met Sally,* the changes in stylistic patterns are not aimed at making the viewer experience subjectivity, but rather in creating a distribution of knowledge. Through the stylistic change, the viewer is able *to know* that a mental process has taken place in Sally's mind.

In *The Benny Goodman Story*, changing stylistic patterns direct the viewer's focus to a process occurring. Benny Goodman and his band are about to embark on their first American tour. The farewell party is underway, and the wealthy Alice Hammond, with whom Benny is mutually in love, arrives at the apartment where the party is taking place. Benny takes her aside and offers her a chair. Gazing at one another, they begin to talk about their relationship. Benny and Alice are both shy and have a tough time getting to the heart of the matter. This part of the scene is shot in profile: as a two-shot. A large table lamp that separates the two figures occupies the space between them. After 40 seconds, the stylistic pattern changes to shot/reverse-shot. The table lamp is still present but due to the angles of the shots it is diminished.

Combining mise-en-scène (the lamp), cinematography and editing, the stylistic patterns change, clearly focusing the viewer's attention on a change in the narration. Changing patterns are *narrational remarks*, comments about what is taking place in the story. Here it signals the change in the behaviour of Benny and Alice, from shyness to a more secure openness.

So far we have seen how segmentation can serve as a tool in allowing different patterns of style to direct the viewer's attention to a kind of interpretive schemata. This form of stylistic patterns can be considered as a type of articulation on a higher narrational level, based on simple differences in stylistic patterns. As demonstrated above, segmentation also operates in scenes and sequences found in mainstream films. But does segmentation undertake the same function in Dogma films?

The Celebration

The Celebration (1998, *Festen*), directed by Thomas Vinterberg, revolves around the celebration of a father's sixtieth birthday. The children, Christian, Thomas, and Helene join in the their father's festivities, but underneath lurks a dark cloud from their common past, which will have destructive consequences during the course of the party. When the eldest son, Christian, toast his father, he announces to all present at the celebration dinner that both he and his deceased sister (who committed suicide) were sexually abused by their father. All are in disbelief, until his sister Helene finds her dead sister's suicide letter and Helene is unintentionally forced to read it aloud to the whole gathering.

The style of the whole film is hand-held camera, no lighting, rough texture, yet the editing is subtle and highly sophisticated. This is clearly seen in one of the initial sequences of *The Celebration*. The sequence begins with a classical establishing shot, high angle, of the room and the guests. The youngest son, Michael, is taking care of the guests, in his own unpolished manner: "Have you got a drink? … Can we have a drink here!" etc. Michelle, a maid at the inn where the celebration is taking place, and with whom Michael had an affair the previous year, approaches him to ask: "Could we have a talk, Michael?" He refuses with the excuse that he does not have the time, though his body language actually indicates that he is anxious to avoid her – later she tells him that she has had an abortion. After this short incident, the sub-plot in the first part of the sequence, we are shown the high angle establishing

shot once again, which in turn is followed by a new "story" with close-ups of Christian, Helene, and another employee at the inn, named Pia.

Michael and Michelle	montage of eye-line matches	
establishing shot	establishing shot	establishing shot

This new "story" is edited in a manner that leads the viewer to form hypotheses about the relations between the people in the room. First, we see the cut between the sister and Christian, an eye-line match cueing the receiver to form the view that there is a special and warm understanding between the two of them. Then, the shot of Pia is edited together, by means of an eye-line match, with a shot of a black-haired woman flirting with her. Next Pia and Christian are talking together and he tells her that he cannot fall asleep unless he is with her. Finally, Helene and her grandfather chat about the speech he will make at the forthcoming dinner, and he tells her that his speech is not for little girls. It is interesting to note here the common topic of conversation in this part of the sequence; it is all about sex, different aspects of sex. The first part of the sequence also deals with sex – it is about Michael who has had an affair with the maid Michelle, and who is now avoiding her.

The style of the sequence is hand-held camera with medium shots in the first part of the sequence, and close-ups in the latter, until Helmuth begins his speech. Why is the sequence split into two parts by the use of a repeated establishing shot? All the incidents and conversations are about sex, but with a subtle difference. Michael's relationship with Michelle is in the past, whereas the other relationships concern the future. The establishing shot serves to frame Michael's lack of responsibility towards Michelle; in contrast to his exhaustive attempt to follow his father's every wish. The other conversations deal with future possibilities. Moreover, they are edited in a way that is quite self-consciously related to film history i.e. montage films. The eye-line match-cut

between brother and sister, and between Pia and the black-haired woman is made coherent by the first part of the sequence, with Michael's retreat from the approaching Michelle. The hand-held style, combined with the close-ups, contribute to the impression of a confused and intense mood at the beginning of the party. So many characters and action possibilities are at stake. By means of this segmentation, the editor and director have chosen a more traditional editing strategy, and made a distinction between the sexual relations in the past and potential relationships of the future.

Conclusion

I have used the neoformalistic theory of style to analyse selected examples from Dogma and classical, mainstream films. The new film and television style has challenged traditional concepts of visual style. The new style applies both the decorative and the functional support of the syuzhet, at the same time. In Bordwell's terms: space is cued by the medium and stylistic conventions. The real challenge is how to distinguish between medium and style.

Segmentation, as a means of employing different stylistic patterns, is applied in both Dogma and mainstream films. Segmentation emphasizes explicit points, to create 'objective' character subjectivity and to articulate points by creating interpretive schemata. In Dogma film (and television) we find subtle applications of the technique of segmentation, from the more traditional method of articulating power relations (*The Kingdom*) to the subtleness of montage editing in segments expressing the contrast between past and future events.

From the viewer's point of view, the Dogma style seems to be overwhelmingly different to traditional art-cinema narration and mainstream style. Nevertheless it contains some of the parameters which we associate with art and mainstream narration, because they are necessary ingredients of storytelling. So the main difference between Dogma and mainstream film being the way in which Dogma films use the segmentation technique to "articulate" interpretive concepts on a high narrational level. A further examination

of film history would likely reveal many other fascinating examples of segmentation. However, the interesting point is the way it has been used in Dogma films, too.

References

Bellour, Raymond. 1996: "Segmentation/Analyzing" in: Rosen, 1986.

Bondebjerg, Ib (ed.). 2000: *Moving Images, Culture and the Mind*. University of Luton Press. Luton.

Bordwell, David. 1985: *Narration in the Fiction Film*. University of Wisconsin Press: Routledge.

Bordwell, D., Staiger, J., Thomson, K. 1985: *The Classical Hollywood Cinema: Film Style and Mode of Production to 1960*. Columbia University Press. New York.

Bordwell, David. 1997: *On the History of Film Style*. Harvard University Press. Cambridge, Massachusetts.

Carroll, Noël. 1996: *Theorizing the Moving Image*. Cambridge University Press. Madison.

Grodal, Torben Kragh. 2000: "Subjectivity, Objectivity and Aesthetic Feelings in Film" in: Bondebjerg 2000.

Grodal, Torben Kragh. 1997: *Moving Pictures. A New Theory of Film, Genres, Feelings and Cognition*. Oxford: Clarendon/Oxford University Press.

Højbjerg, Lennard.1997: "Some Aspects of Style and Space" *p.o.v.* 4 Århus.

Højbjerg, Lennard. 2000: "The New Television Style" in: Bondebjerg 2000.

Rosen, Philip. 1986: *Narrative, Apparatus, Ideology*. Columbia University Press.

Schepelern, Peter. 1997: *Lars von Triers elementer*. Munksgaard-Rosinante. København.

Birger Langkjær

A Story With a Style
Nightwatch and Contemporary Danish Film

The aim of this article is to provide a closer examination of a film that occupies a central place in contemporary Danish film. The film in question is *Nightwatch* (1994, *Nattevagten*) by Ole Bornedal, a thriller that received critical acclaim by reviewers and audiences alike. In 1998, the Miramax production company released an American remake (also by Ole Bornedal). If not otherwise indicated, the comments in this article refer to the original version of the film. My primary focus will be on the film's narrative form, genre and style, my secondary focus will be to explore the context in which the film derives its special status in contemporary Danish film culture.

Leaving Traditional Realism Behind

In 1984, Lars von Trier received his major breakthrough with his first feature-length film, *The Element of Crime*. Mr. Fisher is a former policeman, called back from a hot and sandy Cairo to a dark, humid, and dystopic Europe. A serial killer who murders young girls selling lottery tickets is at large, and Fisher is asked to solve the case. With the aid of a hypnotist, the trip to Europe takes place in Fishers mind, and in the end he is unable to return to the present. Although physically on a cot in Cairo, in the theater of his mind he is trapped in the past in Europe.

In *The Element of Crime*, structuring the narrative form as a journey through memory provides a framework for handling the narration in a playful manner. While it is possible to reconstruct a somewhat classical narrative structure (the investigation), the dramatic premise persistently dissolves, thereby causing our understanding to be only vague or momentary. The plot appears more like a foundation on which to build a visually fascinating universe

containing sparse and "static" sound, collapsing any sense of time into a play with space by camera-movements, dissolves, surprising match-cuts and astonishing mise-en-scène. This is accompanied by a discomforting display of sexuality, violence and a lack of any real possibility for audiences to empathize with the characters. Thus, Lars von Trier sets an aesthetic standard at the expense of a comprehensible storyline, that to this day has not been imitated (see also Grodal 2000). Lars von Trier turned his back on traditional Scandinavian realism and traditional conceptions of Danish film in his use of extreme subject matter for excessive stylistic purposes, and made a place for himself within the international art film scene.

Just as Lars von Trier moved away from realism, so, too, did Bornedal, even though he accomplishes this in a different manner than Trier. *Nightwatch* is an intelligent and (for the most part) well-made thriller, where the story is the central element, even though certain gaps in the plot remain unaccounted for. The plot is closely tied to the thriller genre and some surprisingly well patterned stylistic repetitions and variations. It combines Hollywood inspired narrative standards and style with humor, satire and a rather passive "European" protagonist. From a broader European perspective (and even more so from an international perspective), at first glance the film does not appear to be that different from a typical thriller. Bornedal does not attempt to push our previous or tacit understanding of story and style beyond their limits. Instead, he takes the story seriously and does so with black humor and style. And precisely by doing this, sets new standards for Danish cinema.

While directors such as Lars von Trier and Thomas Vinterberg are both graduates of the National Film School of Denmark, Ole Bornedal is self-taught. He began his career working for the Danish Broadcast Corporation (DR) where he produced three radio montages, i.e. short programs combining documentary and fiction, often employing expressive sound; a form that offers a more "subjective" perspective on certain issues than traditional radio documentary. Later, he worked as a writer for satirical television programs, such as *Den gode, den onde og den virkli' sjove/ The Good, the Bad and the Really Funny*, 1992-93. He wrote for theater (*Den dag lykken*, 1993, *The Day Happiness*) and had his debut as a

screenwriter and director with the television movie, *Masturbator* (1993), a story about a psychotic young man who ends up killing a woman he has loved from a distance. 1994 saw the release of his first feature film, *Nattevagten* (*Nightwatch*). In accordance with dominant, international trends in film, literature and art during the early 1990's, death, sexuality and problems connected with romantic relationships were pervasive themes in his early work.

An important aspect of film narration is that so-called classical narration is often based on genre. The specific genre in question defines the type of conflicts and solutions that are possible, or put in a different way, it defines the overall narrative scheme. In a Danish context, genre has not been the basic norm guiding all filmmaking, but has been one option among many. In the history of Danish film, comedy has been the most prevalent genre, from the light, burlesque comedies of the 1940's to the national archetypical comedy genre known as folkekomedie – Danish popular comedy. But alongside a limited number of genres (at least compared to the wide spectrum of Hollywood genres), realism must be considered the mainstay of Scandinavian film. I have dealt with this tradition elsewhere (Langkjær 2002), and for the purposes of this article a few remarks will have to suffice.

Traditional film realism in Danish Cinema (and in other national cinemas) involves well defined conflicts, which cannot be solved in a simple fashion. Instead, protagonists are forced to change their psychological attitudes, to find other paths in life, or, through psychological maturation, develop new kinds of relations. Like European art film, realism has a fondness for open endings. But while art films often have open endings with no apparent solution in sight, realism often ends, even if only vaguely hinted, with new beginnings. In spite of the fact that endings in realism are open, they can indeed be hopeful. And even though future actions are not spelled-out explicitly, the prerequisites for future change are in place.

The canonical format of Scandinavian realism has produced some masterpieces, but in its less successful form both critics and audiences have scorned it as being of little interest. This criticism is expressed (as it has been on numerous other occasions) in the following monologue in Lars von Trier's *Epidemic* (1987), where a

former consultant for the Danish Film Institute, Claes Kastholm Hansen, playing himself, declares:

"Especially in Danish film – which is, as ill-fate would have it, what I'm forced to deal with – there's so many damn stories where people don't die when they ought to die, where fever of them die than ought to die, where less blood flows than ought to flow, where there's less screaming done than should be done, where things just seem to peter out, as if everything has been engulfed in fog."

Seen from this perspective, *Nightwatch* must have been a revelation for many as several people die, blood flows, and there are plenty of opportunities for screaming. Bornedal himself is certainly conscious of this:

"[...] I hope that *Nightwatch* contributed to a breakthrough for a different kind of Danish film than the often drab film our generation had to suffer through." (Ole Bornedal in: Langkjær 1997: 63)

One advantage of employing genre forms is that they provide inherent dramatic effect. Personally, I don't know many people who have been killed in gunfights or in huge explosions, but in movies it happens all the time. In other words, basic human conflicts are magnified by genre-formats. In real life, people have arguments, even nasty ones, but they seldom kill each other. In crime movies, they often kill each other. In the given format of a genre, a psychological conflict can have an extreme action-outlet, that is, many genres contain an initial action that makes up the inherent dramatic effect of the genre in question, like "murder" (often in crime), "violent combat and destruction" (action), "someone known [at least by the audience] to be in mortal danger" (thrillers), "systematically misconceiving a situation" (comedy), "placing in the foreground the heroic act of not acting" (melodrama), etc ... In a genre movie, an emotional state always motivates some type of specific action or, alternatively, specific non-action as is the case in melodrama. Thus, some genre specific actions make psychological conflicts larger and more visible. Genre shapes conflict, creates action out of psychology (and vice versa), and provides the plot with

an overall direction. In return, satisfying narrative endings can be executed by simple actions, such as the protagonist marrying his beloved, solving the crime, or defeating the criminal. Every genre has its own set of possible solutions, its methods of resolving the chain of actions and events, thereby providing the viewer with a feeling that he or she knows what is needed to be known. As Carroll argued (1988), a well made genre movie always leaves us deeply satisfied in terms of our questions and curiosity, even the relatively few that offer us unhappy endings.

There can be no doubt that *Nightwatch* is a genre movie. To be more specific, it is a thriller. In *Nightwatch* the "someone known [at least by the audience] to be in mortal danger" is a young law student, Martin. As he starts his new job as a night watchman at a Medico Legal Institute, a serial killer is tracking down prostitutes one by one. The innocent-under-suspicion plot that follows is a standard form in Hollywood films, and it is hardly an unheard of device to place the criminal within the police force itself. What is unusual, in a Danish context, is that in terms of its basic plot *Nightwatch* is such a clear-cut genre movie, which seeks the pure pleasure of a thrill.

Plot

According to a model proposed by Kristin Thompson (1999), a narrative can be broken down into four parts (or acts) of approximately equal length. These are referred to as set-up, complication, development, and climax (including a short epilogue), and they are connected by three turning points. According to Syd Field, a turning point (he calls it a plot point) is "an accident, or event, that 'hooks' into the action and spins it around into another direction" (Field 1979: 115). In other words, a turning point can be conceived as an action, event, or decision that provides cognitive focus on events to follow, by elucidating the premises for these actions and conflicts. Field argues for a standard structure comprised of three acts, with a mid-point dividing the longer second act into two parts. However, these (theoretical) disagreements regarding numbers and names are inconsequential when it comes to analysis. Fol-

lowing these concepts (and leaning towards Thompson's four-part version of the classical plot), the structure of Nightwatch can be presented as follows:

Act 1: Set-up. Martin celebrates his 24th birthday together with his girlfriend, Kalinka and another couple, Jens and Lotte. Police Inspector Peter Vörmer is being interviewed on television because a new serial killer victim has been found. In the next scene, Martin begins his new job as a night watchman at a Medico Legal Institute (which also houses a morgue). Later, while attending a university lecture, Jens and Martin engage themselves in a game of mutual dares. One evening, Martin challenges Jens to knock down two 'tough guys' in a bar. Surprisingly, Jens is willing to go all out and is nearly pulled into a fight. In the park afterwards, Jens confesses to Martin that he is bored with their girlfriends and adds that he has visited a prostitute named Joyce. Jens also informs him that he told Joyce his name was Martin (and not Jens). In the park, Jens makes Martin agree that their game of mutual dares is serious – "no limits" as Jens proclaims. This agreement regarding the mutual challenges provides the plot with its first turning point.

Act 2: Complication. A new victim of the serial killer is found, and Martin has his first conversation with Peter Vörmer. On his next duty, the alarm at the morgue goes off. As Martin enters the cold storage room, a body underneath a sheet begins to move. After an initial, tremendous shock, it is revealed to be Jens playing a trick on Martin. Jens challenges Martin again by making a date for him at a restaurant with the prostitute Joyce, and some embarrassing scenes follow. Later, Joyce tells Jens and Martin about a crazy client of hers that likes her to play dead. The next time Martin is on duty, the body of the latest serial killer victim disappears from atop her bier. As the doctor arrives on the scene, the body is again placed on the bier. Martin has his second conversation with Vörmer, this time about fiction and reality. The serial killer plot and the mutual dares plot seem to converge and turns the story in a new direction (the second turning point): who is the one pulling tricks on Martin? Is it the killer? And who is he (or she)?

Act 3: Development. From now on, Martin (as well as the viewer) is in doubt about whether it is actually Jens that is playing

tricks on him. Martin's girlfriend insists on accompanying him on duty, and in the chill of the morgue – overwhelmed by the emotional power of the silence of death – they make love against a wall. Later, Joyce contacts Kalinka and asks her to tell Martin to quit playing games (she believes Jens is called Martin but Kalinka is unaware of this). When Martin goes to work, a recent corpse has been found sexually mutilated, and on the floor the police find semen, apparently from Martin. From this point on, the action revolves around the serial killer plot in a climatic 'last minute rescue' fashion. This climax has its build-up in two phases. In the first, Martin becomes the prime suspect. In the second, Joyce is murdered as Kalinka turns up at her apartment. The viewer is aware that Vörmer is the killer, but Kalinka is unaware of this. This constitutes the third turning point, where an innocent person has been framed, becoming the prime suspect and is in obvious mortal danger. What can he do to turn the tables?

Act 4: Climax. Joyce manages to write Martin's name in blood on a pillow before dying, and a police officer, Rolf, arrives at Martin's house to arrest him. But Kalinka and Jens convince him that Martin (who is secretly listening to their conversation on the phone) cannot be the killer: Jens tells him about the swapping of names, and Kalinka informs him that there was no name on the pillow when she was at the apartment. Meanwhile, Martin searches the personnel archives and finds Vörmer's name, learns that he was once permanently suspended from duty, and he begins to put things together. Just at this moment, Vörmer appears at the morgue and provokes Martin into hitting him ("I have destroyed your life"). Kalinka arrives and thinks that Martin has gone insane, with the result that both Kalinka and Martin end up lying on the autopsy table. Vörmer is interrupted by the arrival of Rolf and Jens, and he subsequently subdues Jens and kills Rolf. After tying up Jens, he is about to kill Kalinka and Martin. But at the last moment, Jens cuts himself loose by sacrificing his own thumb with an ordinary kitchen knife, and shoots Vörmer from behind.

The epilogue takes place in a church, where the two couples are to be married in a joint ceremony. Martin asks Jens to imagine that they are in an American movie and gives Jens a last challenge. When the priest asks the question, he is to say "no". As Jens actu-

ally intends to meet the challenge, Martin regrets what was meant to be a joke. But in the end Jens is able to say "no" without consequences, as the priest mistakenly exchanges their names.

The plot can be seen as quite conventional and classically composed, with each turning point occurring at approximately 25 minutes intervals (the total length of the film is 102 minutes). Whether all at once or in several dramatic beats, each turning point focuses on the protagonist's current problem in each of the four parts. Thus, character, goals, motivation and problems are made salient for the viewer as the story unfolds.

Furthermore, it is a heavily redundant narrative. This redundancy occurs on two broad levels: one concerning narrative information, the other stylistic patterns. These often mesh as stylistic choices take on more or less specific meaning as they are repeated and varied. Examples of narrative redundancy are many, e.g. when the retiring watchman introduces Martin (and the viewer) to his new job. Several times the retiring watchman mentions to Martin that he will need a radio. This dialogue-based piece of information is emphasized by several close-up's focusing on the radio, by the fact that the radio is heard off-screen before Martin even enters the small office and by initially introducing the retiring watchman as he turns a radio dial trying to find a station. The subtext implied by this should be clear: it is night, we are in a strange place occupied only by dead bodies, and any living human being will need some form of company to keep the eerie atmosphere at bay.

The eeriness is reinforced by small pieces of dialogue in connection with the cold storage room where dead bodies are kept: an alarm clock is mentioned several times and showed in several close ups (also diabolically commented upon as "it never happens"); the lights must be turned off (Martin: "why should it matter?"); and the missing handle on the inside of a door handle is mentioned. The old watchman gives two other pieces of important information. He mentions a former watchman who was dispelled from duty because of necrophilia. He shows Martin the personnel files and says, "we're all in here", a line of dialogue emphasized as he gives a little shove to the filing cabinet. This is important information that will make it possible for Martin to eventually discover that the former watchman, the present serial killer and the chief in-

spector are one and the same person. Thus, while the scene has the ostensible purpose of showing Martin being introduced to his new job, we are also given heavily redundant information through varying devices such as dialogue, close-ups, and on-screen as well as off-screen sounds. This information either characterizes the kind of place the characters find themselves in, serving as cues to our expectations and emotional responses, or the viewer is given some expository knowledge that will be useful later, allowing the plot to unfold naturally without further need of explanation and motivation.

Style

Redundancy also occurs in use of style, most excessively in the use of camera-movements. Four kinds of camera movements can be detected:

1. Re-framing keeps moving persons or objects at center frame. Re-framing is a standard technique used to keep things of interest to the plot both moving and visible. Usually it is not a striking device, as this movement is motivated by fictional events and keeps the object of dramatic interest visually accessible to the viewer, as when Martin is seen in a telephoto shot on a bicycle on his way to work followed by a gentle pan to the right.

2. Moving point-of-view (p.o.v.) shots indicate physical movement and an individual's field of vision. They generally provide insight into the protagonist's point of view, but most often limit our knowledge of what is actually taking place. Thus, our perceptual access to and knowledge of our protagonist's visual object of interest, is inversely proportional to our "universal" knowledge of the situation. In short, the high level of perceptual access serves no purpose and often results in feelings of suspense and otherwise unpleasant emotions – even though it can be argued that the unpleasant feeling of nasty things to come (first order perspective), is balanced by the pleasant prospect of being an uninvolved viewer of a fictional work of art (a second order perspective). In *Nightwatch*, moving p.o.v.-shots are often employed, as when Martin makes way through the corridors of the Legico Medical Institute. In these

cases, we are able to identify the character whose viewpoint we are sharing. In other cases, the moving p.o.v.-shot is used as a device to restrict our knowledge. In one case, a moving p.o.v.-shot through the apartment of Martin and Kalinka, is crosscut with a shot of Martin in his bathtub. In this case, it turns out to be Kalinka about to vent her anger over Martin's relation to the prostitute Joyce. And in the restaurant-scene, where Joyce is about to tell Jens and Martin about the strange client who likes her to play dead, we simply never know who is watching them (or whether anybody is watching them). The scene, up until this point, has been filmed from inside the restaurant, but as Joyce begins her story there is an audiovisual cut to outside the restaurant. The three of them are then seen from the viewpoint of outside, with the camera moving along the window with a short but slightly jerky movement that is never explained. Simultaneously, dialogue and sound effects out of the reach of hearing and only dark-timbered, dissonant music can be heard.

3. "Mental movement" are camera movements that reflect the thoughts of the central character. Encouraged by the old night watchman, Martin looks through a small window into a room containing plastic tubes, formaldehyde bottles and human body parts. His movement of leaning towards the window is followed by a shot from behind a tub inside the room. Martin is seen in the background and the look of horror on his face is magnified as the camera closes in on him. It is as if the tub and whatever it contains closes in on Martin: its psychological impact is given physical-visual expression. This is heightened by the sound track in which we hear the sounds of squishing and mumbling, as if the dead tissue was undergoing an organic transformation and returning back to life. The use of camera movement in physical space as an equivalent of mental movement is repeated throughout the film. Even though the old night watchman instructed Martin to turn off the light in the cold storage room, he forgets his first night on duty. He turns around and sneaks in his arm only. As he tries to hit the switch, his hand is seen from within the room as the camera, with increasing speed, approaches his fumbling fingers that just succeed to escape the moment the camera is about to touch. The camera movement visualizes a mental as if experience.

4. Narrative movement in which the film itself appears to insist on taking charge of the narration, as when the camera moves independently of any character-related motivation. Such camera movements accentuate the presence of a certain narrative intention. Of course narrative intention will always be present in films, for the simple reason that a film is an artifact designed to provoke certain conceptions, anticipations, attitudes, and emotions. However, at certain moments this can be accentuated. In *Nightwatch*, this is seen from the very beginning, as the camera somewhat knowingly moves on its own, taking a closer look at objects in the semi-dark apartment, while the two couples can be heard on the soundtrack but are seated in a room that the camera, apart from short glimpses here and there, has not entered. A slow musical pace accompanies the camera movement, with a melody played on strings in the minor mode that makes use of small melodic contours, as if both knowing and awaiting what will happen. Thus, at different moments in the film, the camera insists on a life of its own, as if it knows something still hidden to the viewer.

Some disturbing effects are created when these patterns are combined, e.g. when a camera movement initially is perceived in one way but suddenly the viewer realizes this perception is wrong. As Martin is walking his usual rounds, he suddenly realizes that the latest serial killer victim no longer is atop her metal bier, and only bloody footprints are left behind. We watch Martin as he follows the footprints along the partially darkened corridor, followed by a visual cut to a moving shot. According to the norms already established by the film itself, this implies that what we are now seeing is a p.o.v.-shot from Martin's perceptual perspective. But as the camera moves closer to a corner in the corridor, Martin suddenly enters the frame from around the corner. For the course of a second we feel the presence of the serial killer, giving the viewer a minor shock. In retrospect, the camera movement can either be seen as Martin's mental anticipation of what he is about to see around the corner, or as some sort of narrative intelligence pulling tricks on the viewer. Only the music gives a sense of this being a mental movement rather than a p.o.v.-shot as it is re-used from the hand-fumbling-with-the-switch scene mentioned above. Thus, cross patterning of otherwise distinct kinds of camera-movements

creates a feeling of insecurity in the viewer regarding the reality-status implied by those camera-movements. Is it a person moving? Is it Martins imagination? Or is it a narrative presence playing tricks on us?

Soon after Martin discovers Peter Vörmer's name in the personnel files, Vörmer calls him at work. As their conversation is heard on the sound track, the visuals interchange between Martin and a moving shot. At this point in the film, all shots moving without any contextually specified motivation have been a "narrative movement", that is, an insistence on a narrative presence. It therefore creates a shock when Vörmer, wearing a (large) cell phone, suddenly enters the office and Martin, who is as surprised as the viewer, turns around. In retrospect, the camera-movement was Vörmer's p.o.v. By establishing stylistic patterns, and by combining and interchanging them, the film creates uncertainty and additional frightening surprises.

In terms of overall style, a recurrent feature of *Nigthwatch* is contrast, in terms of basic emotional tones, sound or light. In the first half of the film, the plot often shifts between scenes taking place in Martin and Kalinka's apartment (normalcy) and dreadful scenes that take place at night while Martin is on duty. The contrast between these scenes is augmented by contrasts within scenes. When the killer enters Joyce's apartment, we hear voices of children coming from the backyard. This contrast is interchanged with another and more bizarre contrast, as the killer then turns on a tape recorder and plays a well known song from a 1950's revue about a promiscuous, young girl. It is a song with a somewhat childish and mockingly repetitive quality, especially its refrain, and it sounds rhythmically as the killer stabs her in the stomach several times with a knife (each time he stabs her we see her bloody feet move almost like a ballerina).

Many contrasts and similarities in the unfolding of the plot are dependent on sound. Every soundman knows, or should know, that silence can never be achieved by eliminating sound. Rather, the effect of silence is created when we suddenly hear tiny sounds that usually are buried in our busy, everyday sound texture. When Martin is on night duty, we hear hisses and small sounds that effectively communicate the surrounding silence. The first night he is

on duty, this is contrasted by the sound of rock music coming from his Walkman (performed by the group Sort Sol). He turns it on to keep the silence at distance, but instead it makes him insecure and he stops the music in order to listen. Thus, the viewer is drawn into a perceptual alliance with Martin by the sense that we hear sounds in the same way that he does.

At other times, the montage of sound from a coming scene in the present scene has a disturbing effect, as in the scene where Joyce is murdered and scalped by Vörmer. This is followed by shots of empty corridors in the hospital where we hear beeping sounds resembling those made by machines that monitor heartbeats. As the beeping sound continues, we see Jens waiting with his telephone. In retrospect, the sound heard was the sound of a telephone, as if we our visual senses were at the hospital and our audio senses at the apartment (whether this is "explained" as a spatial collapse or an audio flash forward is really of no consequence here). The sound effect, therefore, is used as a commentary – the beeping indicating Joyce's death – but is soon motivated as a diegetic event (a telephone ringing).

The set design extends the theme or the subtext of scenes as when Martin confronts Jens, asking him if it is he who has mutilated corpses and murdered Joyce. The scene takes place in a hallway at the university, the two of them standing opposite each other across a staircase. In a final shot from above (Jens's point of view) Martin is seen leaving in anger, walking across a black and white checkered floor that resembles a chessboard, giving the impression that Martin is a pawn in the game. This kind of symbolic mise-en-scène is even more obvious in the recurrent close-ups (both sound and image) of moths caught inside a lamp in Martin's office. The small office is like a light cell in the darkness of the morgue and before the final climax Martin looks up to find all the moths dead.

Thus, there is a major difference between the plot pure and simple and its actual execution. The film has in many ways achieved its results by the use of elements of style and stylistic patterns that determine the way in which viewers perceive diegetic events, thereby shaping our experience. For the most part, style is used to focus the viewer's attention and anticipatory cues, without bringing much attention to itself as a device. The exaggerated stylistic choices (e.g.

the camera-movements and the skilled use of sound-contrasts) intensify viewer involvement with characters and situations. At other times, devices such as the seemingly "knowing camera" indicate meta-fictional traits that also permeates the film. Combined with the film's humor and satire, the meta-fictional layer makes it a bearable film to watch.

Meta-fiction and Humor

Nightwatch confers on the viewer a powerful feeling of the presence of some narrative agency. This leads to two distinct kinds of experiences: one relates to the question of what is really happening in the fictional universe (e.g. the camera seems to both know and conceal something from us); the other establishes a meta-fictional layer. During a conversation, which took place in February 2002, the composer Joachim Holbek told me that he and Bornedal thought that the music should allude to an end that is already known. Thus, the slow and slightly hesitating melodic line of the opening music combines well with the camera panning the empty apartment rooms, as if the cinematic space revealed by the camera and music were already a crime scene, but offering only a vague sense of events to come.

The combination of the character's outward appearances, the set design, the camera angles and cuts, and the dialogue, all contribute to the level of the story. This is already the case in the opening scene, where the two couples are celebrating Martin's birthday. As Kalinka turns on the television, there is a report from the scene of the latest serial murder (off-screen). Kalinka says, "it's him", ostensibly implying that the same killer has struck again. A close-up on the TV screen of chief inspector Peter Vörmer immediately follows her comment, and as it turns out it is actually Vörmer that is the real killer. Thus, when watching the film a second time, the timing of the dialogue and visual editing certainly make sense on a realistic level, but they also reveal a rather diabolic and omniscient narrative presence.

This kind of narrative commentary continues in a more or less disguised manner. When Martin is introduced to his knew job by

the old watchman, he takes a look at a photograph of a young man in handcuffs who gazes directly into the camera. Later in the film, Vörmer identifies the photograph as depicting the murderer Lewis Paine just before his execution (it was done in 1865 by Alexander Gardener). It is, therefore, a photograph of a man facing death (both his own and those of his previous victims). At first, we see Martin studying the picture, followed by a cut to a close-up of the photograph. As the old watchman returns, his voice is heard off-screen, "is it you?". His question, despite its rather strange tone, is on a realistic level motivated by the social act of identification. Yet at the same time, it could be construed to refer to the photograph, creating anticipation in the narrative of events to come (i.e. Martin as prime suspect and, in several ways, facing death). In a later scene, as he enters the room there is a visual cut to a close up of the photograph and then to Martin looking directly into the camera, saying "hello", thereby connecting himself with the fate of Lewis Paine and the (all knowing) camera.

These more or less explicit meta-fictional elements are given thematic weight as they creep into the dialogue and the characters themselves comment upon them. During a university lecture, Martin and Jens talk about their game of mutual dares. Martin says that they will take destiny in their own hands, and as both of them look towards the sky, Jens replies: "It's already there with its heavy hand above us". Later, Martin and Kalinka have a short exchange of dialogue about whether it is possible to say, "I love you" without making it sound "like a bad Hollywood movie". The thematizing of fiction and reality is used the second time Martin and Vörmer meet. After a dead body has been removed and replaced to its metal bier, Martin has a conversation with Vörmer, in which he declares that the situation is like in a bad movie, and Vörmer replies that imagination and reality are close company. As they walk past several mirrors, Vörmer tells Martin that sometimes he feels trapped inside a film. It is only when he, Vörmer, suddenly looks into a mirror and sees the man he has been looking for, that he returns to reality.

Meta-fiction appears not only in dialogue but is part of the overall narrative structure, especially so in the epilogue. The epilogue takes place in a church as both couples are getting married.

This double wedding is in accordance with a promise given earlier in the film, when Jens suggested his game to Martin, and added: "And the loser is doomed to marriage and slippers for the rest of his life". As the plot unfolds, they both lose. But while they are waiting for the minister to marry them, Martin says to Jens: "If this were a movie it should be called Night Watch". Then he challenges Jens one last time – he is to say "no" to the minister. Jens does not hesitate and Martin insists that he meant it only as a joke. But the minister accidentally switches their names and Jens is able to say his "no". With their act of commitment finally fulfilled, the story concludes on a humorous, light note.

There is another scene that links the climax with the epilogue. After the dramatic climax, Martin's left eye is seen in a close up as the camera gently moves backwards. Martin lies on his bed, starring. The scene is brightly lit, in harsh contrast to the previous dark-blue lit scenes. Rain is heard off-screen, and then Kalinka's soft voice: "Get up or we'll be late". Martin turns his head and replies, "it's raining". Kalinka answers," it's just a small shower", to which Martin turns his head slightly and looks into the camera. This interlude does not provide any significant action or information, which prepares us for the coming wedding. We might be led to believe that he is recalling the events of the past, or that the whole thing is actually a figment of a dream. His gaze into the camera seems to suggest that while Martin is part of a fictional tale, he consciously addresses an audience. It is also a lyrical moment somewhat similar to the ending of the 1986-film *Blue Velvet* (the camera-movement from inside-out a person, the dreamy protagonist, the artificial innocence of the dialogue and set design). This intertextual similarity suggests what we have seen is most likely a dream, a horrified series of events inside the theater of Martin's mind. This narrative framing-device leaves the film viewer unsure of the reality of what has transpired.

This kind of intertextuality is given some significance as it, with greater or lesser degrees of finesse, permeates the whole film: several times the music is reminiscent of Bernard Herrmann (or like Pino Donnagio's pastiche in Brian De Palma's *Dressed to Kill*), the killer hums a tune similar to the tune in Fritz Lang's *M*, the Hitchcock-like device of accompanying the killing of the prostitute

Joyce with a childish song (like the murder in an amusement park in *Strangers on a Train*), and Martin's "Daddy's home" line as he begins his second shift (reminiscent of Jack Nicholson in Kubrick's *The Shining*).

These extra layers co-exist with a basic, well-driven story line. Genre and classical dramaturgy is both embraced and commented upon, and the film can be enjoyed without the conscious awareness of these extra layers. And in part, this can explain the film's success in Denmark, not only among younger audiences but also among the majority of reviewers. There are, however, certain weaknesses in the plot: it is never explained how Joyce gets Martin's phone number or why she calls him, nor is it explained how she later manages to turn up at the theater where Kalinka works. Most explanations for the above mentioned activities require complicated mental gymnastics. In addition, it is hardly believable that both a corpse and a set of bloody footprints can be removed in such a short amount of time. But other non-probable events are given credibility through the manner in which they are staged, as when Vörmer inspects the body of a victim for the first time, and later when Martin and Kalinka make love in the morgue's cold storage room (not present in the American remake). Both are thematically important scenes, which supply the serial killer plot with thematically and emotionally important dimensions. They serve to join the love-death theme and both are connected by the same piece of music composed by Joachim Holbek; a slow lyrical piece (in minor) with two instrumental voices that each play a melody, that nevertheless seem to respond to each other. In the first scene, Vörmer leans over a dead woman, gently taking her hand, with a strangely suffering expression on his face. This is in accordance with the fact that the old watchman talked about the necrophiliac standing outside crying like a lover. In a later scene, Kalinka accompanies Martin on his watch duty. As they enter the room, she is overwhelmed by the silence of death and turning to Martin she begins to silently cry and embraces him. This leads to sexual intercourse against a wall of the morgue. It is highly improbable that a couple would make love under such circumstances, but the emotional tone evoked by Kalinka's reaction and the music (that create parallels to Vörmer's loving handling of

the dead woman), and the psychological logic that is nevertheless inherent (the prospects of death makes us turn towards life) makes it both an acceptable and a noteworthy scene, which contributes to raising the above the level of the average thriller.

The film also utilizes irony. There is narrative irony, as when Martin makes his confession to Vörmer, or when Kalinka runs with Vörmer after seeing Martin beat Vörmer with the club (an act she will soon regret), or when the priest mixes up their names. Irony is also used in the dialogue, as when Vörmer asks the handcuffed Jens, before leaving him for a while: "Have you ever tried getting killed before? I'll be back soon". Later, when Vörmer turns on a loud autopsy saw, intent on scalping Martin and Kalinka, Martin desperately asks what he plans to do, and Vörmer boldly replies: "The usual thing".

As in all well made crime films, the villain is a central character. In this case, the viewer is not privy to the villain's psychological make-up and we do not understand his motivational forces. His lines of dialogue combine the comic with the horrific, as when Kalinka and Vörmer flee from Martin who has just clubbed Vörmer. As they enter the autopsy room, Vörmer quickly locks the door: "You'll be safe. He can't get in." From Kalinka's perspective at the time, the statement makes sense. But from the perspective of the viewer, there are probably better ways to deal with a serial killer than to be locked-up with him in an autopsy room at night. On the whole, the combination of death, sexuality and deadpan humor is quite unusual for a Danish film. Generally speaking, European filmmakers prefer to present viewers with the human suffering that is at the root of such horrible acts, and to show the villain in somewhat tragic relief. Seen in this light, *Nightwatch* allies itself to the American tradition of movie making.

Nigthwatch, the Remake, and Contemporary Danish Film

Without financial support from the state, Danish film production would not exist. Since the beginning of talking movies, Danish film has been nationally oriented, and as in most European countries has benefited from various forms of state support.

When *Nightwatch* was made, there were two methods of receiving state financial support, and few films were made without this. One method was to convince the 'keepers of the gate' (official consultants) at the Danish Film Institute, that a given manuscript was worth producing. This could lead to state financing of almost half of the budget. The rest of the budget would have to be financed by TV-stations, private investors etc … The two national TV-stations, DR and TV2, had especially increased their support of film financing during the 1990s, both by directly financing production and also by paying royalties for films to be shown on TV. The other available option was the 50/50 policy stemming from the Film Act of 1989, whereby film projects that had already secured financing for half of the budget, were eligible to receive state funding for up to a maximum of 50% of total production costs, with a maximum ceiling of 3.5 million Danish crowns (DKK). In both cases, the money was to be paid back if the film was financially successful. If we exclude the most expensive films, Danish films produced from 1993 to 1995, whose initial funding came from the Danish Film Institute, typically had a total budget of around 14 million DKK. The typical budget for films made under the 50/50 policy, during the same period, was around 8 million DKK. The average subsidy was approximately 6 and 3.3 million, respectively (Andersen 1997:337-38). Thus, the budget for a 50/50-production still relied on substantial state support, but the idea behind it represented a different approach to support: to differentiate between possible types of 'gate-keepers' when it came to state funding. In other words, the fact that private investors, TV-companies or others visibly showed their confidence that a project was worthy of support (in either commercial or artistic terms) by investing in it, would release state support, even though the amount was still decided by the Danish Film Institute. The idea behind this was to promote popular films with commercial potential, i.e. films that could attract audiences.

In the 1980s, the stereotypical picture of Danish film (which to a certain extent reflected reality), was threefold: 1) drab commercial films of no value, mostly dull comedies; 2) big-budget historical or psychological dramas, nice and wholesome, with "artistic" intentions, but lacking an edge; and 3) narrow "artistic" or personal

films, often more interesting for those who made them than for any possible audience. The new 50/50 policy was meant to help promote films of both commercial and artistic value. *Nightwatch* was not found to be worthy of support by the Film Institute consultants, but received support through the 50/50-policy. Michael Obel, the producer of *Nightwatch*, is in many ways the kind of producer the new 50/50 policy hoped to encourage. He wishes to please his audience and at the same time provide them with something out of the ordinary, as is expressed in the following:

"The goal is to make films that attract an audience but at the same time have an edge to them. It is all right to lower the estimated potential audience by a hundred or two hundred thousand [the Danish population is approx. 5.2. million people] if it is necessary in order to make a film that will be remembered in a ten years. But my ambition is to satisfy the audience and the critics at the same time." (Michael Obel in: Film #23)

After the release in Denmark of *Nightwatch*, it was sold to Dimension Film for distribution in Europe. Soon after an agreement was made with Miramax to produce an American version, a major media event in Denmark for the simple fact that this was the first time ever that a contract had been made for an American remake of a Danish film.

Several people involved in the original film, were involved in the remake: the producer (Michael Obel), the director (Ole Bornedal), the photographer (Dan Lausten) and the musical composer (Joachim Holbek). The cast combined American and international actors, including Nick Nolte, Ewan McGregor and Patricia Arquette. The story is basically the same; as are many camera-movements, and some of the music and acting seem very close to the original. But certain scenes were left out, the most important being Kalinka and Martin making love in the morgue, the clerical ceremony held by Martin's girlfriend and the wedding scene at the end. One scene was added (for explanatory purposes) in which Joyce repeatedly tells the killer (we only see his arm) what she will tell Kalinka. As such, some of the complexity of the characters, some of the realism that grounds the film and some of the humor are lost along the way. As the producer, Michael Obel, noted:

"The Danish version is better, we can surely agree on that. Several test screenings and re-editing ended up in a version that is less than optimum." (Michael Obel in: Film #23, 2002).

Nightwatch made use of genre-form and a plot-driven story delivered with a self- confident sense of style. At the same time, it exhibited a notable deviance from Hollywood norms in terms of pace and sensibility. And this combination certainly contributed to its national impact.

After the remarkable international success in the late 1980's and early 1990's, of Bille August (winner of the Golden Palm in Cannes in 1987 and 1992 and Oscar-winner for best foreign language film in 1989) and Gabriel Axel (Oscar for best foreign language film in 1988), both considered traditional realists, contemporary Danish film – when seen from outside of Denmark – now appears to be condensed into two brand names: Dogma 95, and films by Lars von Trier. At present, only Lars von Trier is seriously expanding and developing the art film tradition, including its habit of re-using genre forms for new purposes. Apart from him, contemporary Danish cinema can be divided into two schools: those who revitalize existing genres or mix them, as in Susanne Bier's romantic comedy *The One and Only*, 1999, or Anders Thomas Jensen's action/comedy *Flickering Lights*, 2000; and those who to some extent ground their films in realism, but extend the means of expression by using elements of genre whether this is melodrama (Per Fly's *The Bench*, 2000), the fantastic (Lotte Svendsen's *Gone with the Fish*, 1999) or comedy (Lone Scherfig's *Italian for Beginners*, 2000). All of these have clear storylines, including dogma 95-films like Thomas Vinterberg's *The Celebration* (1998) and Søren Kragh-Jacobsen's *Mifune* (1999). As Torben Grodal (2002) pointed out, the basic virtues of story telling are now central features in contemporary Danish film. Scriptwriting is now a line of study in its own right at the National Film School, making the professional scriptwriter (and not just the director) in charge of providing new story material. The great (mental) divide between genre and artistic vision has dissolved. Furthermore, the Danish Film Institute has established a new fund devoted to developing scripts and ideas and money is being used on pre-production, something Hollywood and other commercial film

industries have done for a long time. In addition, a fund for short films gives young directors the opportunity to develop their talent without being under economic pressure. This has been combined with new financial structures (co-productions with national television, the 50/50 policy, Scandinavian co-production, trans-European co-production), new acting styles among young actors, and a very successful National Film School. For the first time since the 1940's, talented Danish filmmakers can continue being productive. Only ten years ago, this was unthinkable. Together with new styles, new sensibilities and new manuscripts, Danish cinema will most likely provide stories worthy of our attention for years to come.

References

Andersen, Jesper. 1997: "I lommerne på Europa. Internationaliseringen af dansk film-produktion, in: *Dansk film 1972-97*, (ed.) Ib Bondebjerg, Jesper Andersen, and Peter Schepelern, Munksgaard-Rosinante.

Carroll, Noël. 1988: *Mystifying Movies: Fads and Fallacies in Contemporary Film Theory*, Columbia University Press.

Field, Syd. 1979: *Screenplay. The Foundations of Screenwriting*, Dell Publishing, US.

Film #23. 2002. Danish Film Institute, Denmark.

Grodal, Torben. 2000: "Die Elemente des Gefühls. Kognitive Filmtheorie und Lars von Trier", in: Montage a/v, no. 9/1, Schüren, Germany.

Grodal, Torben. 2002: "Filmhistorier i nyere dansk film" (paper for the 15th. Nordic Conference for media and communications studies, august, Reykjavik).

Hjort, Mette & Bondebjerg, Ib. 2001: *The Danish Directors. Dialogues on a contemporary national cinema*, intellect, Bristol, UK.

Langkjær, Birger. 2002: "Realism and Danish Cinema", in: Northern Lights, Museum Tusculanum Press, University of Copenhagen.

Langkjær, Birger. 2000: "Om den nya vågen och dogma 95 i dansk film. Är det bara en skakig kamera och en suddig bild som avgör?", in: Filmhäftet, no. 109, Sweden.

Langkjær, Birger. 1997: "Lyden af ny dansk film", in: MedieKultur no. 27, Aarhus, Denmark.

Thompson, Kristin. 1999: *Storytelling in the New Hollywood. Understanding Classical Narrative Technique*, Harvard University Press.

Peter Larsen

Urban Legends
Notes on a Theme in Early Film Theory

True stories

"A Russian friend told me the following true story", writes Béla Balázs, the Hungarian filmmaker and film theorist, in *Der Geist des Films*, 1930:[1]

Somewhere in the Ukrainian countryside, hundreds of kilometers from the last railway station, there lived a man who formerly owned and after the revolution managed an estate. For fifteen years he had not been to a city. He had kept up with world history, but he had never seen a film. A highly educated intellectual who sent for all new books, newspapers, journals, who owned a good radio set, who was in continuous contact with the world and up to date with all things intellectual. Only he had not yet been to a cinema.[2]

Then during a visit to Kiev he sees his first movie, "a very simple, naive Fairbanks story". The cinema is full of children enjoying themselves. Our man is concentrated, shaking with excitement and effort. All in vain:

He had not understood the film. He had not grasped the *story* that children could follow without difficulty. For it had been a new language which all town-dwellers mastered with ease, and which he, the highly educated intellectual had not yet understood.[3]

Almost twenty years after he wrote these lines, Balázs summed up his views on film culture in a book that was later published in English under the title *Theory of the Film*.[4] Large parts of the book consist of excerpts from his earlier works, but at the place where one would expect the Russian steward to appear there is instead a story about an English colonial administrator "who, during the

first world war and for some time after it, lived in a backward community".[5] He "knew of films, and had seen pictures of the stars and had read film reviews and film stories; but he had never seen a motion picture".[6] Then he finally comes to a city, he goes to the movies, sits down among interested children, watches a very simple film – and the story of the Russian steward is repeated: The Englishman did not understand the film, "because he did not understand the form-language in which the story of the film was told, a form-language every town-dweller already knew at that time".[7]

The colonial administrator has company: A Russian friend has told Balázs about a certain cousin who arrived in Moscow "on a visit from a Siberian collective farm – an intelligent girl, with a good education, but who had never seen a motion picture (this of course was many years ago)".[8] Then, obviously, they send her to the movies; she sits down, watches "a burlesque", and does not understand a thing. She is indignant and agitated. "I can't understand why they allow such dreadful things to be shown here in Moscow!", she says. But what was so horrible then? "Human beings were torn to pieces and the heads thrown one way and the bodies the other and the hands somewhere else again".[9]

A Ukrainian steward, an English colonial administrator, a girl from Siberia: three people who did not understand "the form-language in which the story of the film was told". In order to understand "the new picture language", Balázs writes, you must be able to "make visual associations of ideas", you must "integrate single disjointed pictures into a coherent scene".[10] The steward, the colonial administrator, and the girl from the Siberian kolkhoz had not learned to do that.

Fictions

Are these stories true? Of course not. There are far too many oddities here – the steward's transformation into a colonial officer, the sudden appearance of a Siberian cousin, not to mention some peculiar discrepancies between the German and the English versions of *Theory of the Film*.[11] The almost identical sequences of events should be enough to make one suspicious: First some hazy re-

marks about how the narrator came to know about the incident –
a "true story" told by "a Russian friend"; another one told "by a
friend in Moscow", and "there is a story about an English colonial
administrator ...". Then an explanation about why the protagonist
happened to be so isolated – hundreds of kilometers from the last
railway station; a world war, chance circumstances; the incident
lies many years back. Then the unsuccessful visit to the cinema.
And finally the punch-line: The protagonist did not understand
what he or she saw.

These stories are obviously constructions, fictions, three vari-
ations of one and the same narrative – told in order to support, if
not to prove, one and the same point: that film is a language, a lan-
guage that has to be learned. They do, however, also make another
point. If we only were to read the first story we would probably
miss it, but everything becomes clear as soon as the Ukrainian
steward is replaced by the English/Siberian duo in the *Theory of
the Film* version: Read in sequence these two stories suspend all
traditional distinctions regarding gender, age, nationality, and so-
cial status. A male British government official living in a foreign
colony reacts just like a young peasant girl from a Siberian kol-
khoz. Only one crucial distinction, common to all three stories, re-
mains: that between urban and rural areas.

The steward lived "in the Ukrainian countryside", "had not
been to a city" for fifteen years, and had to go to Kiev in order to
see his first film. The Englishman "lived in a backward commun-
ity" and did not understand the "form-language every town-
dweller already knew at that time". The cousin came "from a Si-
berian collective farm" and was horrified of what she saw in
Moscow. These stories are stories about cities. Film belongs to the
city, they say – thereby articulating and illustrating a central theme
in early film theory.

Film in the City; Film and the City

Within the time frame of Balázs' stories – "during the first world
war and for some time after it" – film was an urban phenomenon
in many important respects. First of all it was an urban *institution*

in terms of social space, audience, and function: In these first decades of the 20th century most films were shown in urban movie theatres – not necessarily in large cities, but in cities nevertheless. As soon as film production became industrialized movies were aimed at mass distribution, the socially heterogeneous urban audience being their prime target. From the very start movies were designed to cut across cultural and educational barriers in the modern cities.

Furthermore most of the early films were city films in terms of basic *narrative material*. With their representations of life in the big city they became powerful socialization agencies, indirectly educating their audiences in the ways of the world, emphasizing the rules and norms of urban life, presenting model situations, model forms of behavior etc.

Balázs' three stories tell us that film comprehension is something you learn, not on an estate in Ukraine, not on a farm in Central Africa, not on a kolkhoz in Siberia, but in a city. This was how he and his contemporaries saw it; this was a central theme in the film theory of his time. However, according to the most radical, and also the most influential, version of this theme, film comprehension must be learned not only *in a city*, but *by living in the city* – not just because movie theatres happen to be located in cities for technical and financial reasons, or because most movies try to catch city audiences by telling them stories about city life, but because movies, on a more fundamental level, are constructed to match basic urban *forms of perception and experience*. The language spoken by the film is not just a new "form-language", as Balázs' stories suggest; it is the language *of* the city. In order to read the film, you must be able to read the city.

Urban Experiences

What is urban experience? The early sociologists tended to give rather abstract answers to this question. An often quoted example is Georg Simmel's famous essay on "Metropolis and mental life" from 1903.[12] Money economy and intellectualism are closely connected phenomena, he argues, and since large cities are the very

centers of modern market economy urban life is by necessity characterized by a high degree of rationalism expressed in a multitude of phenomena – in how people organize their personal life, how they react to each other, which aesthetic preferences they develop etc.

Another example is the American anthropologist Louis Wirth who in a seminal essay on "Urbanism as a Way of Life" echoes Simmel by arguing that the characteristics of an urban population affect how individual members experience their social world, how they deal with each other etc.[13] The mere size of the population prevents people from establishing close social relationships and leads to a rational, calculating view of social interaction. People tend to orient themselves from visual cues as a result of the population density; the social heterogeneity leads to psychological instability and insecurity, and also to a certain blasé attitude.

The radical argument about the connection between film comprehension and urban experience is based on general observations of this kind – often directly inspired by Simmel. A summary of the argument may sound like this: In order to read a film the spectator must to be able to connect dissociated images into a unified and continuous narrative whole, or, in Balázs' words, to "integrate single disjointed pictures into a coherent scene". This particular type of mental activity presupposes a distanciated attitude to the sequence of images and an ability to perform logical, rationalist operations normally associated with urban life. Balázs' fictitious Siberian girl is written into his text in order to support this view: Where the urban cinema audience saw a story, a coherent narrative, the poor girl merely saw unrelated fragments.

The film-city argument appears in many variations and disguises in early writings on film and film theory, often intimately connected with radical political visions and expectations. The perhaps most well known examples are Siegfried Kracauer's and Walter Benjamin's reflections on their experiences in the Berlin cinemas of the 1920s and 1930s.[14]

According to Kracauer and Benjamin film is connected with urban experience in a variety of ways. Both of them consider the film medium to be a social institution that answers the need for stimulation created by the general stress of urban life. The films are not only the reverse, the negative expression as it were, of monotonous work processes, they do themselves bear the stamp of the workplace. As Benjamin argues: "That which determines the rhythm of production at the assembly line, is the basis of reception in film".[15] Thus, the film speaks the *Language of the Factory*, one might say.

Second, film may function as criticism of the very same urban conditions. Both Kracauer and Benjamin argue that the medium can be used as an aesthetic means of developing and organizing knowledge of the contradictions of modernity, and that it can indicate how the social situation can be changed. With its duality of fragmentation and montage the medium offers aesthetic expressions of urban mass existence which are more adequate than most traditional art forms: On the one hand, the cinematic sequence of shots presents a fragmented view of the world which matches the actual disorder of urban reality; on the other hand, the disorder may be solved by means of an interpretative montage producing insights into the historical situation and preparing the spectators for the inevitable, radical change. For Kracauer the film *could* produce the insight that "all this will suddenly burst apart", but as he concludes: "Most of the time it does not".[16] Benjamin is more optimistic: he is certain that film by virtue of its fragmentation has the redeeming power necessary to help the urban masses break the spell of modernity, to blow up "our taverns and our metropolitan streets, our offices and furnished rooms, our railroad stations and our factories".[17] Thus, the film speaks the *Language of Utopia*.

Third, both Kracauer and Benjamin agree that there is a direct, immediate connection between cinematic montage and the everyday experience of urban reality. According to Benjamin, the same perceptual techniques are needed in the cinema as in the metropolitan traffic:

The film corresponds with profound changes in the perception apparatus – changes which the man in the street experiences on an individual scale as he tries to cope with big-city traffic, and which all present-day citizens experience on a historical scale.[18]

Several decades later, Kracauer presents a similar point of view in his *Theory of Film*. The film medium is particularly well suited for catching the transient impressions characteristic of urban experience, he argues, pointing to "the city street with its ever-moving anonymous crowd" where

kaleidoscopic sights mingle with unidentified shapes and fragmentary visual complexes and cancel each other out, thereby preventing the on-looker from following up any of the innumerable suggestions they offer.[19]

Thus, according to Kracauer and Benjamin the film speaks the *Language of the City*, and should be read just like one reads the city. Here we are relatively close to Simmel's general argument as sketched above: In order to cope with the city as well as with the film, the spectators has to shield themselves by adopting a distanciated, blasé attitude and by performing certain rationalist mental processes.

Kracauer's and Benjamin's observations remain inspiring and thought-provoking to this very day.[20] On the other hand, it is hard to deny that their basic arguments have a rather tentative and speculative character. Reading these texts today one gets the feeling that they are to a large extent based on local and/or personal experiences and impressions, and that the suggested connections between film and urbanity are ideological constructs shaped by predominant political and artistic notions of urbanity, modernity, and avant-garde aesthetics.

It is true that the invention of moving pictures coincided historically with the explosive urbanization in the last decades of the 19th century, and there is, as indicated above, a whole range of obvious connections between the new medium and urban modernity, especially in terms of narrative material, but also with regard to film experience as compensation for and critique of urban conditions.

Thus, it is probably correct to say that films spoke the *Language of the Factory*, and in some cases even the *Language of Utopia*, in the early decades of the 20th century. However, the connection between film language and basic forms of urban perception is quite another matter. Did the films then – or do films in general – speak the *Language of the City?* Benjamin's answer to this question is particularly problematic, based as it is on a series of seemingly superficial, textual analogies between cinematic montage and random urban phenomena like traffic, office buildings, railway stations etc.[21]

Learning Processes

At about the same time as Kracauer and Benjamin wrote about going to the movies in Berlin, the Soviet psychologist A.R. Luria traveled from Moscow to Central Asia. The account of his observations throws an interesting light on the argument about the connection between film and urban experiences and may also be read as a commentary and a correction to Balázs' anecdote about the Siberian girl who is said to have traveled in the opposite direction.

In 1931-32, in a period of radical restructuring and social change in the Soviet Union, Luria performed a series of psychological tests on peasant populations in remote villages in Uzbekistan and Kirghizia.[22] The intention was to study the historical shaping of cognitive processes.

During their stay Luria and his staff were able to make comparative studies of "underdeveloped illiterate groups (living in villages)" on the one hand, and "groups already involved in modern life" on the other.[23] Among the latter were women who attended short-term courses in the teaching of kindergarteners, active kolkhoz workers who had taken short courses, and women students admitted to a teachers' school after two or three years of study.

The study indicated substantial differences between these two sections of the rural population. The groups "involved in modern life" scored significantly higher in all tests concerning perception, conceptualization, logical reasoning, self-awareness etc., a fact

which, according to Luria, indicates that changes in the social and practical forms of activity, and especially the introduction of formal schooling, even in the form of short-term courses, produce "changes in the basic structure of cognitive processes and result in an enormous expansion of experience and in the construction of a vastly broader world in which human beings begin to live".[24]

As it appears, the decisive feature in Luria's study was the difference within the rural community itself between a traditional life-style and what he calls "modern life", meaning a life situation characterized by complex, collective work processes, new forms of social relations, and the acquisition of rudimentary theoretical knowledge. Luria's findings are in line with innumerable later studies in the tradition of Jean Piaget showing that basic cognitive abilities with regard to conceptualization, logical reasoning etc. are developed by all individuals at a certain, relatively precisely defined stage in their life, given the right conditions, i.e. provided these abilities are needed in order for the individual to function adequately within the given social context, be it urban or rural.[25]

Applied to the radical version of the film/urbanity question Luria's study strongly suggests that the mental processes said to be characteristic of film comprehension are not necessarily associated with or developed within an urban context: People in rural areas do not have to go to the big city in order to learn the distanciated attitude necessary for making generalizations and abstractions, the ability to perform logical, rationalist operations etc. A "modern life" situation including formal training programs and participation in complex work processes is sufficient.

Visual Literacy

This leads us back to Balázs and his *Theory of the Film*. Immediately after the stories about the Englishman and the girl from Siberia he recalls the situation twenty years ago "when we ourselves would probably not have understood films which are quite obvious to spectators to-day".[26] He remembers seeing a film in which a man is hurrying to a railway station to take leave of his beloved. She has already boarded the train, and the scene ends with a close-

up of the man's face, showing his changing expressions as light and shadows crosses his face more and more quickly. Balázs writes:

When I first saw this film in Berlin, I did not at once understand the end of this scene. Soon, however, everyone knew what had happened: the train had started and it was the lamps in its compartment which had thrown their light on the man's face as they glided past ever faster and faster.[27]

By introducing this new anecdote Balázs in a way neutralizes the city/country distinction which the two previous ones have served to articulate: At some earlier point in time he and his fellow Berliners had been in the same situation as the English administrator and the Siberian girl. The Berlin audience who understood the language of the city was not able to understand the language of the film.

Balázs' heading to this part of the text is "We have learned to see". Benjamin thought that the cinema taught people how to adjust themselves to the dangers of everyday life in a modern city. Balázs, on the other hand, suggests that the most important thing people learn in the cinema is how to watch movies. "We have learned to see": As time went by, people learned to master the new language.

Thus, the English/Siberian duo and the film/city equation notwithstanding, the real point of Balázs' anecdotes seems to be that film comprehension is a question of time and of basic learning processes – a point which obviously places him in a less radical position than both Kracauer and Benjamin on the question of film and urban experience.

However, even this position may be a bit too radical. Several later studies suggest that it is doubtful whether film comprehension *per se* is something you have to learn at all. In an overview of the available literature on the question Paul Messaris discusses Balázs' story of the colonial administrator several times.[28] Each time he tries to take it at face value, but is forced to conclude that in the light of current empirical and theoretical knowledge the Englishman seems to have reacted in a highly unlikely way.

First, there is no reason to believe that a person unfamiliar with

the medium should have problems in understanding moving images *as images*, i.e. as visual representations. On the contrary, most studies support the view that there is a significant connection between perception of images and the ordinary use of the faculty of vision in real-life situations. These studies further indicate that moving images are actually easier to understand for an inexperienced spectator than ordinary still photos.

Second, it seems highly unlikely that this inexperienced spectator should be unable to understand what Balázs calls "the new picture language", i.e. be unable to make "visual associations of ideas", to "integrate single disjointed pictures into a coherent scene" etc. It is true that most early filmmakers doubted their audiences' visual reading skills, and that most of the classical editing procedures were developed with the purpose of helping untrained spectators understand the narrative – which means that if Balázs' Englishman actually went to a movie theater in the mid-1920s he would probably have seen a film in which every possible precaution had been taken in order to make the story intelligible. Whether such precautions were really needed is, however, an open question. Recent studies of first-time television viewers in Kenya and studies of children's understanding of basic editing practices indicate the opposite, namely that inexperienced spectators are perfectly able to understand a story even if it presented in a fragmented, unedited format.[29] On the basis of such studies and other available literature Messaris argues that it is not a spectator's prior experience with the medium, but his or her general cognitive development which determines if a film is understood or not.

Against the Grain

It is probably a bit unfair to introduce psychological and anthropological studies of this kind into what started as a discussion of the film/city theme in early film theory. Obviously, the cognitive fundamentals of film comprehension was not the main point for radicals like Kracauer and Benjamin when they wrote their utopian visions about the connections between film language and urban modernity. Neither was it a decisive point for Balázs. Al-

though he repeatedly stressed that film is a new "form-language" which has to be learned, his prime interest was film aesthetics and his prime concern was to study and discuss what makes film "a specific independent art employing methods sharply differing from those of the theatre and using a totally different form-language". [30]

Nevertheless, it is hard to resist reading Balázs' stories against the grain, interpreting them in the light of Luria's work or later empirical studies. Take for example the cousin of his Russian friend: If she actually was "an intelligent girl, with a good education", if she actually came "from a Siberian collective farm", she would probably have reacted just like Luria's women students "already involved in modern life" or like the first-time television viewers in Kenya discussed by Messaris, i.e. she would had no difficulties at all understanding the film they sent her to see – even if this was the first film she ever saw.

And, ironically, this seems in fact to have been the original point of Balázs' three stories – or rather of their original source. Helmut H. Diederichs, the editor of Balazs' writings, suggests that the first of the stories, the one about the Russian steward, is actually a paraphrase of an article Balazs had read in 1914 in a German-language Budapest newspaper in which the author Margit Vészi told a story about an educated, highly intelligent "old gentleman" who lived "on a lonely estate far away from the Berlin noise". Though he had never been to the movies before, this old man apparently had no problems in understanding the first film he ever saw. According to Diederichs, Vészi used the story to demonstrate that film is a universal language based on gestures and facial expressions; Balázs did not use the story "in the same film aesthetic context", Diederichs dryly remarks, adding: "The way in which Balázs handles supposedly empirical evidence is hardly scientific, but rather poetic".[31]

Notes

1 Béla Balázs: *Der Geist des Films* [1930], quotations below from Béla Balázs: *Schriften zum Film*, vol. 2, eds.: H.H. Diederichs and Wolfgang Gersch, München: Carl Hanser Verlag, 1984 (my translations).

2 Ibid., p. 52.

3 Loc.cit.

4 Béla Balázs: *Filmkultura. A Film müvészfilozofiája*, Budapest: Szikra Kiadó, 1948. A German translation, *Der Film. Werden und Wesen einer neuen Kunst,* came out in 1949; quotations below from the fifth edition of a reprint published by Globus Verlag, Vienna, 1976. The English version is quoted from *Theory of the Film. Character and Growth of a New Art* [1952], Arno Press & The New York Times, 1972. Thanks to Melinda Szaloky for sorting out the intricate relations between the Hungarian original and the two other versions.

5 Balázs, Theory, op.cit., p. 34.

6 Loc.cit.

7 Loc.cit.

8 Ibid., p. 34-35.

9 Ibid., p. 35.

10 Loc.cit.

11 According to the German translation (Der Film ..., op.cit., p. 23f.), the colonial officer was stationed, not "in a backward community", but *auf einer zentralafrikanischen Farm,* i.e. on a farm in Central Africa, and the Siberian girl was actually not a cousin but a new *Hausangestellte,* i.e. new maid who had come to work for Balázs' friend (which seems rather strange considering that the incident is supposed to have taken place some time after the revolution – she did after all come to Moscow from a kolkhoz). Helmut H. Diederichs, the editor of Balázs' *Schriften zum Film,* talks in a lecture of "the undoubtedly fictitious ... 'story of the Russian steward'" and regards the transformation of the story as "a funny example" of how "Balázs' film theory developed from 1924 to 1948", cf. Helmut H. Diederichs: "Béla Balázs und sein Beitrag zur formästhetischen Filmtheorie", lecture at Freie Universität Berlin, Institut für Theaterwissenschaften, November 20, 1997, quoted from http://www.sozpaed.fh-dortmund.de/diederichs/texte/balazsvo.htm.

12 Georg Simmel: "Die Grosstädte und das Geistesleben", in *Die Grossstadt. Vorträge und Aufsätze zur Städteausstellung.* Jahrbuch der Gehe-Stiftung Dresden, Th. Petermann ed., Band 9, 1903. English translation: "The Metropolis and Mental Life", in Kurt H. Wolff, ed.: *The Sociology of Georg Simmel,* Glencoe, Ill.: Free Press, 1950.

13 "Urbanism as a Way of Life" [1938], in Louis Wirth: *On Cities and Social Life. Selected Papers,* Chicago: The University of Chicago Press, 1964.

14 Several central Kracauer texts are reprinted in English translation in Siegfried Kracauer: *The Mass Ornament*. Cambridge, Mass.: Harvard University Press, 1995 (for example "Kult der Zerstreuung: Über die Berliner Lichtspielhäuser" [1926], "Die Photographie" [1927], and "Der heutige Film und sein Publikum" [1928]. See also the film reviews reprinted in Siegfried Kracauer: *Kino. Essays, Studien, Glossen zum Film*, Frankfurt: Suhrkamp, 1974. The central Benjamin texts are "Das Kunstwerk im Zeitalter seiner technischen Reproduzierbarkeit" [1936] and "Über einige Motive bei Baudelaire" [1939].

15 "Über einige Motive bei Baudelaire", quoted from the reprint in Walter Benjamin: *Illuminationen. Ausgewählte Schriften*, Frankfurt: Suhrkamp, 1977, p. 208 (my translation).

16 "Kult der Zerstreuung", quoted from the English translation in *The Mass Ornament*, op.cit., p. 327.

17 "Das Kunstwerk im Zeitalter seiner technischen Reproduzierbarkeit", quoted from the reprint in Walter Benjamin: *Illuminationen. Ausgewählte Schriften*, Frankfurt, 1977, p. 161 (my translation).

18 Ibid., p. 165.

19 Siegfried Kracauer: *Theory of Film. The Redemption of Physical Reality*, New York: Oxford University Press, 1965, p. 72.

20 This should perhaps be taken with a grain of salt. Rumor has it that Torben Grodal once threatened to resign from a research project on *Urbanity and Aesthetics* if he had to listen to one more summary of Benjamin's thoughts on urban experience. The present article is written with this rumor in mind.

21 Cf. Peter Larsen: "Benjamin at the Movies. Aura, Gaze, and History in the Artwork Essay", in *Orbis Literarum* 48, 1993, and "Benjamin, Kracauer, Mass Culture", *Working Papers 26, Department of Media Studies, University of Bergen*, 1997.

22 A.R. Luria: *Cognitive Development. Its Cultural and Social Foundations*, Cambridge, Mass.: Harvard University Press, 1976.

23 Ibid., p. 14.

24 Ibid., p. 163.

25 For an overview of Piaget's work, see John Flavell: *The Developmental Psychology of Jean Piaget*, New York: Van Nostrand Reinhold, 1970. A series of Piaget-inspired anthropological studies of "primitive thought" comparable to Luria's work in Central Asia are discussed in C.R. Hallpike: *The Foundations of Primitive Thought*, Oxford: Clarendon Press, 1979.

26 Balázs, *Theory of the Film*, op.cit., p. 35.

27 Ibid., p. 36.

28 Paul Messaris: "Visual 'Literacy': A Theoretical Synthesis", in *Communication Theory* 4, 1993. See also Messaris' introduction to his

book *Visual "Literacy": Image, Mind, and Reality*, Boulder, Colorado: Westview Press, 1994.

29 For a report on the Kenya-study, see Renee Hobbs et. al.: "How first-time viewers comprehend editing conventions", in *Journal of Communication*, 38, 1988.

30 Balázs, *Theory of the Film,* op.cit., p. 30.

31 Helmut H. Diederichs, op.cit.

Johannes Riis

Film Acting and the Communication of Emotions

Film theory has shed relatively little light on the communicative process between actor and spectator. Although a spectator primarily directs his or her attention toward the actors in narrative film, we do not know what factors are important during this process. If we wish to gain an explicit and comprehensive understanding of stylistic choices, and, by extension, of the art of film acting, a model of the process between actor and spectator might contribute in laying the groundwork. By modeling the kind of information gained by the spectator, as well as the underlying principle factors, we might be in a better position to attack head on the problems implied by terms such as timing or unconvincing acting. We may also gain a more complete understanding of which kinds of communicative purposes are served by acting styles that do not rely on psychological realism as a method of acting. Rather than merely describing these as norm breaking and signified only by their marked deviation, by means of a communicative theory we might be able to view them within the same framework as acting employing psychological realism. Thus, we should be better able to see overlapping and continuity in the principles used, as opposed to categorizing acting solely in terms of standards of conformity or non-conformity.

In the following essay, I will attempt to put forward a framework for understanding character expressiveness in films.[1] We may define expressiveness as the form in which a character's emotions and thought processes are communicated. The term expressiveness is specifically chosen because it signals a certain type of interaction with the spectator, in which we are cognitively influenced by, and react emotionally towards, expressive representations, even if this only entails reacting with irritation toward an actor whom we perceive as unconvincing. I will suggest that we detect the *function* underlying expressiveness, as an integral part of perception pro-

cesses. Viewing the spectator as having the role of detecting which function is served by expressiveness, allows us to move beyond a linguistic approach in which we focus on form, i.e. recognizable meaning units. As we shall see, focusing on form has only limited explanatory potential with respect to acting, presumably, as Richard Dyer has pointed out, because acting has an analogical nature.[2] In formulating a theory of the communicative function of film acting, I have drawn on Noël Carroll's theory of point-of-view editing, as well as a functionalist theory of emotions by the Dutch psychologist, Nico Frijda.[3]

What Purposes Emotions Serve

The clue to explaining expressiveness lies in putting aside that most important tool for analysis and theory, language, as the central pathway to understanding what a character's expressiveness means. It calls for a cognitive approach in which we look beyond the performances, since there is little hope of discovering a system of meaningful units. Rather than assuming a system of units, which are meaningful in relation to each other, or by means of cultural conventions, a cognitive approach assumes, as Torben Grodal has pointed out, "our cognition is based on a series of different mental activities that interact pragmatically, they are not part of a 'system' in any linguistic sense."[4] Moreover, we need to look for principles underlying expressiveness and our role in perception, by going beyond the text itself. I will begin by describing a model that explains what emotions are, and the functions that they serve, after which I will apply this model more generally to film acting.

Emotions are central to understanding film acting and the task of the actor. Acting carries out other communicative roles as well, such as representing types based on social, geographic or sexual inferences and schemas. What renders emotions pivotal in acting is that they are particularly demanding of the actor's skills and imagination. We easily identify emotions that seem fake or in other ways false; yet expressiveness must be present, in order for the fictional universe to avoid appearing 'cold' and bereft of relevance. To a great extent, actions acquire meaning because of the intentions

or emotions guiding them. Thus, at an unconscious level, perceptual activity takes place, which leads the spectator to judge certain types of expressiveness as indicative of true or honest emotional activity and certain types as inauthentic.

In order to understand this perceptual activity and, by extension, the art of film acting, it is necessary to make explicit our assumptions about the information contained in expressiveness. One way of understanding the information contained in expressiveness, is to look at the role performed by emotions. In his book, *The Emotions*, Nico Frijda contrasts two theories that seek to explain the evolution of expressive behavior. One theory views emotional behavior as serving communicative purposes, evolved in order to let other people know how we feel. The other theory, however, sees expressive behavior as functional, serving the function of allowing us to behave adaptively to the environment in response to specific concerns.[5] This is the explanation favored by Frijda, in part because it subsumes the communicative functions of certain expressive manifestations such as smiling and crying. Smiling strengthens bonds with others, or allows us to form new bonds, certainly an adaptive kind of behavior. Crying calls attention to our need for the help and sympathy of others, thus inclining them to act in a situation we are unable to cope with. Frijda points out that explaining emotion by means of their function, allows for similar forms of expressiveness in response to very different situations.[6] As an example of this, consider *disgust* as form of expressiveness that allows us to behave adaptively to the environment in response to specific concerns. Frijda notes that when we experience disgust, we curve our tongues to minimize gustatory contact with the ill-tasting substance and we even prepare to eject the substance from our mouth, again with the tongue.[7] It is of adaptive value to be able eject what is ill-tasting since our continued well-being is an important concern to be monitored, and this results in the activity which others may detect as expressiveness. In order to understand the difference between functionalist and communicative theories of emotions, we must take into consideration that even if we accept the evolutionary value of communicating to others that we dislike the substance in our mouth, the communicative model does not explain why disgust has taken the specific and

universal form it has, allowing us to even recognize disgust in other species. What we detect in the facial behavior and sound patterns stemming from disgust is the tendency to eject what is distasteful.

Detecting the Function of Expressiveness
in Hamlet-performances

According to Frijda's functional model, emotions are not only linked to action, but actually defined as either action tendencies, or, more broadly, relational activity. The reason we speak of emotions and not reflexes, Frijda argues, is that expressive behavior does not control action in the same way as reflex does. He notes that nasal irritation makes us sneeze by reflex, with no possibility of controlling the muscles carrying out the action.[8] In contrast, emotions are marked defined by cognitive flexibility, which offers numerous adaptive possibilities for dealing with concerns. Cognitive flexibility allows us to adapt our emotional responses to particular circumstances; for example, when we are angry, depending on the situation, we can choose between showing indignation and preparing to fight. In addition, cognitive flexibility allows us to learn from experience by feedback (we may, for instance, learn to suppress disgust at dinner parties, or even avoid food with certain ingredients) and it allows us to "choose" between alternative courses of action in response to a specific emotion.

By linking emotion to cognitive flexibility, we are better equipped to understand the nuances of an expressive performance, even though the emotion expressed may be subsumed to a broad category. Consider, for example, the various versions of despair expressed in performances of the Hamlet soliloquy "to be or not to be." In Laurence Olivier's *Hamlet* (1948), we see a Hamlet (played by Olivier) on the brink of resignation, whereas in Tony Richardson's *Hamlet* (1969), we meet a sarcastic and ironic Hamlet (Nicol Williamson), distancing himself from his despair and his failure to take action. In Franco Zeffirelli's *Hamlet* (1990), Mel Gibson's Hamlet is full of quite different emotions, depending on the objects and aspects addressed in the various lines, but he begins

and ends the scene in resignation and sorrow. In contrast, in Kenneth Branagh's *Hamlet* (1996), Hamlet (played by Branagh) plays the scene with seething, self-contained anger. Yet, in all four versions, Hamlet can be said to be responding to the same underlying dilemma, and at a general level, attempting to communicate the character's despair.

As spectators we look for, and cognitively detect, the function of expressive behavior in film. We detect a readiness to eject a substance in the manner that Williamson's Hamlet speaks (slightly curving the tongue as in disgust), but note also a sense of relaxation–he does not feel personally threatened. In contrast, Branagh's Hamlet is agitated, speaking loudly and standing erect, calling attention to himself (as in indignation). His muscular activation is so intense that it prevents him from speaking in a fluid manner, forcing him to utter words in short bursts, as if suppressing an urge to fight, hence the knotting of the eyebrows as if to protect the eyes in a fight. This is not the case with Olivier's Hamlet, who appears overwhelmed by the existential problem; and unable, except for a brief moment, to initiate any readiness for action; he is muscularly deactivated. Frijda explans apathy and resignation by the absence of intentions, and Olivier communicates this absence by his acting.[9]

Expressive behavior, in Frijda's scheme, is behavior whose goal is the modification of an individual's relationship to the environment in one of two ways: either directly brought about as the result of one's own actions, or indirectly, by communicating to others and inclining them to act in order to change the situation (called *interactive expressiveness*, e.g., smiling and crying).[10] Consider again Olivier's Hamlet; "apathetic in resignation" describes what we may infer about the character's state of mind, but the phrase does not capture the interactive effect of the performance upon the spectator. His soft spoken, high-pitched, modulated voice makes sense as interactive expressiveness. It is an almost unobtrusive call for empathy; he would probably sound on the verge of crying were it not for the steady pace of his delivery and the highly controlled vocal patterns that cause us to attend to the verbal meaning of the words.

The functional significance of a high pitch is to give the impression of smallness, in contrast to a deep voice that suggests a large

bodily resonance, and this explains why a high-pitched and softly modulated voice such as Olivier's can be employed to interact in a non-threatening way. Even if vision is the best sensory source for detecting the size of others, or at least the most prominent, there are good reasons for supposing that sound can carry information about size, proximity, or even the texture of objects, processed to some extent independently of other sensory channels. Olivier does not try to minimize his character's visual appearance, and the vocal signals of communicating smallness are unobtrusive, but they still affect the spectator in such a way as to create a feeling of concern for the Hamlet character.

The Problem of Realism in Acting

The objection could arise, that if we are not conscious of the function of emotions, then we will not necessarily perceive these functions. Nevertheless, I shall argue that functionalistic principles are exactly what underlie perception of expressiveness, and that this may explain both so-called realist acting as well as more stylized forms. Instead of seeing what we tend to call realistic or convincing acting as a mimicry of real life behavior – in stark contrast to stylized forms – we may describe both styles of acting as ways of focusing the spectator's attention on implications, necessities, or possibilities for action in the diegesis.

As evidence of functionalistic principles underlying perception at an unconscious level, consider the fact that physiognomy, or perhaps costume or make-up, often function expressively. From the large lips of the young man in Kieslowski's *A Short Film about Killing/Krótki film o zabijaniu* (1988), we detect a readiness for sensory contact, and from his small, somewhat closed eyes, we detect a withdrawal from the world, as if he is trying to minimize visual input. The impression that we get from these two attributes is the tendency of the character protect his vulnerability, an interpretation confirmed by the narrative context. Moreover, lips may signal heightened readiness for sensory contact if painted red with lipstick, and perhaps this is due to highlighting an inherent attribute of lips, namely that they react to sensation by becoming red-

der. I suspect that what we are accustomed to explaining as culturally acquired, symbols for something else, e.g. lips as a vagina symbol, may be explained by functionalistic principles, with the result that we often end up with a meaning implied by the symbol. A functionalistic explanation, however, emphasizes that meaning is embedded in the intermediate step – perception of the functional significance ænot necessarily in the reference to another object.

The fact that we are quite good at recognizing "fake" expressions, inherently seeing them as efforts to deceive, also supports the claim that we look for the function underneath expressions. If an actor tries to convey a certain kind of readiness for action and we find it unconvincing, we will often react by instantly becoming irritated. We see in it an intention to fool or mislead us. Even though we are seldom struck by the fact that a scene in a film actually is comprised of actors at work, we immediately detect what Erving Goffman has termed signals *given off*, displayed without awareness or ability to control, as opposed to those that are *given*, especially verbally, to foster a certain impression.[11] It is important to note, however, that signs *given* are not necessarily a matter of deceit in film acting. Moreover, signs given may be motivated within the fictional universe. That we cannot easily place signals as either given or given-off can be illustrated by Lilian Gish's smile toward her bullying father in D.W. Griffith's *Broken Blossoms* (1919). We know from the previous shot that she manufactured the smile with the tip of her fingers, but when we actually see the smile, it gives the impression of being entirely convincing because of its inherent qualities.

In order to explain the perception of a performance as unrealistic, we must recall that that there are always two sides of the coin in film acting, two crucial concerns that must be taken into account. One is the functional logic of direct and indirect expressiveness within the film's fictional universe. This is the concern that renders seminal the techniques first described by Konstantin Stanislavsky in *An Actor Prepares*, e.g., attending the fictional circumstances. The other concern is just as important: the interactive effect upon the spectator of the expressiveness depicted.

The Direct Addressing of the Spectator Versus the Concealed Addressing of the Spectator

Even if we are always aware that an actor is communicating to the spectator, this is implicit, and need not be signaled through the acting. Consider the fact that when a film overtly addresses the spectator, we do not respond with the same kind of irritation as we often do when we are addressed in a concealed manner. If an actor works hard at behaving as if his or her expressiveness serves a purpose within the diegesis, and the functional "analysis" in our perceptual apparatus lets us detect that this is not the case, irritation towards the actor is often the result. When our perceptual operations detect that expressiveness does not serve the function corresponding to the emotion aimed at by the actor, we speak of unconvincing acting or acting lacking realism.

By explaining unconvincing or unrealistic acting as detected by way of more or less unconscious processes of perception, I leave room for direct addresses to the spectator. It is important to point out that we do not become irritated if there is no postulation of functional significance within the diegesis. The theory of expressiveness as a detection of function is also supported by the fact that it is imperative that even the direct address must be carried out according to its function. As Michael Caine once said, glancing directly into the camera is not necessarily felt as disturbing if the actor speaks as if he is intimately addressing a friend. The direct address is problematic when carried out as if speaking to a large audience, as is necessary in a theatrical play where there is no single perspective.[12] This is evident from a number of examples of direct addresses towards the camera: Ian Richardson as Urquhart revealing his machiavellian schemes to the TV viewers in Seed's *House of Cards* (1990); Matthew Broderick's sharing of the character's point of view on events in Hughes' *Ferris Bueller's Day Off* (1986); Emily Watson's somewhat sad glance toward the spectator, as if aware of what the future has in store, in Trier's *Breaking the Waves* (1996).

A useful method of describing unrealistic/unconvinving acting is: a perceived lack of functional significance, which the acting is implicitly claimed to fulfill in the diegesis. In Penn's *The Miracle*

Worker (1962), the performance of Anne Bancroft as Ann Sullivan, trying to make contact with the deaf and mute Helen Keller during their initial meeting, appears unrealistic. It strikes us as an actor trying to communicate the intentions of the character and overdoing it. Nevertheless, it is possible to follow the reasoning behind the actor's choices. Wide-open eyes, a forward leaning posture, and a readiness for responding to Helen makes relational and functional sense. In real life situations, we often see wide-open eyes on the faces of parents and teachers trying to make a resistant child pay attention. But here, for some reason, Bancroft's wide-open eyes strike as unconvincing. Bancroft's gaze, perhaps a bit too prolonged and static (thus not really responsive to Helen), is perceived instead as having functional significance in relation to the spectator; with the intention of making us believe that the character is trying to get in contact with Helen Keller.

It is important to note, however, that these interactive signals towards the spectator originally were intended to be detected when the film was produced in the early 1960s. Today, they might seem a bit more obvious due to a high exposure to inhibitions and self-control on the screen, or we may explain the historicity of our reaction as cued by the photographic style (the scene is staged, lighted and filmed in a theatrical style, and in fact it was originally a theatre production). The difference is one of degree, not category. Since the term convention, at least in its linguistic sense, implies that a performance is coded, suggesting that the meaning of x was y in 1962 but z in 1998, it is less suitable for describing historical fluctuations associated with perceptions of realistic and convincing acting.

The Problem of Non-realist Acting Styles:
Bresson's Automatism

Although we are not under the illusion of witnessing actual emotional behavior while observing character expressiveness in a film, our perception processes behave as if we were, detecting intentions behind depicted expressiveness. The question remains whether this in-built assumption is also operative in our perception of acting

styles which differ from the psychological realism of mainstream film. The acting style often employed in Robert Bresson's films, is a good example of non-realist acting. The performances are marked by a remarkable lack of activation, as if the characters were carrying out perfunctory tasks, performed in an automated fashion.

A memorable example of this is the protagonist's escape from the car in *Un condamné à mort c'est échappé* (1956), which is performed without any of those signs of physical activation that we expect to be mobilized when life is at stake. Nor is his attempted escape accompanied by a deactivation, as if he believed the attempt was certain to fail (even though the spectator is prevented from getting his or her hopes up: the camera awaits the protagonist's return to his seat). Bresson stated that he tried to depict the habits and automatism that pervades reality, by letting the actors (in his terms, models) perform the action over and over again in order to make "their relations with the objects and persons around them /.../ right, because they will not be thought."[13] What is significant here, however, is that this kind of automatism is used in conjunction with emotional situations where concerns are at stake that normally would cause the opposite of automatism, namely expressiveness. Note that a similar kind of automatism, for instance, is employed in Truffaut's *Tirez sur le pianiste* (1960), and thus it is not exclusively attributable to Bresson's personal oeuvre.

Like Frijda, I previously posited that expressive behavior is the result of a modified relationship to the environment, and as such, the automatized style of acting should not be considered as expressiveness at all. Indeed, many viewers find Bresson's films boring for exactly the same reason: there are no action tendencies, inherently demanding attention with the purpose of making the spectator discover the emotional significance of events. Yet an important part of narratives is to relate causally a course of events by emphasizing which concerns are at stake. If the spectator pays attention to the emphasis placed on events, even if the characters are unaware that important concerns of theirs are at stake, he or she will probably be moved. My personal response was relief when the convict manages to escape in *Un condamné à mort c'est échappé*, and deeply felt despair at the tragic ending of *L'Argent* (1983).

The communication of the character's thought processes should be obvious from the term automatism: according to the expressiveness depicted, the protagonists fail to realize that important concerns are actually at stake. Yet if we want to understand exactly what is achieved through automatism, it is necessary to account for the interactive effect. When attending to the tragic course of events in *L'Argent*, we realize that important concerns are at stake and become deactivated, as in despair, because we cannot influence the course of events; but we are able to see exactly what incidents have lead the innocent protagonist to his misery. In other words: the spectator's despair is the result of a kind of dramatic irony, similar to that of suspense, with a protagonist seemingly unaware – in contrast to the spectator – of what important concerns are at stake. The attentive spectator becomes activated and wishes to intervene for the same reasons that we would want to intervene in a friend's life when events take a tragic course without him or her realizing it. Moreover, the cognitive content of this despair is not only caused by following story events and awareness of the characters' lack of expressiveness, but to some extent also has the fictional frame as a component. The lack of expressiveness in *L'Argent* functions to activate the patient and attentive spectator toward intervention, which of course is impossible in a fictional story.

A comparison to reality is often invoked, when speaking of realist and non-realist acting styles. However, from a theoretical point of view, we are served much better by relating the performances to perception processes. By looking at both the communicative function (what we may infer about the character's relationship to his or her environment), and the interactive effect upon the spectator (e.g. interest, or, more specifically, despair), we may acquire a greater understanding of what is achieved by employing a particular acting style, whether it is realist or non-realist. Moreover, Bresson's choice of automatism is crucial in communicating the protagonists' relationship to the environment (that they fail to realize that important concerns are at stake), and thus central to creating the expressive and interactive effects.

In addition, we may demonstrate the advantages of a functional model of expressiveness in film by noting that a certain feature of human behavior, such as automatism, may function to achieve

quite different effects in film. Thus, a kind of automatism is also employed in acting styles associated with comedy, often used in conjunction with signals of voluntary control. An example of this is to be found in the exaggerated sounds accompanying accidents in Laurel and Hardy films, or Stan Laurel's exaggerated blinking when he weeps. The exaggerations suggest voluntary control of expressiveness, but in contrast to unconvincing acting, they do not claim to be involuntary. The signaling of voluntary control informs the spectator that the emotional implications of being hurt are not really there, allowing us to laugh at the painful and humiliating situations. Yet, it is the actions performed, which cause us to see that character concerns are at stake in the first place, giving the situation an emotional character. Due to the contrast between actions and expressiveness, we see that the characters are not hurt; they merely suggest being sad and hurt.

In conclusion

Objections may arise that I have been highly interpretative in my discussion of the functional model in explaining expressiveness. If true, this explanation ought to be recognizable intuitively, by means of introspection. Nevertheless, introspection is not a valid parameter for judging what is essentially a perception theory. In order to explain the function of stylistic choices in art, we must assume that much of our thinking takes place outside conscious control, as part of information processing. The theory put forth in this essay should be evaluated according to how well it explains the ways in which we understand a character's emotions and thinking; and how it, for example, explains timing, unconvincing/unrealistic acting or what is achieved by employing different acting styles.

My theory hinges on envisaging emotions within a functionalist perspective. The central argument in Nico Frijda's functionalist theory is that human beings have concerns that are constantly monitored cognitively: when we detect changes that might pertain to these concerns, the result is emotional behavior. This information is extracted by the spectator as a matter of perceptual and cognitive activity which interacts, to use Grodal's phrasing, in a prag-

matic way, taking into consideration the narrative context, the photographic style as well as our general knowledge schemas for human concerns.

Using film acting as our point of departure may bring us closer to the phenomenology of the film experience, by putting character and emotional concerns at the center. When discussing subjectivity, in the sense that we experience what the character experiences, we often focus on editing but choice of words, vocal delivery, bodily reactions, and the timing of pauses also communicate emotions. I have tried to stress the double-sided effects of expressiveness. Film acting not only cues the spectator to observe the emotional significance of events, it involves a kind of interaction as well: we react with sympathy, disgust, desire, admiration or even indifference, to name just a few possible reactions.

Notes

1 I have elaborated this framework in Johannes Riis, *Spillets Kunst – Følelser i Film* (København: Museum Tusculanum, 2003).
2 Richard Dyer, *Stars* (London: British Film Institute Publishing, 1979), 152.
3 Nico H. Frijda, *The Emotions* (Cambridge & New York: Cambridge University Press, 1993). I have mainly taking the idea that character emotions cue us to see the story world in a particular light, by searching for the aspects, which may cause the emotion in question, from Carroll. See Noël Carroll, "Toward a Theory of Point-of-View Editing: Communication, Emotion, and the Movies," *Poetics* 14, no. 1 (1993).
4 Torben K. Grodal, "Old Wine in New Bottles," *Film-Philosophy* 5, no. 12 (2001).
5 Frijda, *The Emotions*, 60.
6 Ibid., 66.
7 Ibid., 11.
8 Nico Frijda, "Emotions Are Functional, Most of the Time," in *The Nature of Emotion: Fundamental Questions*, ed. Paul Ekman and Richard J. Davidson, *Series in Affective Science* (Oxford: Oxford University Press, 1994), 113.
9 Frijda, *The Emotions*, 56.
10 Ibid., 71.
11 Erving Goffman, *The Presentation of Self in Everyday Life* (New York: Anchor Books, Doubleday, 1959).

12 Michael Caine, *Acting in Film: An Actor's Take on Movie Making*, ed. Maria Aitken, Rev. ed., *The Applause Acting Series* (New York & London: Applause, 1997), 97f.
13 Robert Bresson, *Notes on Cinematography*, trans. Jonathan Griffin (New York: Urizen Books, 1977), 12.

Murray Smith

A Reasonable Guide
to Horrible Noise (Part 2):
Listening to *Lost Highway*

Ordinary film music is ignored by the average person because he assumes that it is (film is) a visual form. He is therefore not entirely alive under film bombardment, but if the building he is in begins to burn down, he will wake up and use his liveliness to save himself.

<div align="right">

John Cage[1]

</div>

Made to be played loud at low volume.

<div align="right">

Declaration on the cover of
Damned Damned Damned,
The Damned (1977)

</div>

Things have gotten weirder and weirder as the day has gone on. I feel like I'm in a David Lynch movie.

<div align="right">

Tom Carver, BBC correspondent, reporting on the
Washington sniper case, October 2002

</div>

Like the earlier landmark films *Scorpio Rising* and *Mean Streets*, David Lynch's *Lost Highway* successfully draws on the resources of contemporary rock music to fashion and articulate its vision. For this reason, the soundscape of the film – its integration of music with other types of sound – forms a particularly telling way of approaching and appreciating the film. Just as *Mean Streets* revivified the gangster movie through its use of contemporaneous popular music – in ways that continue to reverberate in popular culture, as is evident in *The Sopranos* – so *Lost Highway* makes the hoariest of horror movie sub-genres, the haunted house movie, seem genuinely disturbing again, in considerable measure by virtue of the film's sonic and musical design. The range of styles of rock music that Lynch draws upon in *Lost Highway*, however, testifies

to the way in which the field of rock music has diversified – or, to put it more dramatically, the way in which the phrase 'rock music' has become a container for a host of varying musical projects and styles. But there is more to Lynch's soundtrack for *Lost Highway* than a simple use or 'quotation' of various styles of rock music. Lynch frequently exploits the most physical elements of sound – of loud volume, of sudden dynamic shifts in volume, of extreme low frequencies, of the all-encompassing character of surround sound – elements which are felt as much as they are heard, and which together establish an affinity with the fundamental aesethetics of rock music (a point to which I will return towards end of this essay).

The extraordinary climax of *Lost Highway* provides a telling entry into both the film's soundscape and its narrative structure. As Fred Madison (Bill Pullman) flees his Hollywood home and heads out onto the eponymous highway, the musical cue provides a thrilling and almost sickeningly overpowering accompaniment (if heard under the 'right' conditions) – a dense mix of wailing police sirens, screaming voices, violin glissandi, roaring engines, over-driven guitars, the whole propelled by a driving techno-rhythm – an apt array of sonic elements for a film that revolves around a character (or characters) afflicted by the extreme form of psychosis known as a 'fugue.' A close look at the arrangement of these sonic elements – among themselves and in relation to the image track – reveals how carefully the audio-visual design has been worked out, and gives the lie to any notion that soundtracks using the idiom of contemporary rock or popular music are simply 'slapped on', necessarily lacking the plasticity and intricacy characteristic of classical musical scores.

To be sure, this is in part due to Lynch's idiosyncratic and painstaking approach to sound design, involving the intensive electronic processing of recorded sounds. Lynch collects sounds, and commissions (or adopts) music from a variety of sources – a process he describes as the gathering of 'firewood.' In the case of *Lost Highway*, original music was composed by longtime collaborator Angelo Badalamenti (dissonant, modernist classical pieces), Trent Reznor (the force behind the group Nine Inch Nails, responsible here for guitar drones), Barry Adamson (formerly a

member of Magazine, and the Bad Seeds, contributing big band jazz compositions), and Arthur Polhemus (synthesizer pieces); and pre-recorded music by various artists was also incorporated. All of these sonic elements – pre-recorded music, specially composed music, dialogue, effects – were then meticulously 'orchestrated' in a final sound mix overseen creatively by Lynch. The sound design was conducted at the cutting edge facilities of Digital Sound and Picture, a fact apparent in the enormously varied and intricate sound texture of the film, and the overtly 'treated' quality of much of the sound.[2] What makes Lynch's approach so distinctive is the degree to which all elements of sound – score and dialogue included – are subordinated to an integrated sound design, in contrast to the relative autonomy retained by music, dialogue and effects in conventional sound design.

In the most basic terms, the final chase cue functions as a crescendo, giving musical expression to the dramatic climax reached in the narrative. The cue gradually thickens as it progresses, through both a staggered increase in loudness, and the introduction of additional layers of sound, the end result embodying a kind of techno-thrash version of Phil Spector's celebrated 'wall of sound'. In expressive terms, the focus of the cue shifts from the chase itself, with its emphasis on rapid movement through space, to the psycho-physiological disintegration experienced by Fred as the sequence climaxes, to the emptiness left in the wake of this disintegration.

We can track these phases of the cue in detail. The opening of the sequence and cue supports Jeff Smith's observation that 'the stylistic combination of rhythmic propulsion, harmonic stasis, and electronic colouring makes [rap, techno and trip-hop] … especially appropriate … for chases and action scenes.'[3] Over the first few seconds of the scene, as Fred runs towards his car, a series of small rhythmic embellishments – half- and quarter-beat hi-hat fills – underline the kinetic quality of the music, stressing the actions of flight and chase. As the scene progresses, however, the 'inhuman' precision and relentless character of the drum machine, and the use of a highly compressed snare drum sound, come to the fore, expressive of the entrapment and loss of control central to the narrative and thematic dimensions of the film.

The next layer of sound – heavily-distorted guitar playing a simple three-chord riff – again modifies the character and expressive focus of the cue, this time in the direction of a harsh, assaultive mood, the timbre of the guitar reinforcing the fierce roar of the car engines. Brian Eno's remark on the expressive quality of distortion is apt here: '[Distortion is] the sound of failure ... of a medium pushing to its limits and breaking apart. The distorted guitar is the sound of something too loud for the medium supposed to carry it.'[4] The percussive chopping or 'scratching' of the overdriven guitar – the technique of strumming with the plectrum hand while loosening the pressure exerted by the hand on the fretboard, so that the notes of the guitar sound in a muted fashion[5] – is rhythmically coupled with the snare drum half-beats which punctuate the cue. Moreover, this 'scratching' mimics the sight and sound of burning rubber – of car tyres spinning on the road surface – to the extent that both depend on the generation of friction between two surfaces. Similarly, the diegetic sound of the car sirens interweaves with the non-diegetic violin glissandi, an effect redolent of the fusing of human shrieking and stabbing violin phrases in *Psycho*. Arguably, this close integration of diegetic and non-diegetic sound increases the dramatic and expressive force of the musical cue, by running sonic lines through the music which have their roots in the diegesis but which become bound within the musical structure.

The chase into the desert compresses several hours, as afternoon turns into night in a matter of seconds. The cue continues to intensify, particularly as the scene narrows down visually to the montage of jump cuts representing Fred's final dissolution: an additional layer of reverberant, low-pitched percussion rumbles underneath the guitar; the guitar riff itself is doubled in the mix; and the volume overall increases. The simplicity of the 'melodic' and rhythmic spine of the cue enables it to form a kind of closed musical circuit in which the pressure continually mounts as the riff repeats – through the increasing density and loudness of the cue – literally to the point of disintegration. Combined with the tightening shot-scales on Fred's face, and the expression of terror on his face, the intensity renders an acute claustrophia – Fred is not only trapped in a car and in a seemingly endless chase, but in his body.[6] Brought to a climax by the final additional layer of screaming, and

an ever more insistent rhythmic stress as we see Fred's face agitated and blurring as if in its death-throes, the scene abruptly lapses into silence – or the near-silence of a faint ambient sound – as it cuts visually to the road. Like most great sound stylists, Lynch knows how and when to use silence. The lingering, phantom sound – the distant and dying echo of Fred's scream – is sustained for several seconds before the entrance of the film's final musical cue, 'I'm Deranged' by David Bowie and Brian Eno, itself characterized by mellifluous timbres and shuffling rhythms standing in sharp contrast to the aural 'brutalism' of the cue for the final chase.

Madness and Music: Fugues

The 'doubling' of the guitar sound, along with the layering of one police siren on top of another and the violin glissandi, are parallelled by the use of visual superimposition in the sequence – two highways appear to lay on top of one another, and Fred's spinning head seems to split into several ghostly visages (*a la* Francis Bacon). This 'schizophrenic' imagery, of course, recapitulates and summarizes the central conceit of *Lost Highway* – two quite separate men appear to exist in, or alongside, or in succession with, one another, with perhaps a dim and fleeting awareness of this, inparallel universes populated with similar, but never quite identical, figures. The film begins with Fred in his house; responding to the intercom buzz, Fred hears an unfamiliar and enigmatic voice intone 'Dick Laurent is dead'. Over the next few days, Fred and his wife Renee (Patricia Arquette) receive a series of packages on their doorstep, each of them containing a videotape with grainy footage of, initially, the exterior of their house, and subsequently the interior of the house as well. This pattern culminates in a tape which reveals Renee dead, apparently murdered by Fred himself – an event not without plausibility, given the current of tension and barely repressed anger that seems to exist between the two of them, inspite of the narrative disjunction created here: the murder of Renee by Fred is revealed on tape as Fred watches the tape, and he evinces no awareness of her apparent demise at his hands. The next thing we know, Fred has been imprisoned and charged with the murder

of his wife. The disorientation created by this elision is then compounded by the next major event, the metamorphosis of Fred into Pete Dayton, an (apparently) entirely different character: younger, from a different town, with his own history and police record, and of course played by a different actor (Balthazar Getty).

At first dazed and confused, Pete picks up the threads of what we understand his life to have been before a mysterious and obscure event interrupted it. He returns to work as a garage mechanic. While at the garage, Pete meets and falls for Alice – Renee's blonde double, and like Renee, played by Patricia Arquette – the mistress of gangster and porn racketeer Mr Eddy. Alice and Pete hatch a plan to escape the controlling influence of Eddy, but Pete is deserted by Alice, and at this point he turns back (over a match on action) into Fred Madison, equipped now with a motive for the bitter resentment we see him directing at Renee in the first half of the film. A shoot-out involving an unnamed, menacing figure (listed as the 'Mystery Man' in the credits) and Dick Laurent (Mr Eddy's counterpart in the world of Fred and Renee) results in Laurent's death. Fred returns to his house in Hollywood, presses the intercom and delivers the message: 'Dick Laurent is dead.' The narrative of the film thus describes a perfect circle (tempting one to speculate that the title of Lynch's subsequent feature, *The Straight Story*, on one level acts as a sort of counterpoint within the larger work that is Lynch's oeuvre). But the moment at which Fred delivers the message into the intercom, on the steps of his house, is also the moment that initiates the final chase – and this sequence, of course, escapes the circle that the rest of the action describes. Rather, it exists as a tangent, though the implication of this tangent is consonant with that of the circular structure: if Fred and Pete are caught in a cycle of eternal recurrence – Pete's betrayal bringing us back to the moment at the beginning of the film when Fred is informed of the death of Dick Laurent – then Fred's attempt to escape the vicious circle only ends, as we have seen, in annihilation.

Extravagant and surreal as this narrative structure and its play with characters is, it is hardly without precedent and certainly not as impenetrable as many critics have suggested. Many of Lynch's films have featured strange and impossible transformations; *Twin Peaks* provided a veritable army of doppelgangers. Lynch's films

have always shown a fascination for archaic, pre-modern belief systems, which defy everyday reality and modern scientific scepticism alike.[7] *Lost Highway* is exceptional only to the extent that it refrains from establishing any explicit supernatural framework (contrast this with the elaborate symbolism surrounding the Black and White Lodges in *Twin Peaks*). In terms of the 'cognitive-emotional' genre typology formulated by Torben Grodal, *Lost Highway* combines elements of 'obsessional' and 'schizoid' horror fiction. Appearance and reality are dislocated; motivations are obscure; cognitive dissonance disturbs the very foundations of narrative coherence; temporal and causal sequence become paradoxical.[8] And more specifically, the story can be understood in terms of the condition known as a *fugue*, a term for a psychological dislocation so severe that the sufferer takes on an entirely different character and existence, divorced from and apparently oblivious to their former or 'normal' character.

The notion of a psychological fugue is a relatively recent one. The identification of the condition – if not the invention of the term – has been attributed to William James, who described the case of the Reverend Ansel Bourne, an itinerant preacher from Rhode Island who one day left for Pennsylvania, and lived for the next two months under the name of Brown, managing a small shop, until he awoke one night as 'himself' again.[9] As Brown, he had no memory of his previous existence as Bourne; and as Bourne, no adumbration of wishing to be Brown or memory of having been Brown. The psychological notion draws metaphorically on the much older notion of the musical fugue, a form in which two or more musical voices exist in counterpoint with one another. A psychological fugue is like a musical fugue in that a person suffering from this affliction exists as two 'persons', for a fugue is a single musical piece with two quasi-autonomous instrumental 'voices.' This earlier (and still the standard and primary) sense of 'fugue' also has pertinence to *Lost Highway*, insofar as the film interweaves different styles of music in order to give expression to the psychic crisis at the heart of the film. Of course, musically speaking, the structure is 'fugal' in an eccentric way: a classical fugue interweaves two or more instrumental voices, rather than styles of music; and the relationship between the voices is predominantly harmonious

rather than fractured and dissonant. The suggestion, nevertheless, is that the film sets different styles of music in contrast and sometimes in conflict with another, in order to evoke different states of mind and the riven destiny of Fred/Pete. If the looseness of the analogy seems just too imprecise to give the metaphor any bite, it is worth remembering that 'fugue' in the musical sense derives from Latin *fuga*, to flee – the action with which, as we have seen, *Lost Highway* concludes.

Death Metal, Dark Ambience, and Dissonance

How, then, does the film interweave different musical voices? Sonically speaking, *Lost Highway* breaks roughly into two halves, each characterized by a particular mix of sonic and musical elements. The first half is dominated by a mixture of 'dark ambient' or 'illbient' atmospheres, and 'industrial' music – recalling the soundtracks of *Eraserhead* and *The Elephant Man*. The second half shifts the emphasis to, on the one hand, a kind of lite jazz (best exemplified by Antonio Carlos Jobim's bossa nova composition 'Insensatez'), and on the other hand those gaudy cousins, 'black' metal, 'death' metal, and shock rock (in the form of tracks by Rammstein and Marilyn Manson). (The final chase cue is a synthesis of the two major strands – that is, of industrial and illbient noise with the pounding rhythm and heavy distortion of typical metal.) Along the way, various other styles of music make fleeting appearances, like the love balladry of Lou Reed's 'This Magic Moment' and some free jazz.

Although the use of such shock rock acts as Marilyn Manson and Rammstein has invited scorn, Lynch draws here on a kind of 'Grand Guignol' tradition of rock, traceable to earlier acts like Alice Cooper, and entirely suited to *Lost Highway*.[10] The generally atavistic qualities of the Lynchian universe are joined in this film by more-than-faintly satanic imagery and overtones. This is most overt in the scene inaugurated by the sinister incantations of Rammstein's 'Heirate Mich,' which accompany Pete as he enters the mansion where he has planned to meet Alice, with the intention of eloping with her. The demonic mood is compounded later

in the scene when Pete, staggering upstairs with a crippling headache, opens a door and is as saulted by a vision of Alice on her knees and *in flagrante* – a sight rendered in garish-red, solarized tones, and conjoined with a brutal metal riff (this time from the eponymous 'Rammstein'). Multiple selfhood is presented here as possession, not schizophrenia; the film is imbued with a sense of good and evil as absolute, metaphysical principles. Moreover, the use of rock music to evoke an atmosphere of escalating dread and catastrophe, as in the closing moments of *Lost Highway*, finds a striking precedent in the final sequence of Kenneth Anger's *Scorpio Rising*, as a biker spins to his death to the accompaniment of the Surfaris' 'Wipe Out', with its cackling, devilish vocal overture. Anger is perhaps the crucial predecessor to Lynch here, as a director fascinated equally by Hollywood and Aleister Crowley, conjuring 'evil' from popular culture in both *Scorpio Rising* and in the later *Invocation of My Demon Brother* (soundtrack courtesy of one Mick Jagger).[11]

The role of satanism, black metal and shock rock in *Lost Highway* deserves fuller discussion, but here I want to focus my attention on 'illbient' music in the film, a form on the very fringes of rock, and one whose distinctiveness poses particular problems for critical analysis. Associated in the US with DJ Spooky and DJ Olive, and in the UK with such artists as the Aphex Twin, Coil, Scorn and :zoviet*france, illbient is the downbeat counterpart to the ambient music formulated and composed by Brian Eno, among others.[12] While illbient music maintains the ambition of ambient music to work in the background, creating moods without drawing attention to itself, the emphasis here is on bleak sonic atmospheres, as the name suggests; one might think of it as a kind of radicalanti-muzak. Most illbient music is the product of either electro-acousticor electronic instrumentation, that is of synthesizers, fully-fledged studios or more basic devices, like turntables and tape recorders. It is not, in general, composed using traditional methods of compositional notation, nor with traditional instrumentation in mind. It frequently lacks articulation into discrete notes, working instead in continuous streams and clusters of sound which ebb, flow and evolve; and its timbral qualities are often as salient, if not more salient, than its melodic or harmonic qualities.

Not surprisingly, then, it does not yield easily to conventional musicological analysis; one finds oneself talking about scraping, rustling, whistling and clicking sounds, rather than notes, beats, and intervals. While I hope it is evident from my language that conventional musical analysis and terminology still plays a role here, this essay is in part an exploration of just how one goes about analysing ambient and illbient soundscapes. The sequence which culminates with Fred's nightmarish vision of Renee as the Mystery Man is a tour de force in its use of illbient sound (the basis of this cue is a track called 'Various Ominous Drones', credited to Trent Reznor and Peter Christopherson, the latter of Coil, mixed with elements of a theme by Badalamenti titled 'Fred and Renee Make Love'). The sequence begins with Fred and Renee having sex – or least attempting to have sex, in their bedroom. Fred then recounts a dream to Renee, a dream in which he moves through their house and discovers Renee in the bedroom, but does not recognize her as Renee (though we see Renee in the shots which represent the dream). Fred relaxes after recounting his dream, but in a final twist, he glances towards Renee and sees the Mystery Man in her place. The dream thus foreshadows both this later, hallucinatory moment in the sequence (in each case, Renee is usurped by the presence another), and her ultimate demise (since the dream concludes with her screaming as she is apparently assailed on the bed).

The first shot of the sequence shows Fred lying in bed, framed in tight close-up and by impenetrable shadow, with a look of troubled distraction on his face. We hear a low, hollow drone, like the hum of an industrial unit – a descendant of the illbient sounds so pervasive in *Eraserhead*, though importantly in this case there is no visual correlative to or motivation for the sounds. Philip Brophy describes the ambience created by such drones as 'an excess of nothingness … a dense and moist bed of rumbling tone which lugubriously bleeds into the air conditioned atmosphere of the cinema.'[13] Although drones like this one will come and go in the course of the sequence, together they nevertheless function as a sonic bedrock in the scene, establishing an underlying tone enriched and complicated by additional layers of sound.

The close-up of Fred alternates with a series of 'memory' shots,

of the previous evening, showing Fred playing sax in a club, and Renee and her friend Andy apparently leaving the club during the performance. The synchronous sound that would normally accompany these shots, however, has been stripped away – or 'suspended', to use Chion's term[14] – and replaced with an illbient drone. The sense of loss, detachment and emptiness that this substitution generates is made still more emphatic by a particular feature of the 'silenced' images. These images, and especially those which show Fred playing sax, are instances of *sonic imagery* – images which are highly evocative of sounds. What's more, Fred is not playing the sax in any old way – he is 'overblowing', a technique of jazz playing involving considerable physical exertion, which results in a kind of hyperventilated squealing (which we *do* hear in an earlier scene at the club itself). If the sound of the sax assumes symbolically the pain and anger that Fred feels, the fact that the sound is, as it were, masked, and only available from memory and by inference from what we can see, underlines the frustration and explosive containment we see in Fred as he lies still on the bed.

The sound of a door brings Fred out of his dark reverie, and an ear-silence ensues as he watches Renee prepare for bed – the only sounds present here are the occasional sounds of Renee's movement, and the sound of breathing. The close-miking of the performers creates an intimacy, but a clinical rather than a sensual one. As Renee and Fred begin to kiss, another drone insinuates itself into the action, but at a lower-pitch and at a quieter level than previously. As the couple continue to kiss and Fred moves onto Renee, the volume of the drone increases, and it gradually resolves itself into a recognizable musical pattern – a slow, funereal phrase fusing cello and low-brass colouring, which repeats five times with small variations. (Here I think we can hear the 'burning' of Lynch's 'firewood,' as fragments from Badalamenti and Reznor blend and merge to the point that they become organically fused.) As the phrase repeats, two additional layers enter the mix: the sound of breathing returns – more prominent than before – and the Tim Buckley song 'Song of the Siren' begins, as ethereally performed by This Mortal Coil.

Then a key moment of transformation occurs: the sustained wash of a gong, combined with a brief flash of light which for a

second whites-out the screen, inaugurates a passage rendered in visual slow-motion and with aural reverb. Reinforcing the cavernous drones which have run under much of the action in the sequence, the reverb bestows still further desolation on what is nominally a scene of intimacy. Moreover, 'Song of the Siren' itself uses heavy reverb on the singer's voice, to create an effect of distant yearning. The appearance of the song here prefigures its use towards the end of the film, where it will accompany the final betrayal of Pete by Alice.

As Fred exhales after orgasm – or emits a groan of defeat? – so the reverb rapidly 'contracts' along with most of the sound, leaving us with only the sound of Fred gasping (notably, Renee appears to make no sound during this part of the sequence, just as she is obscured visually for much of it). The effect of this is to emphasize the physical concreteness and presentness of Fred. While he is haunted by sounds and images from other times and places – the memory of the club, the brief flash of light a presentiment of a future he cannot imagine, the remembered dream that he will recount to Renee later in the sequence – he is also indelibly present-to-himself (and to us) as a physical being, bound in a particular moment. And his state of being in this respect is, at this point in the story, in marked contrast to the figures that surround him – Renee, for example, is so elusive that Fred cannot even quite identify her with her bodily, physical appearance, as the action which follows in the sequence attests.

Later in the scene, after the failed sexual encounter, Renee puts her hand on Fred's back, and the aural fog of the illbient drone returns again, this time accompanied by crashing cymbals, timpani drum rolls, and violin glissandi (similar if not identical to those that will appear in the climactic chase). Deep in the mix, barely perceptible, Renee intones 'It's OK', a verbal gesture with no more feeling in it than the hand which strokes Fred's back. The pace of this cue is noticeably faster than those preceding it, but as Fred rolls off Renee, the soundtrack falls silent again for several seconds, and the tempo slows – visually as well as aurally – with the silence. When Fred begins to recount his dream, however, the cue enters its most complex phase. The hollow drone – now a shifting, uneven one – returns and is complemented by a timpani drum-roll,

accompanying Fred as, in his dream, he moves through the house, again shrouded by darkness. Fred's breathing and whispered narration is joined by Renee's distant calling, and faint high-pitched screeches, sometimes carrying an instrumental, sometimes a clanking, industrial, timbre. A shot of a roaring fire, and the rushing sound of the fire – as hot air races up the chimney – slices into this mix of sounds, abruptly dominating (though not erasing) all of them. The shot of the fire recalls but inverts the shots of 'suspended' sax playing near the beginning of the sequence: where the shots of the sax evoke powerful, dramatic sounds which we *cannot* hear, the shot of the fire brings with it a sound that would normally be no more than a minor ambient sound, but one which imposes itself here with the force of a violent storm. And the two sounds – of the sax and the fire – are both caused by the rapid movement of air through narrow spaces. The sequence thus reveals an underlying pattern of aural imagery.

The final phase of the sequence – in sonic terms – begins with a shot of dense, billowing smoke. At this point, the dynamics and rhythm of the sound become generally more rapid, but also more unstable and unpredictable than heretofore. The hollow drone is joined by a low rumble (heard fleetingly before but consistent from this point), and a distinctive new 'voice' is added to the mix: a heavily-treated string sound, with a fluctuating pitch quality somewhat like a vibrato effect, but more synthetic and replete with dissonant overtones, which emerges out of the high-pitched industrial screeches. The voice also has a peculiar, shifting quality in terms of its attack and decay – perhaps the result of several tones, played backwards and forwards, being overlayed, akin to the technique used by Lynch for the voices in the Red Room scenes in *Twin Peaks*. Initially, the voice plays a simple but unsettling two-note phrase, based on the minor second interval, but as Fred enters the bedroom (in his dream) the voice moves through a pattern of three dissonant notes, played in an erratic but accelerating fashion, paralleling the sudden lurch of the camera in towards Renee. And just prior to this, as the camera moves over the foot of the bed, another layer of breathing is added – presumably motivated by the fact that Renee is about to come into sight, though the sound perspective is much closer than that of the image. A rushing wind sound joins the

voice-over, breathing, and dissonant violin as the camera moves in on Renee's face, along with first her high-pitched scream as she shields her face, and then an abrasive tearing sound over the cut to Fred. Conceived in musical terms, the sound at this moment is 'played' *sforzando* – that is, with sudden, emphatic force – and it constitutes what appears to be the climax of the entire sequence.

This complex compound of sounds is curtailed by a vertiginous decay, which recalls the effect of contraction following Fred's orgasm (or despairing groan). At much reduced volume, the pattern of three notes repeats as Fred – now in what we take to be the reality of the film's fictional world, not the dream – looks towards Renee's silhouette, subsiding into silence as he looks away, relieved. A final, sudden burst of sound – another, even more emphatic *sforzando* effect – then occurs, fusing the dissonant violin, the droning and rushing sounds which have been used earlier in the sequence, and deep vocal groans. The sound accompanies Fred's second glance towards Renee and the sight of the Mystery Man, before the vision disappears, the scene concluding with nothing but the sound of Fred's panicky breathing. This blast of sound thus situates the first *sforzando* moment as a *false* climax, inviting us to drop our guard before hitting us with a final shock. Visually, this is a moment of Magrittean surrealism, the face of youthful feminine beauty displaced by a visage of ageing, masculine menace. The swirling currents of the soundtrack, however – along with the dynamics of the image and editing – give the moment an altogether more visceral quality, reminding us that Lynch began making films when he realized the potential for sound to invest the static, painted image with a sense of motion.[15]

Lynch and the Rock Aesthetic

Christgau calls it 'skronk.' I have always opted for the more obvious 'horrible noise.' Guitars and human voices are primary vectors, though just about every other musical instrument has been used over the years … You probably can't stand it, but this stuff has its adherents (like me) and esthetic (if you want to call it that).

Lester Bangs[16]

I noted at the outset that Lynch makes use of a diverse range of (broadly speaking) 'rock' styles of music in *Lost Highway* (and one might add that this is typical of his work, especially since *Wild at Heart*). Two of the styles that I have concentrated upon here – illbient, and the techno-thrash-metal of the final chase cue – form two of the most divergent styles within this spectrum. So it might be wise to conclude with a few remarks in defence of the notion that such apparently different styles can usefully be grouped into the meta-category of 'rock,' and that the core features of this category are ones which, to put it circumspectly, find a kinship with the aural character of Lynch's films. The family of features that I have in mind include, first, loud volume and an all-enveloping sound, along with volatile dynamics which emphasize the play with differential volume; secondly, rhythmic intensity and intricacy, achieved either through highly-regular hypnotic metres or shifting, unstable pulses; and thirdly, timbral idiosyncracy, especially as this is created through the technologies of recording and electronic manipulation.[17] (The fascination with timbre forms the sonic partner to Lynch's interest in visual texture. Parts of the orchestral score for *Lost Highway* were recorded, for example, with the microphone placed inside bottles or long plastic tubes, in order to inflect timbrally the orchestral sounds in a unique way from the moment of recording.)

Illbient and techno-thrash-metal are testimony to this cluster of features, to the 'rock' style of Lynch's soundscape. For the power of the final chase cue depends on the combination of harmonically simple musical structures with a much more elaborate use of rhythm and timbre. The dissonant intervals and phrases in the bedroom scene suggest that melodic and harmonic factors play a more important role in this case, and indeed they do, but timbre, dynamics, and rhythm are ultimately what make the cue innovative and powerful. Few musical conventions are more familiar than the use of dissonant intervals – like the minor second and the tritone[18] – to establish a bleak mood or negative affect; put through Lynch's sonic blender, however, the convention acquires renewed and disturbing force, as one crucial factor in the film's revivification of the tropes of madness and possession.

In one respect, the claim that Lynch's use of sound design echoes

the musical character of rock should hardly raise any eyebrows. Lynch is a member of just that generation of American directors for whom the use of rock, and other idioms of popular music, has become a normal practice in scoring films. But Lynch draws on a wider and more eclectic array of pop and rock styles than any other prominent contemporary director, and synthesizes them with aspects of avant-garde classical and jazz music. So while Coppola turns to the Doors and Scorsese to the Stones and Clapton, Lynch appeals to the more experimental and outré fringes of rock, to its omnivorous as similation of other traditions of music, and to its fascination with the bedrock of noise. Writing of the 'tradition' of 'horrible noise' of which rock counts as a central instance, the rock critic Lester Bangs offered the following explanatory plea: 'Look at it this way: there are many among us for whom the life force is best represented by the livid twitching of one tortured nerve, or even a full-scale anxiety attack.'[19] Those of us who understand and appreciate the work of David Lynch know just what he means.

Notes

1 Quoted in *Documentary Monographs in Modern Art*, ed. Richard Kostalanetz (New York: Praeger, 1970), 115-6.

2 For more on the production of the film's soundtrack, see the documentary *Pretty as a Picture: The Art of David Lynch* (Toby Keeler, 1997); and 'Down the "Lost Highway,"' in *Sound for Picture: The Art of Sound Design in Film and Television*, 2nd Edition, ed. Tom Kenny (Vallejo: Mix Books, 2000). See also the commentary on Lynch's use of computerized sound mixing in *Fire Walk with Me* in Michel Chion, *David Lynch*, trans. Robert Julian (London: BFI, 1995),150.

3 Jeff Smith, *The Sounds of Commerce: Marketing Popular FilmMusic* (New York: Columbia University Press, 1998), 215.

4 Brian Eno, *A Year: With Swollen Appendices* (London: Faber, 1996), 283.

5 The underlying sound and technique is very similar to the 'chicken scratch' guitar sound established by the James Brown band in the 1960s, though the musical context here is quite different from Brown's funk.

6 This is a good example of what Michel Chion terms the 'reciprocity'of sound and image, each element affecting our experience of the other.

See Michel Chion, *Audio-Vision: Sound on Screen*, ed. and trans. Claudia Gorbman (New York: Columbia University Press, 1994), 21-24.

7 See Chion's remarks on this, in *David Lynch*, 22.

8 Torben Grodal, *Moving Pictures: A New Theory of Film Genres, Feelings, and Cognition* (Oxford: Oxford University Press, 1997), 168-70, 174-6.

9 James' discussion of the case is to be found in *Principles of Psychology II* (New York: Dover Press, 1890), 391-3, where he refers to it as a case of 'alternating personality,' 379. Kathleen Wilkes, referring to James' case, describes the condition as a 'fugue,' but it is not clear from her discussion whether the metaphor is her own elaboration or one derived from previous debate on cases of 'multiple selves.' See Kathleen V. Wilkes, *Real People: Personal Identity without Thought Experiments* (Oxford: Clarendon Press, 1988), 103-5.

10 In a related vein, Philip Brophy identifies a Disneyesque combination of 'carnival obviousness' and 'perceputal hucksterism' in Lynch's work: '*Lost Highway*: Booms, Drones and Other Dark Waves,' *Realtime* 20 (Sydney, 1997) (available on the *Cinesonics* website), 1.

11 The association between blues and rock with anti-christian imagery and sentiments has wide and deep roots, hardly restricted to the pantomime clowns of rock – beginning with blues guitarists like Robert Johnson ('Me and the Devil,' 'Hellhound on my Trail'), running through the flirtations between Kenneth Anger and both the Rolling Stones (*Their Satanic Majesties Request*) and Led Zeppelin (Jimmy Page wrote a score for Anger's *Lucifer Rising*; he also purchased a mansion once belonging to Aleister Crowley), and onto contemporary black metal (Marilyn Manson, whose music is used in *Lost Highway*, was made a priest in the Church of Satan in 1994). The genealogy of the notion of 'the devil's music' is a fascinating and complex subject, especially given the strong element of devotional sentiment in some rock music (think of the influence of gospel on some rock artists). The persistence of the association between blues, rock and the anti-christ, and some sense of its symbolic parameters, can be gleaned from Giles Oakley, *The Devil's Music: A History of the Blues* (London: Da Capo, 1997); Robert Walser, *Runnin' with the Devil: Power, Gender, and Madness in Heavy Metal Music* (Hanover: Wesleyan University Press, 1993); and Gavin Baddeley, *Lucifer Rising: Sin, Devil Worship and Rock 'n' Roll* (London: Plexus, 1999). It's also worth noting in this context that the very title *Lost Highway* resonates with the history of American popular music. 'Lost Highway' is the title of a song by Leon Payne, most famously performed by Hank Williams, subsequently used by Peter Guralnick as the title of his study of various blues, country, and rock 'n' roll artists. The image is the symbolic

flipside to the 'road to salvation,' evoking vanished, tarnished or otherwise compromised ideals. See Peter Guralnick, *Lost Highway: Journeys and Arrivals of American Musicians* (Boston: David Godine, 1979).

12 Though it should be said that some examples of ambient music have had a decidedly 'illbient' effect on listeners: when Eno's *Music for Airports* was actually played in an airport in 1982, 'passengers complained of its altogether disquieting effects.' John Robinson, 'Elevating the functional,' *Guardian*, The Guide, March 4,2000, 10.

13 Brophy, 1.

14 Chion, *Audio-Vision*, 131-33.

15 Chion, *David Lynch*, 10.

16 Lester Bangs, 'A Reasonable Guide to Horrible Noise,' in *Psychotic Reactions and Carburetor Dung* (New York: Vintage Books, 1988), 301.

17 The view of rock music informing this discussion is elaborated in Theodore Gracyk, *Rhythm and Noise: An Aesthetics of Rock* (Durham: Duke University Press, 1996).

18 On the use of minor seconds and other dissonant intervals in film music, see Royal Brown, *Overtones and Undertones: Reading Film Music* (Berkeley: University of California Press, 1994), 7.

19 Bangs, 301.

Casper Tybjerg

The Sense of *The Word*

Do the humanistic disciplines produce knowledge? This question haunts much public debate on the future of the universities, where many commentators worry that fields of more obvious public utility (biotechnology, applied physics, etc) may fall behind because the humanities attract too much funding and too many bright students. Even if the increase still leaves the humanists with a relatively small share of the total, any such growth remains a concern to these commentators: while the sciences produce innovations that enhance life and underpin prosperity, the humanities (in their view) do not. Indeed, they cannot, because they do not produce knowledge – and worse: they do not want to. This seemingly widespread view is well expressed by Danish sociologist and media researcher Henrik Dahl:

It is often the case that they [the humanistic disciplines] no longer aim at describing the world in a cogent and methodical manner, but only to interpret it on the basis of impressionistic or purely subjective descriptions. This is most clearly visible in the trend within the humanities called "cultural studies," which everywhere in Europe and the USA has a strong standing within media studies, literary studies and newer subjects such as women's and gender studies. (Dahl 153)

This passage comes from a recent essay written as a contribution to an anthology addressing the purported crisis of the natural sciences and published in abbreviated form in Denmark's leading intellectual weekly paper *Weekendavisen*. The essay's title suggests that the relation between the humanities and the hard sciences has changed "from alliance to hostility." Particularly since the 1960s, the humanities, in Dahl's view, have taken up an oppositional position with respect to "the system," the wider social order, and since the system is perceived as rational and scientific, humanists

have embraced irrationalism and hostility to science to such an extent that there is little hope of any return to reason. Dahl writes:

The path away from the anti-rational track is dialogue about the relationship between the two cultures. This will first and foremost require a great deal from the natural sciences, as I regard the culture of the humanities and social sciences as largely lost within its oppositional preconceptions, where the natural sciences as part of the system are regarded with the utmost mistrust. In short, I do not expect that there will be any major initiatives from the humanities and social studies to criticize the consequences of the anti-rational world-view. (Dahl 160)

The assertion that the humanistic disciplines are basically beyond the reach of rational argument is one that should give pause to humanistic scholars. In the following, I shall put forward the suggestion that scholars in the humanities, in part in response to such hostile statements, have tended to overemphasize the import and potency of interpretive activity. A highly significant critique of this tendency has been mounted by David Bordwell, but it has met with considerable resistance; in the following, I shall examine the most important objections against his book *Making Meaning*. This will lead to an extensive discussion of Dreyer's film *Ordet* ("The Word," 1955) in order to ground the methodological issues in concrete detail.

Interpretation as Power-Tool

While the Sokal affair is not explicitly mentioned in Henrik Dahl's article, it is an important part of the debate arising from the revelation by physicist Alan Sokal that he had managed to get an article published in the prestigious cultural studies journal *Social Text* which he then revealed was a parody and a hoax.[1] The implications of the well-publicized scandal that followed have now been superbly analyzed in "The Sokal Affair and the History of Criticism" by John Guillory, a professor of English at NYU.

Guillory acknowledges that the self-identification of many humanistic scholars as "oppositional" plays a part in their acceptance

of radical and provocative statements about the social construction of reality, blinding them to the trap set by the "teasingly extreme anti-realism" (Guillory 494) propounded in Sokal's hoax article. But rather than viewing this as an expression of a widespread and dangerous anti-rationalist *Zeitgeist* "where we are very close to taking numerologists and distance-healers as seriously as molecular biologists and nuclear physicists" (Dahl 159), Guillory regards the relativism of humanists as a product of weakness and impotence. They are haunted by a nagging suspicion (that of a wider public if not their own) that their work might indeed be merely "impressionistic or purely subjective." This has attracted them to theoretical discourses that not only project a daunting aura of intellectual complexity and weightiness (protecting practitioners from the charge that they simply lack the discipline required by the "hard" sciences) but also allow them to undermine the privileged position of the sciences by accusing them of philosophical naiveté:

The elevation of social construction from methodological procedure to epistemological principle [...] empowers the humanities to contest the epistemic dominance of the sciences. From the summit of epistemology the critics can taunt the scientists, "You have the numbers, but we have the heights." (Guillory 497)

Or again:

Having failed to settle the epistemic status of criticism, which threatens always to fall to the level of mere opinion, the critics have embraced their abjection and turned it around into its opposite, into epistemic superiority. The division of the disciplines into sciences and humanities has been triumphantly reconceived as the distinction between *knowledge* and the *critique of knowledge.* (Guillory 505)

This is, however, a losing strategy. It provides little in the way of convincing arguments to counter attacks like Dahl's. It may be that the aggressive emphasis humanists place on critique springs from frustration with their own inability to "successfully explain to themselves and to others what kind of knowledge it is that they

produce," (Guillory 481) but it would probably be a better idea to try to overcome this handicap, difficult as that may be, than to try to make a virtue of it.

It should be noted that Guillory defines "the category of the humanities" as "comprising literary and cultural studies based on a methodology of interpretation" (Guillory 480 note 23). Dahl, similarly, notes the heterogeneity of the humanistic disciplines, but by presenting cultural studies as an emblematic trend within the humanities, he also underscores the centrality of interpretation. The basic idea of cultural studies can be said to be the extension of "the interpretive techniques of literary criticism to the social world" (Guillory 482); Antony Easthope, a leading proponent of cultural studies, similarly remarks that "the method of cultural studies" is "to extend 'the literary reading' to non-literary texts" (Easthope 178). The anti-realism attacked by Sokal and Dahl consists mainly in the claim that everything (including the sciences) ultimately depends on interpretation; interpretation can thus be "reconceived as an instrument for the skeptical critique of knowledge-claims" and "enlarged into a *holistic* principle governing all sites and modes of knowledge production" (Guillory 498). Such ambitious claims seem untenable in practice and leave the humanities at an impasse.

Of course, one could try to argue against the centrality of interpretation to the humanistic disciplines, but such arguments are unlikely to command wide assent. In recent years, a relatively small group of scholars have tried to advance the idea that the study of literature, film, and other arts should find a new framework drawn from the fields of cognitive science and evolutionary psychology. Tony Jackson, a not unsympathetic commentator, has suggested that such ideas have little chance of being other than minority pursuits if they have nothing to offer practical criticism:

If evolutionary psychology and cognitive science are really to matter in literary studies, then they will have to do more than say *what* literature is. In other words, if a theory does not produce much of interest in the way of practice, then however true the theory may be, it just will not make much difference to most literary scholars, who after all have a bottom-line concern with interpreting specific texts. (Jackson 338)

Jackson also mentions another widely shared misgiving about cognitive-evolutionary approaches; namely, that they are reductive, that they function in "a kind of rationalist cookie-cutter fashion" (Jackson 340). He quotes from a review by Sabine Gross of Mark Turner's cognitivist book *Reading Minds*, charging that the "imposition of cognitive discourse will in fact abolish or reduce the distinguishing features of literary discourse. In other words, tailoring the object of inquiry to the mode of inquiry entails refashioning the former in ways that fail to do it justice" (Gross 282, qtd. in Jackson 340). Only generalities are left, and the specifics of literature disappear from view:

Turner risks reducing literature to the lowest common denominator, to what *everyone* sees, knows, and reads in a text. [...] Turner's insistence on what is common and general in literature needs to be balanced by a consideration of what makes works of art specific and unique. His emphasis on quasi-scientific analysis favors what is predictable; literature is brought alive by what is baffling, provocative, unpredictable. (Gross 293)

As Gross sees it, part of the problem consists in a misguided urge to deck out the humanities with the trappings of "hard" science. In a sub-section entitled "The Scientific Fallacy", she argues:

Turner's approach raises the question of whether the emulation of scientific respectability sets the most fortunate or productive standard for the study of literature. Should literary criticism not be creative, imaginative, and, in lucky cases, brilliant, in order to bring out new meaning in literary texts? Can these accomplishments be measured according to a "right-or-wrong" model (which in itself represents a simplistic view of the process of scientific inquiry and hypothesis formation)? (Gross 286)

Very similar complaints have also been voiced in film studies. In a review of Torben Grodal's *Moving Pictures*, Eva Jørholt writes: "What becomes of the magic of art if the experience is described exclusively as neuronal mechanisms in the brain? [...] What about the artistic intentions of the creators and the cultural context within which the artwork has been created?" (Jørholt 114)

One of the most significant contributions to the debate on interpretation has come from film studies. David Bordwell's *Making Meaning*, by detailing the set of procedures customarily employed by academic film criticism, seeks to challenge the whole system of interpretation. He concludes by presenting what he calls "historical poetics" as an alternative to the activity of interpretive criticism. It is worth looking closely at the issues he brings up and the objections his book has provoked.

To Bordwell, viewing and making sense of a film inescapably involves the construction of meaning by the spectator. He identifies four different types of meaning: *referential* (fitting the elements of the plot together into a story, a fictional world), *explicit* (abstract meanings directly stated by the film), *implicit* (covert, symbolic; "themes"), and *symptomatic* (repressed, divulged "involuntarily"). The construction of the first two kinds of meaning Bordwell defines as "comprehension," while "interpretation" is the construction of the last two kinds of meaning (Bordwell, *Making Meaning* 8-9). Since, to some extent, interpretation is an inevitable activity, Bordwell does not advocate that it should be abandoned, but he does suggest that it should be displaced from the position of overwhelming dominance it is widely understood to have in the humanities in general and in the field of film studies in particular.

Bordwell's chief objection to interpretation, as typically practiced by academic critics, is that it has become a largely doctrinaire activity, ruled by theoretical assumptions that are imposed on artworks. Therefore, such interpretations tend to be predictable and unsurprising. Moreover, common critical practice is not based on systematical research; instead, critics examine a given artwork in order to find points of attack, specific details to which they can attach their pre-existing theoretical apparatus. In *Making Meaning*, Bordwell describes these procedures in considerable (and polemical) detail: focusing on beginnings, on scenes with mirrors, and on scenes with characters observing other characters, tend to be popular and frequently repeated analytical patterns.

Bordwell also raises the issue of knowledge. If one wants to dis-

cover what sort of knowledge academic criticism produces, he suggests that one should look at the questions criticism – more or less explicitly – seeks to answer:

First, how are particular films put together? Call this the problem of films' *composition*. Second, what *effects* and *functions* do particular films have? If criticism can be said to produce knowledge in anything like the sense applicable to the natural and the social sciences, these two questions might be the most reasonable point of departure.

How does the interpretive critic answer these questions? He presumes, I think, that the film's composition and effects are the vehicles of its implicit and/or symptomatic meanings. Such meanings determine the films' use of subject matter, ideas, structure, and style; they also govern the film's effects on spectators within social contexts. (Bordwell, *Making Meaning* 261-62)

To see how this operates in practice, one may find some illustrative examples in different analyses of Dreyer's work, and in particular, of *Ordet*. Carren Kaston's article "Faith, Love, and Art: The Metaphysical Triangle in *Ordet*," published in the lavish catalogue accompanying the Museum of Modern Art's complete Dreyer retrospective in 1988, is a case in point, a typical instance of the ascription of implicit meaning, not only to *Ordet*, but to Dreyer's total oeuvre:

From the hint of sorcery in his early film *The Parson's Widow* (1920) through the tormented saintliness of *The Passion of Joan of Arc* (1928), the interest in vampirism and witchcraft in *Vampire* (1932) and *Day of Wrath* (1943), the assured, embodied miracle of resurrection in *Ordet*, or *The Word* (1955), and the atheism of *Gertrud* (1964), Carl Theodor Dreyer kept asking: how does the spiritual fit in with life on earth? How is "ordinary" human life to accommodate the life of the spirit, without falling victim to the fanatical intolerance of witch-hunts or a repressive distortion of what it means to be human? [...] Dreyer explores the mystery surrounding characters who somehow cross back and forth between the spiritual and the material world. In many cases the meeting ground between the visible and the invisible world, the realm of matter and spirit, is love [...] (Kaston 67)

Kaston mainly builds this interpretation on the characters' statements and actions, i.e., dialogue and story, on some remarks made by Dreyer in interviews, and on the ideas of other critics. There is relatively little discussion of Dreyer's style, and even this is largely confined to comparisons with famous paintings, particularly those of Vermeer. Kaston reproduces and describes a still from *Ordet*, showing a scene relatively early in the film, with Inger (wearing a checkered apron) standing next to Old Borgen. Kaston remarks that "Edward Snow's magnificent evocation of a second Vermeer painting, *Young Woman Reading a Letter*, serves as a perfect gloss" on this still (75) and proceeds to quote this description of the Vermeer painting:

The letter, the map, the woman's pregnancy, the empty chair, the open box, the unseen window – all are reminders or natural emblems of absence, of the unseen, of other minds, wills, times, and places, of past and future, of birth and perhaps of death – in general, of a world that extends beyond the edges of the frame. [...] And yet it is the fullness and self-sufficiency of the present moment that Vermeer insists upon – with such conviction that its capacity to orient and contain is invested with metaphysical value. (Snow 6, qtd. in Kaston 75)

Kaston believes that "there could hardly be a better description of the sense of life made manifest in Dreyer's *Ordet*," and continues: "Dreyer's overriding similarities to Vermeer in *Ordet* rest precisely on this imperative to make his medium a vehicle for recording both everyday outwardness and its immanent spiritual essence" (76). It is evident that the images are described and understood in terms of thematic content: for Kaston, they are vehicles of implicit meaning.

As an example of a symptomatic reading, Mark Nash's 1977 book *Dreyer* is an useful choice, because it is explicitly symptomatic in its approach. It refers to the films directed by Dreyer as "the Dreyer-text" and concludes that this "Dreyer-text can be characterised as a type of hysterical discourse" on a number of levels, including that of style:

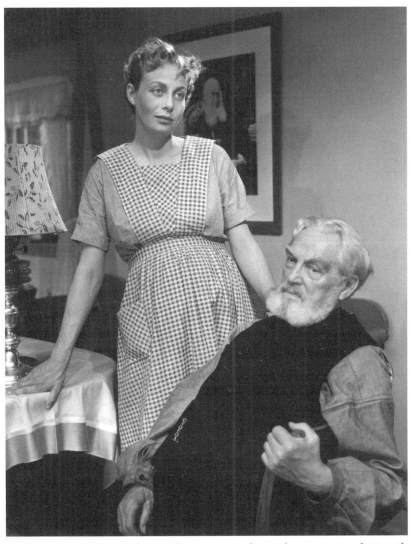

Still from Dreyer's Ordet, with Birgitte Federspiel as Inger and Henrik Malberg as Old Borgen. This is the still discussed by Carren Kaston; note also the checkered apron, discussed by Mark Nash. (DFI Archive Collections, ©Palladium A/S)

Those qualities of immobility and abstraction often referred to as hallmarks of Dreyer's style, become, in this reading, symptoms which form part of the hysterical discourse, a kind of hysterical paralysis at the level of the *mise-en-scène*, a fictionalising pressure working through the diege-

sis pushing towards a resolution of the problems represented, against a counter-pressure tending to fixity, immobility. In *Gertrud* this vectoral balance may be said to be represented by the scenic tableaus. In *Ordet*, the economy is slightly different; a series of moving shots link the scenes, marking a process of exchange between town, church, farm and country, with these scenes as it were compensating for that mobility by their own immobility, with 270 degree pans, markedly more centered on the camera's axis. (Nash 30)

Nash employs many of the interpretive moves Bordwell discusses; in fact, he cites Nash's book to exemplify what he calls the "punning heuristic", using word-play to reveal hidden meanings:

[Nash] proposes that Dreyer's films often contain a motif of bars, a signifier of repression which appears in *Ordet* as a checkered pattern in Inger's dress and on her tablecloth; this signifies "a potentially productive female body precisely 'in check.'" Quotation marks and the use of the word *literally* are clear marks of the punning maneuver. (Bordwell, *Making Meaning* 139, quoting Nash 13)

There is in this description an evident touch of sarcasm, and Bordwell makes clear that the punning heuristic is one of the interpretive conventions he finds "forced and unproductive" (Bordwell, *Making Meaning* 258).

Another procedure is exemplified by an article included as an appendix to Nash's book, Frieda Grafe's "Spiritual Men and Natural Women" (originally published as "Geistliche Herren und natürliche Damen"). It is the deployment of pairs of opposites, doublets: the critic takes a pair of concepts in some relation of opposition; aspects of the film are then associated with each of the opposed concepts, which can then in turn be linked with other doublets on a more abstract level. The very title of Grafe's essay links two doublets, male/female and spiritual/natural (since "geistlich" in German also means "clerical", the latter doublet could also be rendered as Christianity/nature). These two doublets are then in turn connected with interior/exterior, evoking a common figure in Dreyer criticism, even if the movement usually goes from concrete to abstract, as Bordwell has noted: "the critic often moves

from referential oppositions to implicit or symptomatic ones. In discussing *Day of Wrath*, Jean Sémoulé tallies the diegetic doublet nature/exteriors with life/death and freedom/confinement" (Bordwell, *Making Meaning* 119).The first pair is surely a misprint for nature/*interiors*; in his 1962 book on Dreyer, Sémoulé does indeed contrast the somber, gloomy interiors to the sensual outdoor imagery and link this opposition to more abstract concepts. He writes: "Throughout the film, nature, release and life are opposed to closed interiors, petrification and death" (Sémoulé 99).

Interestingly, we can find another commentator, Robert Warshow, who also takes up the outdoors/indoors doublet, but he links it with very different abstract terms in his article on *Day of Wrath* (written in 1948, when it was first released in the United States). Warshow remarks on the pattern of leaves appearing on Anne's face when she bewitches Martin and the many images of trees associated with the illicit lovers' trysts: "In general, there is an attempt to equate the outdoors, the world of nature, with evil (the pastor's mother, who is the one firm moral pillar, is never seen outside the rigidly ordered household she controls)" (Warshow 266).

This passage is quoted in a stimulating recent paper by Gilberto Perez, where he speaks of such linkages of surface features of films with more abstract ideas as "rhetorics"; he calls the identification of nature with good the "romantic rhetoric," with evil, the "religious rhetoric":

Warshow takes Dreyer to be espousing the religious rhetoric, but it seems to me he's doing something more complex and sophisticated. He's assuming that in our time we would all tend to espouse the romantic rhetoric, the identification of nature with good, and he's countering that ideology with a religious rhetoric that he knows we will resist – who among us can readily accept the identification of nature with evil? – so as to make us aware that, whether the romantic or the religious, either way we are yielding to the sway of rhetoric, either way we are falling under the spell of ideology. (Perez paragraph 5)

This is very ingenious, and I think there is much to be said for Perez's suggestion that Dreyer seeks to avoid condemning any of the parties in the moral struggles found in many of his films: while

he does not agree with the witch-burning priests, he does not make them out to be evil, and he tries to give the spectator a sense of the belief system that convinces them that their terrible deeds are righteous and necessary. Nonetheless, the three different interpretations of *Day of Wrath* are also testimony to the flexibility of the use of doublets: nature can be taken to stand for either good or evil or both at once.

Meaning: Made – or Made Up?

Bordwell is playing a dangerous game. In demonstrating that criticism to a considerable extent relies on predetermined routines and that interpretations need have only a loose connection to what actually appears on the screen, he risks picturing film study as an activity closer to an esoteric parlor game than a scholarly pursuit. The film historian David Cook comments: "My first thought on reading *Making Meaning* was how to prevent the book from falling into the hands of my Dean, since it suggests the essential uselessness of everything Film Studies has accomplished in the last thirty years" (Cook 31).

It is clear that Bordwell is no friend of grand theorizing or of interpretations which claim to "apply" theoretical doctrines. Cook's misgivings, however, do not appear to be motivated by irritation with Bordwell's attacks on what he has sarcastically called SLAB theory (for Saussure-Lacan-Althusser-Barthes) in his article "Historical Poetics of the Cinema." Instead, Cook is troubled by the way Bordwell seems to say that any interpretation is a fabrication. In some detail, Cook describes some of the implicit meanings of Paradzhanov's *Shadows of Forgotten Ancestors* and the Uzbek film *The Shock* (1989) in order to show that the films really must be explicated in this way to be properly understood: "I have offered these rather lengthy accounts [...] to demonstrate that films can demand scholarly interpretation for reasons both textual and contextual, and that in neither case need meaning be fabricated or imposed" (Cook 37).

That Bordwell should appear to be claiming that meanings are fabricated or imposed is a consequence of his constructivism.

Bordwell's constructivism in many ways goes quite far. He suggests that in a traditional understanding of how interpretation proceeds, the "artwork or text is taken to be a container into which the artist has stuffed meanings for the perceiver to pull out. Alternatively, an archaeological analogy treats the text as having strata, with layers or deposits of meaning that must be excavated" (Bordwell, *Making Meaning* 2). Bordwell firmly rejects these conceptions:

[*Making Meaning*] argues that films do not harbor meanings "inside" or "behind" them; how could they? Interpretation is an interaction of critic and film. What the critic brings to this engagement is human perceptual equipment, cultural experience and values, tacit norms of comprehension, and a repertory of knowledge structures and critical procedures for building an interpretation out of cues which she or he discriminates in the film. We don't just see meanings, literal or interpretive; the critic *constructs* meaning through a complex process of assumption, testing, projection, inferential trial and error, and comparable activities. Both comprehension and interpretation are inferential activities. Meaning is made, not found. (Bordwell, "Film Interpretation Revisited" 103)

Before we address Cook's complaint that this implies a dismissal of film interpretation as worthless, it is worth examining the objections to Bordwell's stance raised by certain analytical philosophers of the cinema.

Berys Gaut has written a critical article about Bordwell's work, entitled "Making Sense of Films: Neoformalism and its Limits." Gregory Currie concurs with Gaut's objections: while Currie quotes with approval Bordwell's remark, "Contemporary interpretation-centered criticism [...] has become boring," he then goes on to note: "Not that I agree with Bordwell's own theoretical recommendations," directing the reader to Gaut's article (Currie 44, 57 note 3, quoting Bordwell, *Making Meaning* 261). Gaut accepts Bordwell's assertion that perception to a considerable extent works through constructive processes; for instance, the perception of apparent motion when watching films, or the perception of the environment in three dimensions. But Gaut does not accept what he takes to be Bordwell's conclusion: "The existence of conceptual construction in respect of perception and the mind's activities in

general gives no grounds for thinking that the objects of perception or meanings are constructs" (Gaut 14).

Here, Gaut conflates two things. Nowhere does Bordwell claim that the "objects of perception," the stuff in the real world, are constructs. The film as a strip of celluloid, as a series of photographic images, clearly has an independent existence. On the other hand, as the quote above makes clear, Bordwell certainly maintains that only the constructive mental activity of a spectator can join those images together to become a story. A good example is the well-known distinction between *syuzhet* and *fabula*, which Bordwell has taken from the Russian formalists and which has an important place in his theory of narrative. The *syuzhet*, the set of narrative elements as they appear in the film, provides the material for the construction of the *fabula*, the chronological reconstruction of the course of the narrative. To take a simple example: in *Ordet*, when Old Borgen finds out that Peter, the tailor, won't allow his daughter to marry the youngest of Borgen's sons, he decides to visit him. We see Borgen get into his overcoat and go out the door with his son; then we see the two of them driving a wagon along the road; then, a prayer-meeting at Peter's house; after a little while, the doorbell rings, and Borgen comes in. We do not see the horses hitched or Borgen either getting on or off the wagon; we simply assume that he has done so.

Gaut will not accept that this constructive process can be used to demonstrate that viewers make the meanings of films: "Certainly, film spectators ought to imagine things which they do not actually see on the screen: but it does not follow that *they* determine what they ought to imagine" (16). Gaut wants to keep in place the idea of the artwork as a container, or as he calls it, a "detectivist" view of interpretation, which he defines as "the view that the meaning of the film is there to be found, i.e. that it is determined independently of the viewer's opinion about it" (9). While he allows that understanding films involves an exercise of the imagination, Gaut insists that this imaginative activity is constrained and directed, and the spectator therefore cannot be said to make meaning: "the question of whether meaning is made by the audience is a question about whether they play any role in determining what they *ought* to imagine" (16).

The idea that there is something the spectator "ought" to imagine is Gaut's. In his view, there must be some way in which meanings are *determined*, some way to determine which meanings are correct. He doesn't like the wild interpretations of SLAB-theory-inspired writers any more than Bordwell does, but he believes that they can be dismissed as incorrect. Thus, Gaut refers to Mark Nash's pun that Inger's checkered dress shows her to be "held in check"; to Gaut this is simply a wrong interpretation because *Ordet* is a Danish film, and the pun does not work in Danish (18).

Even so, while I find Nash's ideas rather far-fetched, I do believe that we cannot dismiss as simply wrong the suggestion that the checkered dress and tablecloth is meant to evoke crisscrossed prison bars and accordingly indicate that Inger the pregnant housewife is, so to speak, imprisoned by the patriarchal Christian household she lives in, even if the pun doesn't work in Danish. I also think the previously-discussed example of the meaning of nature in *Day of Wrath* demonstrates that there is often no obvious way to decide whether particular interpretations are right or wrong, even where it is possible to choose between two diametrically opposed explications.

To Gaut, the only alternative to a detectivist view, where meanings are determined independently of the spectator, is a relativist one, where meanings are entirely determined by the spectator. Accordingly, Gaut compares Bordwell to Stanley Fish and claims that he subscribes to "critical school constructivism" which Gaut defines as "the doctrine that if members of a qualified critical school, acting within the norms of that school, interpret the film as having a certain meaning, then the film has that meaning" (Gaut 17). This is an absurd caricature of Bordwell's views. The whole point of Bordwell's book is that films do not *have* meanings; meanings are not properties of films in an ontological sense. The story of a film, for instance, does not exist independently of the spectator who constructs the *fabula*. This does not mean that Bordwell believes that the construction proceeds in an arbitrary fashion; in fact, many inferential activities occur automatically as a consequence of the way the human mind works.

On the other hand, it is part of Bordwell's argument that the critical institution does decide what counts as an acceptable inter-

pretation. Note that this is very different from what Gaut claims him to be saying; Bordwell does not argue that the critical institution can decide what the properties of a film *are*, only that it can decide what sort of things it is OK to say about them. It is, however, precisely this aspect of Bordwell's constructivism that worries Cook and others so much. The problem is that the descriptions we get of the operations of the critical institution show that it is quite tolerant of procedures that are "impervious to counterexamples" and "self-fulfilling" (Bordwell, *Making Meaning* 251, 60), and that it sanctions readings of films that largely derive from preestablished doctrines rather than any detailed investigation. This could certainly be taken as evidence of dereliction of duty on the part of the community of film critics, having failed to uphold standards of inquiry appropriate to scholars. No wonder Cook is worried about the reaction of his dean.

Historical Poetics

Bordwell asserts that film interpretation has turned "into a new scholasticism, complete with a canon (Hollywood and some venerated oppositional works), received truths (Theory), highly regulated interpretive moves, and guaranteed points of arrival. Underlying all these features is an appeal to authority" (Bordwell, *Making Meaning* 262). As an alternative, Bordwell proposes that film scholars should shift their attention from meanings to the surfaces of films, to form and style. He refers to this project as "historical poetics" and asserts that in contrast to the scholasticism of film interpretation, it "frankly offers *scholarship*" (Bordwell, "Historical Poetics" 391).

By examining the formal and stylistic features, not only of single films, but of larger groups of them, historical poetics seeks to describe the range of devices available to filmmakers at particular historical junctures: "A historical poetics will thus often be concerned to reconstruct the options facing a filmmaker at a given historical juncture, assuming that the film-maker chooses an option in order to achieve some end" (Bordwell, "Historical Poetics" 372-73). More generally, the central point of historical poetics is that

what is most interesting about films must be something inherently related to the fact that they are films.

This is less obvious than it seems. To many critics, the interpretation of films is a way to engage with other issues. In a review of *Making Meaning*, Geoffrey Nowell-Smith made this point: "Like it or not, criticism is an engagement with the world. Films do not exist in a universe in which there are only films, and knowledges do not exist in a universe in which there is only one kind of knowledge" (296). To complain that film criticism is doctrine-driven is to overlook that the critic may be more concerned to explore the implications of a particular doctrine than to say something about a film: "The extraneous element – the psychoanalysis, the feminism, the Marxism, the Catholicism – may be more important to the critic, and the critic's readers, in their engagement with the world than the film which is the ostensible object of criticism" (296). Where Nowell-Smith concludes that "film study is only partly about films, and equally, if not more, about the worlds in which they circulate" (297), Bordwell would insist that film study should be more about films.

This stance resembles that of the Russian formalists, with their concern with the specifically *literary*, that particular linguistic property which makes literature literature and separates it from texts of other kinds. Indeed, the link is made explicit when Bordwell and Kristin Thompson refer to their brand of historical poetics as neo-formalism. Bordwell and Thompson have taken some of their conceptual tools from the Russian formalists. The Russian formalists, for instance, believed that over time, the devices used to give a text a poetic, literary character are dulled and lose their power; then artists must make them stand out, "roughen" them, to restore their poetic force. This creation of texture they called *ostranenie*, making-strange or "defamiliarization," and this concept is frequently used in neoformalist analysis.

In passing, it is worth pointing out that Bordwell is at some pains to distinguish interpretation from analysis:

There is a principled difference between pointing out pertinent relations of parts and wholes (analysis) and positing abstract meanings (interpretation). You can analyze composition and color in a painting, melodic mo-

tifs and harmonic texture in a musical piece, prosody and plot in litera-
ture, and so on. [...] If you show patterns in the spatial relations of shots
across a sequence, you are producing an analysis. You may make the
interpretive move of ascribing an abstract meaning to the patterns you
disclose, but you could also stay at the analytical level, perhaps by discus-
sion of denotative and diegetic functions which these patterns perform.
(Bordwell, "Film Interpretation Revisited" 97)

In making this distinction, Bordwell follows the lead of Monroe
Beardsley, who writes: "Critical descriptions are of all levels of
precision and specificity, but they are most helpful when they dis-
criminate and articulate details, and thus give us an insight into the
inner nature of the object. Such a description is called an analysis"
(Beardsley 75). The emphasis on description shows, again, Bord-
well's concern to encourage film scholars to pay more attention to
the formal and stylistic features of artworks.

Many critics have been dissatisfied with Bordwell's proposals.
They regard the detailed study of style, form, and cinematic de-
vices as an arid and dreary pursuit. The emphasis on norms, in par-
ticular, has led to accusations that the unique qualities of particu-
lar films are drowned out. Thus, in an introductory collection of
film-theoretical texts, *The Film Studies Reader* (Hollows, *et al.*),
there is a section devoted to historical poetics. In the introduction
to this section, the editors acknowledge the "detailed historical
scholarship" (159) displayed by Bordwell and his colleagues, espe-
cially in *The Classical Hollywood Cinema* which they not unfair-
ly single out as the most prominent example of the approach. On
the other hand, they worry that one consequence of historical
poetics would seem to be "that the similarities between, say, *The
Crowd*, *The Band Wagon* and *Touch of Evil* overwhelm their more
distinctive qualities" (157, quoting Jenkins 104). They go on to say
that "there is something very unsettling about a *historical* account
of cinema which suggests that nothing fundamental has changed in
80 out of 100 years of cinema" (158).

This is a misleading complaint, however. The concept of a clas-
sical Hollywood cinema has been extremely influential, and the
book's description of it has been embraced even by film scholars
with completely divergent theoretical views (for just one example,

firmly based in SLAB theory, see Judith Mayne's *Cinema and Spectatorship*). Moreover, the stylistic analysis is quite subtle and takes into account the smaller variations within the overall norm. Bordwell's recent article "Intensified Continuity," which explores the style of recent Hollywood film, is a good example. It identifies four important devices that distinguish contemporary Hollywood filmmaking while remaining within the Classical norm and allows Bordwell to make observations like the following: "A late silent film like *Beggars of Life* (1928) looks much like today's movies: rapid cutting, dialogue played in tight singles, free-ranging camera movement" (Bordwell, "Intensified Continuity" 21). This is nothing if not historically informed.

Related to the objection that historical poetics erases the differences between films is the charge that it is somehow blind to what films are really "about"; that because of its focus on style, it loses sight of the stories, the themes, the emotional and intellectual content that made us care about movies in the first place. Historical poetics, on this account, takes the heart out of film studies. David Cook is particularly scathing:

To turn "against interpretation" – to reject the entire concept of an expansive and meaningful world cinema for the insular security of a narrow formalism – *that* would truly be the commission of professional suicide, worse, even, than reporting to our deans that most academic film criticism is worthless and that we ourselves are expendable. (Cook 37)

This is a powerful objection, but I am not convinced that historical poetics seeks or provides "the insular security of a narrow formalism"; hopefully, the following extended example will bear this out.

Impoverishing Ordet?

Ira Bhaskar's article "'Historical Poetics,' Narrative, and Interpretation" appears in the anthology volume *Blackwell's Companion to Film Theory*, but while most of the other essays are introductions to theoretical positions written by proponents, this one is as much a critique as a presentation.

To demonstrate the inadequacies of historical poetics, Bhaskar takes as his central example the analysis of Dreyer's *Ordet* in Bordwell's book *The Films of Carl-Theodor Dreyer*.[2] Bhaskar writes that "while Bordwell presents [*Ordet*] as intriguing and challenging through an analysis of its style, his reading is inadequate and impoverished because he refuses to encounter its themes or to see the embodiment of the content in the form" (400). What Bordwell is concerned with in his book is, first and foremost, to present a very detailed analysis of Dreyer's use of particular cinematic devices, of his use of camera movement, image composition, as well as his use of narrative structure.

Bordwell stresses how Dreyer's technique, particularly in the later pictures, very deliberately distances itself from the classical Hollywood norm. Also, unlike the stories of Hollywood films, which are driven by the goals and actions of characters, Dreyer's narratives are said to be driven by absent, impersonal causes. Set against the classical norm, Dreyer's way of doing things is "defamiliarizing." Raymond Carney, whose book on Dreyer provides the basis of some of Bhaskar's points, is particularly unhappy with the concept of defamiliarization. By emphasizing it, Bordwell turns the function of style into something purely negative, nothing but the negation of the classical norm, and this, Carney claims, represents "an utter trivialization of the possibilities of artistic expression" (48).

First of all, it is worth noting that Bordwell's critics simply do not pay attention to what is on the screen the way Bordwell does. A striking example occurs in the course of Carney's discussion of the way the actors express themselves through practical and social activity: "Except for his moving camera [...], Dreyer does not feel the need to intervene to supplement [the actors'] practical expressions with visual and acoustic effects. He lets the social expressions of his actors stand on their own more than in his other work, and indulges in *almost no special lighting effects*" (Carney 184, italics added). It is rather surprising that Carney has missed the extraordinary care with which the film has been lit. In his Dreyer book, Bordwell quotes the following passage from an interview with Henning Bendtsen, the cinematographer:

Dreyer's basic rule was to arrange people for the sake of photography and lighting rather than acting. Normally you work with a much simpler lighting plot in which the actors are not tied to a specific area because they must have the opportunity to act freely. In *Ordet,* their positions were so carefully planned that they had to count their steps at the same time as they said their lines. A single step too much to one side or the other would mean that we would miss a certain predetermined light effect and the scene would have to be reshot. [...] Another of the lighting effects of the film created almost insoluble problems. While Johannes is insane, he is walking around in darkness all the time, whereas all the other characters have light on their faces. (Qtd. in Bordwell, *Dreyer* 224-25)[3]

The shortcomings of Carney's consideration of visual style do not, however, necessarily invalidate his objections to an exclusive concentration on such matters.

Close attention to camera movement, narrative causality, and the like does tend to produce a somewhat technical and distanced attitude which may seem cold to some and which keeps the emotional impact of a film like *Ordet* somewhat at arm's length. This is a serious drawback, because when people go "silent and rapt" from the film (which was Dreyer's declared objective, according to his remarks in the screenplay (Dreyer, "Ordet" 107)) it seems unlikely that this is because he has defamiliarized their conception of camera movement.

To Bhaskar, Bordwell's formalism is particularly vexing because he believes that it occludes the ideological dimension of the film, an ideological dimension produced by the fact that the Christian religion plays a central role in *Ordet,* and religion is something essentially ideological. By saying, as Bordwell does, that Dreyer is un-ideological and first and foremost interested in formal devices, this whole dimension of the film is somehow suppressed, hidden from view. It is not that Bordwell denies the centrality of Christianity to *Ordet* – quite the opposite. He writes, for instance, that "virtually every gesture in the film is freighted with Christian significance" (Bordwell, *Dreyer* 146). But he insists that it plays a subordinate role relative to Dreyer's overriding formal concerns:

All of which is to say that in *Ordet* narrative principles characteristic of Dreyer's work are transposed into their most explicit forms. The absent and impersonal cause is now brusquely collapsed into God. [...] It is not that Dreyer is "a religious director" and has found in *Ordet* the perfect narrative. Just the opposite: Dreyer's typical narrative unity finds in *Ordet* its most thoroughgoing justification – religion. Christianity becomes Dreyer's most overpowering formal device. (Bordwell, *Dreyer* 146-47)

This passage, in Bhaskar's view, epitomizes Bordwell's blindness to "the thematic and philosophical significance" of the formal and stylistic choices made by Dreyer, the way the director seeks out forms that will "convey the range of meanings his themes *demand*" (403, italics added). Bhaskar maintains that the composition and effects of the film are vehicles of its meaning:

The limitations of Bordwell's approach to *Ordet* become obvious in that he misses completely the contemporary significance of Dreyer's concerns because of the anachronistic form of the medieval miracle play within which Dreyer embeds his realistic narrative. [...] Christianity is not just a formal device in *Ordet*, but rather the very fabric and texture of the social and cultural life Dreyer wishes to explore, as well as what is endangered in the pervasive and destructive disbelief of the contemporary moment. In retelling an old story in a modern context, in using an older form (the miracle-mystery play) to structure the meaning of a modern experience, he not only demonstrates the generic continuity of cultural experience, but also expresses a collective wish for resurrection from the despair of doubt into which modernity has plunged Western culture. (401)

Here, Bhaskar asserts that there is an evident implicit meaning in the way Dreyer deploys his Christian themes: Dreyer is critical of modernity, and the loss of faith in the modern world is deplorable. As evidence for this, Bhaskar refers to Dreyer's use of the medieval mystery play.

However, Dreyer is not "retelling an old story" or "using an older form." The film is an adaptation of a modern play, written by Kaj Munk in 1932. I do not know where Bhaskar got the idea that *Ordet* draws on medieval miracle plays, and I have found no evidence that either Dreyer or Munk drew on them. It is clear from

Munk's writings on the theater that he desired above all to be modern and in tune with his times, to write grand drama befitting a world utterly changed by the slaughter of the Great War. He wrote in 1928:

A young generation has grown up that does not go to the theater to sit there in a nice and proper way and watch nice and proper things; its appetite for life is much too ferocious to be fed on biscuits and teacup dramas whose writers have visibly been scared stiff that something should happen on stage. Its eyes have seen too much of the red mist of reality to be taken in by long-drawn-out psychological portraiture and delicate shading. Better the movies; there, something at least happens; there is fighting and fleeing, cheating and forgiving, kissing and killing; they are a reflection of life, life not contrived in the overwrought brain of an anaemic poet, but created by God's own contradiction-blazing will, the life of the world in which this young generation has grown up, where nation stood arrayed against nation with their existence at stake, where necessity knew no law, and good and evil was no more, because everyone thought only of himself and was himself God, while heads rolled and limbs were shattered and brains burst, and peace came with labor struggles and fraud and intoxication and poverty and pestilence. (Munk, "Omkring 'En Idealist's Urpremiere" 221)[4]

The link to the medieval plays is difficult to see. Of course, *Ordet* may seem rather far removed from the violence of this passage. It is, however, a drama about faith in an age of doubt, and that was a burning issue, not only for Munk, who was a pastor as well as a playwright, but for many others as well.

The dramatists that were most evidently inspired by the medieval theater, figures like Maeterlinck and Hofmannsthal, belong to a previous generation with very different concerns. In fact, if one looks a little more closely at what the medieval miracle plays were, the difference from Munk's work becomes even more striking. In the *Encyclopedia Britannica*, a miracle play is said to be a medieval vernacular drama that "presents a real or fictitious account of the life, miracles, or martyrdom of a saint," usually St. Nicholas or the Virgin Mary (s.v. "miracle play").[5]

The only link, in fact, between *Ordet* and the medieval drama is

the miracle itself. It bears little relation to the miracles of the medieval theater, but is of course still a central issue in all discussions of Dreyer's film.

Debating the Miracle

The Danish premiere of the film gave rise to a great deal of debate, much of it focused on the miracle. The well-known writer Knud Sønderby published a newspaper essay on *Ordet* a month after the premiere, where he sharply criticized Dreyer and accused him of having "castrated" Kaj Munk's play (Sønderby, "Dreyers *Ordet*"). A key isssue for Sønderby was the fact that Dreyer had eliminated a line of dialogue which occurs just after Inger wakes up. The doctor (who is present at Inger's bier) says: "The *ligsynsmand* system must be abolished." Literally translated, a *ligsynsmand* is a 'corpse inspector'; in Denmark, this was a locally appointed layman who inspected dead bodies, ascertained that signs of death were indeed present, and signed death certificates. Because these people were not trained professionals, there was considerable worry (particularly among doctors) that they might overlook signs of life in people in deep coma, people only apparently dead.

Knud Sønderby characterized the *ligsynsmand* line as the "rational safety valve in the play," leaving open the possibility that Inger was not really dead, but only in a deep coma, and that at the end of the play, she just wakes up: there is no miraculous resurrection. Sønderby clearly believed this to be the right way to understand the play; he stated flat out his conviction that Inger is only "apparently dead – I am expressly saying apparently dead." In Sønderby's view, Dreyer had closed off this rational safety valve by taking out the line, forcing the spectators to accept the miracle as real.

Uncharacteristically for Dreyer, he chose to reply the very next day with a letter to the editor where he rejected Sønderby's interpretation, citing a biography of Munk written by Hans Brix, who was a professor of literature and had been artistic consultant at the Royal Theater in the 1920s; in that capacity, he had come to know Munk well. It was Brix who prompted Munk to write *Ordet* by suggesting that he should write a play about the peasantry; Brix

saw the various drafts and struggled unsuccessfully to get the play performed at the Royal Theater, and the published play is dedicated to him. In his book, Brix refers to an early draft of the play which does not appear to survive, but which he would certainly have seen. He mentions it in connection with another play written by Munk, *En Almanakhistorie* ("A Penny Novelette"), which was a sequel to *Ordet* (it has never been performed): a young woman from Borgensgaard is seduced by a villainous artist, has an abortion and is plunged into despair, but at the end, the gates of Heaven open up and God appears to offer salvation. Brix comments:

Munk thought to teach those reviewers a lesson who, when *Ordet* was performed, wanted to discover in the doctor's declaration [...] a reservation on part of the author with respect to the miracle of the reawakening which is the meaning and core of the play. In the oldest form of the play the relevant remark by the doctor does not exist at all. (Brix 154)[6]

Dreyer drew directly on Brix for his letter. When the idea of the doctor's remark as a rational safety valve was proposed by reviewers, Dreyer wrote,

the author protested against this explication and asserted that *"the miracle" was precisely the meaning and core of the play*. To Kaj Munk, Inger was not apparently dead, and the doctor's line was not a back door through which the author could escape if he came under fire because of the "prodigy."
 [...] Also, Professor Brix supplied the interesting information that the doctor's line was not found at all in the oldest version of the play. For this reason and because Kaj Munk had so plainly made known what "the meaning and core of the play" was, I left the doctor's line out in the film.
 (Dreyer, "En instruktør overflødig")

Brix also wrote a response to Sønderby's essay. He takes the line to be simply an expression of the inveterate agnosticism of the doctor: even when confronted with a genuine miracle, an act of God, he refuses to believe.
 Still, the weight attached to the line by several reviewers suggests that it was given considerable emphasis in the original stage

production of *Ordet*. Moreover, Munk wrote a treatment for a film version of *Ordet* in 1931, before the play was first performed; and this treatment not only gives some weight to the line, it also includes an entire scene showing two not particularly competent-seeming *ligsynsmænd* inspecting the body and signing the death certificate.

This does not mean, however, that Dreyer was incorrect in believing that Munk meant the miracle to be real. The literary historian F. Billeskov Jansen has plausibly suggested that the reason Munk might have wanted to provide an escape hatch was to force the spectator to choose between a rational and a miraculous explanation, so that the choice to believe, to have faith, becomes an explicit one.

The doctor's remark aside, Munk was quite explicit about his view of the crucial importance of miracles for the Christian faith. Partly in response to the debate that followed in the press after the opening of *Ordet* (the play) on 2 September 1932, Munk wrote an essay, "About the Miracle," which appeared a couple of weeks later. He stated forthrightly: "Belief in God is belief in miracles. Only by breaking the laws of nature can God get in touch with a human being. To believe in God is to be right in the middle of that wonderful domain where not only God's laws work, but also God's hand" (Munk, "Om Miraklet" 31).[7]

Natural Explanations

Dreyer presented himself as a faithful adaptor of Munk, being rather careful to ascribe the Christian ideas to Munk. The copies of the screenplay that were used during the making of the film contained an afterword by Dreyer, which was not included in the published edition of the screenplay. Here, Dreyer explained to his cast and crew:

The purpose of the film must be to make the audience quietly accept the author's premise – as it is expressed in the last section of the film – namely, that he whose faith is strong enough also holds the power to work miracles. The audience must be slowly prepared with this purpose in mind,

they must be put in a religious mood, must be enmeshed in an atmo-
sphere of religious mysticism. To make them receptive to the miracle they
must be placed in that peculiar mood of sorrow and melancholy in which
people find themselves when they attend a funeral. Once they have been
brought to this condition of reverence and introspection, they more
easily let themselves be induced to believe in the miracle – for the sole rea-
son that they – being forced to think about death are also led to think
about their own death – and therefore (unconsciously) hope for a miracle
and therefore shut off their normally skeptical attitude. The audience
must be made to forget that they are watching a film and induced or, if
you will, hypnotized to believe they are witnessing an act of the divine,
so that they go away silent and rapt. (Dreyer, "Ordet" 107)[8]

With this description of his goals, however, Dreyer placed himself
at a considerable distance from Munk, and this reveals itself in sev-
eral ways. The play was explicitly written as a response to
Bjørnstjerne Bjørnson's 1890s play *Over Evne*.[9] It is about a
preacher whose "nervous intensity" is so great that he is able to
perform miraculous cures, but Bjørnson makes clear that this is
brought about through a sort of parapsychic effect, certainly
something natural, produced by the man's high-strung tempera-
ment and having nothing to do with God. Making precisely this
kind of natural explanation for miracles was completely unaccept-
able to Munk. The whole point of his play is that faith deals with
what science *cannot* explain, the exception that does not adhere to
the laws of nature:

The believer also knows of these laws; furthermore, he believes that God
wrote them, and through his boundless admiration for the force and wis-
dom of these laws, he thus venerates God. But the God who wrote them
and who is behind them is then likewise also above them. Who would
forbid the watchmaker to touch the big hand with his fingertip? (Munk,
"Om Miraklet" 29)[10]

And that is what happens in *Ordet*.

But the passage from Dreyer's screenplay afterword shows that
he has missed Munk's central point. Dreyer explains that the
power to work miracles depends on the intensity of faith of the be-

liever, but little Maren is not particularly fervent, nor is Johannes after his madness leaves him. They simply do not doubt that God has the power to cause the miracle, and therefore He makes it happen. But note that for Munk, it is *God*, not Maren or Johannes or anyone else, who causes the miracle. Dreyer, on the other hand, told an Italian interviewer that "the important thing is not to believe in supernatural forces but in one's self. Johannes's strength is the strength of faith. Since Johannes believes he is able to perform a miracle, the miracle happens" (qtd. in Gallagher note 5).[11] To a Danish interviewer, he gave a somewhat divergent explanation when asked whether the miracle was brought about by Johannes's crazed intensity: "No, by the firm faith of the child, the little girl. Johannes is the medium, but the child is the power. It is by holding her hand that he gains the power to speak the word" (Dreyer, "I dag ved vi alle, at der er mirakler til" 10). In either case, however, the miraculous powers reside in the human characters.

Not only did Dreyer assign the wonder-working power to his human characters; he turned to precisely the sort of pseudoscientific "natural" explanation that Munk had wished to reject decisively with his play. In a radio interview from September 1954, when the film was still in production, Dreyer explained that he first saw the play at its opening in 1932 and immediately wanted to make it into a film, but was only able to do so more than twenty years later:

Then I saw Kaj Munk's ideas in a different light. For so much had happened in the meantime. The new science that followed Einstein's theory of relativity had supplied [evidence] that outside the three-dimensional world which we can grasp with our senses, there is a fourth dimension – the dimension of time – as well as a fifth dimension – the dimension of the psychic, that proves that it is possible to *live* events that have not yet happened. New perspectives are opened up, which make one realize an intimate connection between exact science and intuitive religion. The new science approaches us [sic] towards a more intimate understanding of the divine power, and is even beginning to give us a natural explanation to things of the supernatural. (Dreyer, "Metaphysic of *Ordet*" 24)[12]

In a report on the 1955 Venice Film Festival, where *Ordet* won the Golden Lion, Guido Aristarco spoke uncomplimentarily of Dreyer's "relentless Protestant nature" and criticized him for "rejecting science for the miracles of religion" (23). Dreyer responded with a letter entitled "Metaphysic of *Ordet*," where he quoted the radio interview above and concluded:

As will be seen from the above, I have not rejected modern science for the miracle of religion. On the contrary, Kai [*sic*] Munk's play assumed new and added significance for me, because the paradoxical thoughts and ideas expressed in the play have been proved by recent psychic research, represented by pioneers like Rhine, Ouspensky, Dunne, Aldous Huxley, etc., whose theories in the simplest manner explained the seemingly inexplicable happenings of the play, and established a natural cohesion behind the supernatural occurrences that are found in the film. (Dreyer, "Metaphysic of *Ordet*" 24)

Dreyer was quite knowledgeable about psychic research, and the four names he refers to were all prominent figures in the field of parapsychology in the first half of the twentieth century. In fact, the term "parapsychology" was invented by Joseph Banks Rhine (1895-1980) to describe his field of research. Rhine, who had his own laboratory at Duke University, also invented the terms "ESP" (Extra-Sensory Perception), and "PK" (Psycho-Kinesis), as well as the Zener cards, which became an established tool for researchers testing people for parapsychic abilities.[13] His book *The Reach of the Mind* (1947) was translated into Danish in 1949 as *Sjælens Evner*. Peter Demianovich Ouspensky (1878-1947) was a disciple and popularizer of the Russian mystic Gurdjieff and the author of the theosophy-inspired treatise *Tertium Organum*, first published in Russian in 1912, translated into English in 1920 and Danish 1949. When Dreyer links Einstein's theory of relativity with the idea that "it is possible to *live* events that have not yet happened," he is probably referring to the ideas of John William Dunne (1875-1949), who provided a pseudo-Einsteinian explanation for the reality of precognitive dreams (those that foretell the future) in *An Experiment with Time* (1927),[14] translated into Danish in 1947 (*Et Eksperiment med Tiden*); in *Nothing Dies* (1940, Danish 1947: *In-*

tet dør), he claimed that his ideas could also account scientifically for the immortality of the soul. Aldous Huxley (1894-1963) sought to describe the eternal, mystical verities underlying all religions in *The Perennial Philosophy* (1945, Danish 1950: *Den evige filosofi*), where he also cites Rhine and *The Reach of the Mind* approvingly.

With the exception of *An Experiment with Time*, we know for certain that Dreyer owned copies of all these books,[15] and I think that it is worth emphasizing the way Dreyer used these para-psychological speculations to rationalize the miraculous. Some months before *Ordet* went into production, Dreyer gave an inter-view where he spoke about his long-cherished project for a film about Jesus:

He [Jesus] had a large number of talents which must have astonished his contemporaries and which must be seen in connection with the divine by us as well. I am thinking of the many psychic powers we now know to exist "around the brain," for instance thought transference and clairvoy-ance. We know that there are people who are capable of knowing the thoughts of another without using the senses. And a person can sudden-ly, as in a vision, see a close relative – mother or wife – lying dead at home, and then find the mother or wife lying dead in the position they envis-ioned. This is presumably one of the talents Jesus had.

Some have the ability to know of events that are happening many miles away. Another talent is psychokinesis – it is possessed by people who are able to wish so strongly for something that it happens. I believe it is Dr. Rhine who tells of a young girl who had this ability, and who agreed to participate in an experiment. Two dice were thrown from a mo-torized container, and she wished 25 times in a row that they came up 7. They did. In this connection, one refuses to believe in coincidences.

Jesus had all these talents. (Dreyer, "Filmen, der skal aflive myten om jødernes skyld")[16]

It would seem that parapsychological ideas were somewhat in vogue in the late 1940s. Still, it is all but impossible to reconcile such ideas with any sort of minimally orthodox Christian belief. Describing Jesus as an ordinary man, but endowed with certain guru-like ESP powers, is a direct contravention of the most basic tenets of Christianity. Rather than conscious rejection, Dreyer's at-

titude toward these issues of faith seems to have been one of indifference: "Whether he [Jesus] was in the most literal sense the son of God, I don't know. It does not interest me very much either" (Dreyer, "Dreyer vil skabe").[17]

Maurice Drouzy, Dreyer's biographer, then still a Dominican monk, hailed *Ordet* on its appearance in 1955 as "one of the most religious films" ever made: "For two hours, Dreyer's images effect us like liturgy and sermon. We hear the words of the Gospel as if for the first time. This film makes us grow and be purified – it leads us into the world of the sacred" (Drouzy, "*Ordet*" 23). Yet in his book from 1982, he concluded on the basis of remarks like those quoted above that Dreyer could not be said to be a Christian in any meaningful sense (Drouzy, *Dreyer* 330).

One does not get the sense at all, however, that Dreyer sought to discredit Christian teachings or to provoke or offend believers by saying the things he did. He probably did not realize just how heterodox his parapsychic explanations were; in particular, he evidently did not comprehend the extent to which they ran directly counter to the ideas of Kaj Munk. On the contrary, he prided himself on having been as faithful as possible to Munk's play, but that only underscores his uncertain grasp of Christian dogma.

God is in the Details

One could argue that I have made far too much of some rather foolish ideas that do not manifest themselves in any discernible way in Dreyer's film. Certainly, critics have generally ignored them completely, and it would not be difficult to argue that the film *Ordet* is in fact in complete agreement with Munk's ideas. One could ask which of the following two explanations for Inger's return to life best describes what happens in the film: Has God exercised his boundless power because of the innocent, unquestioning faith of the little girl? or has the channeling of Johannes enabled the little girl to use her powerful PK talent? My guess would be that most people would pick the first one. But why make so much of the fact that Dreyer's own answer laid closer to the second?

The point is not that we should grit our teeth and accept that a great and moving film actually promulgates occultist poppycock. It is, rather, to demonstrate why it is a mistake to argue, as Bhaskar does, that Dreyer's central concern was that Christianity was "endangered in the pervasive and destructive disbelief of the contemporary moment" (401). Bhaskar confidently assumes that he can detect the meaning and thematic content of the film, and he chides Bordwell because "he does not imaginatively engage with the thematic concerns of Dreyer's work, so that his reading of form is not impregnated with the vision of the work" (402), asserting by implication that his own reading is so impregnated. The oddity of the metaphor aside, I believe that Bhaskar's self-confidence is misplaced.

Of course, it might be objected that he offers a reading of *the film*, and that Dreyer's pronouncements are irrelevant in that context. This argument will not stand up, however. Throughout, Bhaskar insists that historical and ideological context must be taken into account, and he explicitly states that the conscious intentions of filmmakers and other artists play an important role: "the particular effects that a work has are not only the result of the meanings that its themes have structured, but are also deliberate ideological choices that the makers have made" (399-400). So when Dreyer says that he doesn't care whether Jesus was the son of God or not, and explains that his miracles were caused by his PK powers, it decisively undercuts the claim that Dreyer seeks to teach "an object lesson on the value of faith that transcends the rationalistic forces of modernity" (403).

How, then, can we account for the powerful, affirmative religious experience that Bhaskar, Drouzy, and many others have had with the film? We must, I think, discard the idea that the form of the film can be explained from thematic or ideological concerns that exist prior to and apart from the film. Dreyer did not start out with worries about faith threatened by disbelief and then chose a form and narrative that could represent that. Dreyer wanted to bring off a credible miracle, and the means by which he sought to do this was to get the audience "enmeshed in an atmosphere of religious mysticism," as he wrote in the screenplay afterword. The gap between, on the one hand, Dreyer's instrumental attitude to-

ward religion and his heterodox beliefs, and on the other hand, the deeply religious meaning many critics have found the film to have, proves the profound insight of Bordwell's observation: "Christianity becomes Dreyer's most overpowering formal device" (Bordwell, *Dreyer* 147).

We can extend our understanding of how this operates in practice by turning to Torben Grodal's article "Art Film, the Transient Body, and the Permanent Soul" (2000). He argues that "the typical difference between an art film and a mainstream film is based on a difference between portraying 'permanent' meanings and 'transient' meanings" (Grodal, "Art Film" 33). Transient meanings are those that are linked to concrete, practical, everyday interactions with the world. Permanent meanings, on the other hand, are those linked to memory, identity, and abstract concepts. The mainstream narrative film confronts its characters with here-and-now problems to be resolved through action (catch the villain; kiss the girl). In the art film, the issues facing the characters are usually persistent ones that do not admit of practical resolution (who am I? what is the meaning of it all?) The best art films, Grodal continues, will "employ two intertwined procedures for creating higher and permanent meanings: a 'symbolic' representation of some fields of meaning above the basic level [...] and a series of salient stylistic features that are made 'permanent' by a relative isolation from a transparent narrative function"("Art Film" 50).

The representation of higher meaning can take various forms: striking imagery can encourage metaphorical projection, opaque storytelling can produce a feeling of epistemological uncertainty, and characters' subjective states of mind can be given precedence over their interactions with the world. In *Ordet*, higher meaning is very overtly present through the pervasive importance of religious issues: Christianity, as Bordwell notes, "motivates all the plotlines" (Bordwell, *Dreyer* 144), faith is a constant theme in the dialogue, Johannes believes himself to be Jesus, and the film culminates in a miracle. The very title of the film refers to what could be said to be the ultimate higher meaning: The Word of God.

More pertinent to a discussion of the methodological soundness of historical poetics are Grodal's observations about "permanent" stylistic features. He writes:

Bordwell has [...] pointed out that in the mainstream film, style is a raw material that is transformed into the fabula, the story line. In mainstream films it is difficult to remember the stylistic "surface" because of this transformation, which destroys the conscious memory of the stylistic features. In art films, style, however, is not strongly tied to a salient story line, and therefore the style cannot be transformed into story information. (Grodal, "Art Film" 50)

For instance, the slowness of *Ordet* and its intricate camera movements are not necessary for the coherence of the story, and both are so marked that they encourage spectators to think about what they mean without allowing them to arrive at a conclusive answer. Grodal continues:

Contrary to stylistic features that can fully be transformed into story information, the "excessive" perceptual salience of style cannot. [...] The viewer, therefore, has a feeling/an emotion that there must be some deep meanings imbedded in the salient style features, because the emotional motivation for making meaning out of the salient features is not turned off. ("Art Film" 50)

Critical reactions to *Ordet* yield very clear examples of how this works in practice. Here, for instance, is Drouzy on Dreyer's rhythm, his slow pacing:

He is a man who takes the liberty of contemplating the little things: a candle burning, a clock ticking. And thus, together with him, we can discover the beauty of the things around us: the clouds in the sky, the lyme grass in the dunes, the washing drying on the clothesline. This life at a slow pace gives us a contemplative gaze. It makes us discover things and people. The smallest details become important. We leave behind the superficial world where we normally live, to enter an inner world where everything is transfigured. We step out of time to enter a world without time, a world of eternity. (Drouzy, "*Ordet*" 23-24)[18]

The distinction between transience and permanence could hardly be more clearly expressed. It is obvious how the "excessive" stylistic features leave an impression that there is something important

at stake; what it is, cannot necessarily be explained, but it produces a different sort of attention.

Grodal's point is that it is precisely the function of such features to create this feeling of significance. His account allows us to understand that defamiliarization does not mean that style functions in a merely negative way. The purpose of defamiliarizing devices is to produce certain emotional responses, just as other stylistic devices do, even if they are of a different kind. In another article, Grodal writes: "A director who decides on particular emotions, must also choose the particular narrative structures and audiovisual representational forms through which the desired emotion and its eventual modalization or filtering may be produced" (Grodal, "Elemente" 94).

Visual allusions may well have a similar function. Carren Kaston's comparison of the images of *Ordet* to the paintings of Vermeer could be said, in a sense, to be an argument that Dreyer uses compositional techniques similar to Vermeer's in order to instill a sense of higher meaning. When Ira Bhaskar writes of the similarity between the two, however, his point is that the "intertextuality is not incidental" (402). This may be so, but it is not at all obvious what we should make of it. The interpretation of Vermeer's pictures is anything but a settled issue, and even if we accept that Dreyer deliberately alludes to them (which I would regard as debatable) I am not convinced that we can or should try to pin a particular meaning on it. Rather, one might argue that for the spectator who notices the resemblance between the film images and the famous paintings the effect is, again, to lead attention away from immediate narrative concerns towards the permanence of great art, to create a feeling of meaningfulness and significance.

This, finally, brings us back to the issue of interpretation and knowledge. Grodal's view is that filmmakers typically do not make decisions about the form of their films because they want to convey particular meanings, but because they want to prompt certain emotional responses. Dreyer's own description in the screenplay afterword of the purpose of *Ordet* would appear to bear this out. Taking such a position, which shifts attention from meanings to effects and functions, is attractive, because it allows film scholars to move away from a dependence on interpretive routines. It allows

us to analyze the operation of stylistic features in detail without forcing us to understand them as vehicles of intrinsic or symptomatic meanings.

One of the sequences in *Ordet* most frequently written about is the scene with Johannes and the little girl, Maren, where they talk about what will happen when Maren's mother dies. It occurs about an hour and twenty minutes into the film, in shots number 50 and 51. Johannes and Maren are framed in an unusually close shot while the camera circles them. Bhaskar claims that

when the movement ends with Maren and Johannes composed centrally and in the foreground, with Inger's door in the background, the vital connections between these three individuals and the forces they represent become clear. If there is a true faith, it is in this triumvirate, with the coming together of childlike faith, infinite trust in the divine, gentleness, compassion, understanding, a vast and tender love. (Bhaskar 402)

Bhaskar praises Bordwell for "insightfully" analyzing the camera movement, but condemns him for failing to see its meaning (402-3). Yet Bhaskar's insistence that such a clear meaning exists actually comes at the price of leaving the camera movement itself out of the picture, discovering the point of the sequence only when the movement ends. At the same time, the characters are said to represent "forces", but there certainly is no consensus about what the lunatic Johannes can be said to represent. Here, the urge to make meaning occludes the strangeness of both Dreyer's camera movements and of the character of Johannes.

Grodal's functionalism not only allows us to take such features into account. By attaching importance to the representation of fields of meaning as much as to the use of stylistic devices, his approach ensures that critical discussions need not neglect, for instance, the issues of love and faith which must play a role in any reasonable account of the power and impact of *Ordet*. (Let me say for the record that I do not believe that Bordwell's analysis is neglectful in this regard, even if his emphasis is different.) At the same time, I also believe that this approach is quite compatible with close attention to artistic intentions and historical contexts, and I hope my discussion of *Ordet* bears this out. I do not think that we

take the heart out of film studies by tempering our eagerness to ascribe implicit or symptomatic meanings to films, and I share David Bordwell's conviction that "historically and theoretically informed analytical research into how films are designed and used offers one path to a richer, more expanded, knowledge-based criticism" (Bordwell, "Film Interpretation Revisited" 113). In short, contrary to Henrik Dahl's pessimistic expectations, an initiative has come from the discipline of film studies that leads us away from the anti-rational track.

Notes

Except as noted, all translations are my own.

1 The Editors of *Lingua Franca*, ed., *The Sokal Hoax: The Sham That Shook the Academy* (2000) provides a useful collection of the most important articles; see also Alan Sokal's web site.

2 The book was published in 1981 but written some time before, around the middle of the 1970s (in a note, Bordwell refers to Mark Nash's *Dreyer* (1977) as having been written "after this book was completed" (Bordwell, *Dreyer* 233 note 6). One might question the appropriateness of taking the Dreyer book to exemplify a position that Bordwell himself had not yet begun to formulate, but Bhaskar's criticisms are of a piece with those leveled at Bordwell's later work and therefore relevant enough in this context. Even so, it is perhaps worth remarking that the Dreyer book is not particularly timid about advancing interpretations. To take just one example, on page 35 Bordwell writes of Dreyer's "use of the symbol of the book to signify the authority behind narrative representation" and backs it up – with quotations from Derrida and Roland Barthes!

3 Translated by Grete Jakobson. Danish original: "Hans [Dreyers] hovedregel gik ud paa at placere personerne ud fra hensyn til fotografi og belysning i højere grad end ud fra hensyn til skuespillerne. Normalt arbejder man med en langt enklere 'lyssætning', hvor skuespillerne ikke er bundet til et bestemt omraade, fordi de skal have muligheder for at spille uhæmmet og frit. I *Ordet* var deres placering saa nøje beregnet i hver enkelt scene, at de maatte tælle deres skridt frem og tilbage samtidig med, at de sagde deres repliker. Et enkelt skridt for meget til en af siderne vilde bevirke, at man gik glip af en bestemt forudberegnet lysvirkning, saaledes at scenen maatte tages om. [...]

Maaske skulle man ogsaa nævne en anden af filmens lysvirkninger, der ogsaa skaffede os næsten uløselige problemer. Mens Johannes er sindssyg, gaar han jo hele tiden omkring i mørke, hvorimod alle de andre personers ansigter er belyst" (Bendtsen 1955).

4 "Der er vokset en Ungdom op, der ikke gaar i Teater for at sidde pænt og artigt og se pæne og artige Ting; dens Livsappetit er altfor voldsom til at lade sig spise af med Kiks og Thevand og tørre om Munden med Hviske-Stykker, hvis Forfattere har været besat af synlig Nervøsitet for, at der skulde ske noget paa Scenen. Dens Øjne har set for meget af Virkelighedens røde Taage til at kunne fastholdes af timelange Sjælemalerier med Nuanceringer. Saa hellere Film; dèr sker dog noget; dèr kæmpes og flygtes, snydes og tilgives, kysses og myrdes; dèr genspejles det Liv, der ikke er udspekuleret i en blodfattig Digters fortænkte Hjerne, men skabes af selve Guds modsætningsflammende Villie, Livet ude fra den Verden, denne Ungdom er opvokset i, hvor Folk stod rejst mod Folk med Eksistensen som Indsats, hvor Nød brød alle Love og godt og ondt ikke mere var til, fordi enhver kun tænkte paa sig selv og var selv Gud, mens Hoveder faldt, og Lemmer knustes, og Hjerner brast, og Freden kom med Arbejdskampe og Svindel og Sansedøvelse og Armod og Pest."

5 The tenuousness of the link becomes, if anything, more marked if we look at the few documented examples of Danish miracle plays. The most important is *Ludus de Sancto Kanuto Duce*, "The play about Saint Canute the Duke," written in the late fifteenth century (Kvam et al. 32-34). Knud Lavard (Canute) was a twelfth-century nobleman assassinated by a rival claimant to the Danish throne and later canonized; the play ranges across numerous locations, including various royal castles, with much incident, including the hanging of a thief and of course the climactic murder of Knud.

6 "Munk tænkte dermed at give de Anmeldere en Lektion, der ved "Ordet"s Opførelse, i Landsbylægens Votum [...] vilde finde et Forbehold af Digteren overfor Underet med Genopvækkelsen, der er Skuespillets Mening og Kerne. I ældste Form af Skuespillet findes den paagældende Doktorbemærkning slet ikke."

7 "Troen paa Gud er Troen paa Miraklet. Kun ved et Brud paa Naturlovene kan Gud komme i Forbindelse med et Menneske. At tro paa Gud er at være midt i det vidunderlige, hvor ikke blot Guds Love virker, men ogsaa Guds Haand."

8 "Formålet med filmen må være at få tilskuerne til stiltiende at godkende forfatterens idé – således som den kommer til udtryk i filmens sidste afsnit – nemlig, at den, som er stærk nok i troen, også ejer magten til at gøre undere. Tilskuerne må langsomt præpareres med dette formål for øje, de må stemmes religiøst, indspindes i en stemning af

religiøs mystik. For at gøre dem modtagelige for underet må de bringes i den særlige stemning af sorg og vemod som folk kommer i, når de overværer en begravelse. Er de en gang hensat i denne tilstand af andagt og indadvendthed, lader de sig lettere gradvis suggerere til at tro på underet – alene af den grund, at de – idet de tvinges til at tænke på døden også føres til at tænke på deres egen død – og derfor (sig selv ubevidst) håber på underet og derfor lukker af for deres normale skeptiske indstilling.Tilskuerene skal bringes til at glemme, at de ser en film, og suggereres eller om man vil hypnotiseres til at tro, at de overværer en guddommelig handling, så de går tavse og grebne bort."

9 In Munk's *Ordet*, we are told that Johannes became so agitated by a performance of *Over Evne* that he had to be saved from an onrushing automobile by his fiancee, who was run over and died as a result; Johannes' insanity is brought on by his grief over the loss of his beloved. Dreyer believed that if this story was to be included, it would have to be shown in the film (Gustav Molander's Swedish film version from 1943 does exactly that), and that would have ruined the dramatic unity of the drama. Accordingly, Johannes' madness is blamed on Kierkegaard instead.

10 "Den troende ved jo ogsaa om Lovene; han tror ydermere, at Gud har skrevet dem, og naar han grænseløst beundrer disse Loves Visdom og Vælde, ærefrygter han altsaa Gud. Men den Gud, der har skrevet dem og staar bag dem, staar saa ogsaa tillige over dem. Hvem vilde forbyde Urmageren at røre ved den lange Viser med Fingeren?"

11 I would like to thank Tag Gallagher for bringing this interview (from *Cinema nuovo* no. 67, September 1955) to my attention.

12 Dreyer's own translation. Danish original: "Jeg så da Kaj Munks ideer i en anden belysning. For i den mellemliggende tid var der jo sket så meget. Den nye videnskab, der fulgte efter Einsteins relativitetsteori, havde bragt beviser for, at der uden for den 3-dimensionale verden, vi kan sanse med vore sanser, findes både en fjerde dimension – tidens dimension – og en femte dimension – dimensionen for det psykiske. Det bevistes, at det er muligt at opleve begivenheder, der endnu ikke har fundet sted. Der åbnes nye perspektiver, som får os til at erkende en dyb sammenhæng mellem eksakt videnskab og intuitiv religion. Den nye videnskab nærmer os til en inderligere forståelse af det guddommelige og er godt på vej til at give en naturlig forklaring på overnaturlige ting" (Dreyer, "Filmatiseringen af *Ordet*" 78).

13 The Zener cards are a set of five cards, each carrying a different, distinctive symbol (star, circle, waves, cross, and square) used to test experimental subjects for telepathic abilities; at the beginning of *Ghostbusters* (Ivan Reitman, 1984), Bill Murray conducts such an experiment.

14 Dunne's ideas were an important influence on the "time plays" of J. B. Priestley: *Dangerous Corner* (1932), *I Have Been Here Before* (1937), and *Time and the Conways* (1937).

15 After the death of Dreyer's daughter in 1990, what remained of his library was sold by an antiquarian bookseller; the Danish Film Museum was offered the lot, but unfortunately decided only to acquire part of the collection. A published catalogue provides the complete list: Nansensgade Antikvariat, bogliste nr. 37, "Fra Carl Th. Dreyers bibliotek" (September 1991).

16 "Han har haft et stort Antal Egenskaber, som maatte forbløffe hans Samtid, og som ogsaa af os maa ses i Forbindelse med det guddommelige. Jeg tænker paa alle de psykiske Kræfter, som vi i Dag kan paavise eksisterer 'udenom Hjernen', f. Eks. Tankeoverføring og Clairvoyance. Vi ved, der er Mennesker, som er i Stand til at kende en anden Persons Tanker uden at Sanserne bruges. Og et Menneske kan pludselig som i et Syn se en nær Slægtning – Moder eller Hustru – ligge død hjemme og derefter finde Moderen eller Hustruen ligge død i den sete Stilling. Dette er vel en af de Egenskaber, Jesus havde.

Nogle har Evne til vide Besked med Begivenheder, der finder Sted mange Kilometer borte. En anden egenskab er Psykokinese – den besidder Mennesker, som formaar at ønske noget saa stærkt, at det hænder. Det er vist *Dr. Rhine*, der fortæller om en ung Pige, der havde denne Evne, og som gik ind paa at medvirke i et Eksperiment. To Terninger blev kastet ud af en motordreven Beholder, og hun ønskede 25 Gange i Træk, at Resultatet skulde blive 7. Det blev det. I denne Forbindelse nægter man at tro paa Tilfældigheder.

Alle disse Egenskaber havde Jesus."

17 "Om han er Guds søn i ordets bogstaveligste forstand, ved jeg ikke. Det interesserer mig heller ikke så meget."

18 "Det er en mand, som tager sig frihed til at betragte de små ting: et lys, der brænder, et ur, der dikker. Og sådan kan vi sammen med ham opdage skønheden i tingene omkring os: skyerne på himlen, marehalmen i klitterne, vasketøjet, der hænger til tørre. Dette liv i langsomt tempo giver os det kontemplative blik. Det får os til at opdage ting og mennesker. De mindste detailler bliver vigtige. Vi forlader denne overfladiske verden, hvori vi plejer at leve, for at gå ind i en indre verden, hvor det hele forklares. Vi går ud af tiden for at gå ind i en verden uden tid, en evighedens verden."

References

Aristarco, Guido. "Venice Film Festival." *Film Culture* 1, no. 5-6 (1955): 23-24.

Beardsley, Monroe C. *Aesthetics: Problems in the Philosophy of Criticism.* 2nd ed. Indianapolis: Hackett, 1981.

Bendtsen, Henning. "Den mest udmattende opgave, jeg har haft." Interview by Thorkild Hansen. *Information*, 24 January 1955.

Bhaskar, Ira. "'Historical Poetics,' Narrative, and Interpretation." In *A Companion to Film Theory*, edited by Robert Stam and Toby Miller, 387-412. Oxford: Blackwell, 1999.

Bordwell, David. "Film Interpretation Revisited." *Film Criticism* 17, no. 2-3 (1993): 93-119.

——. *The Films of Carl-Theodor Dreyer*. Berkeley & Los Angeles: University of California Press, 1981.

——. "Historical Poetics of Cinema." In *The Cinematic Text. Methods and Approaches*, edited by Barton Palmer. New York: AMS Press, 1989.

——. "Intensified Continuity: Visual Style in Contemporary American Film." *Film Quarterly* 55, no. 3 (2002): 16-28.

——. *Making Meaning: Inference and Rhetoric in the Interpretation of Cinema*. Cambridge, Mass.: Harvard University Press, 1989.

Bordwell, David, Janet Staiger, and Kristin Thompson. *The Classical Hollywood Cinema: Film Style and Mode of Production to 1960*. London: Routledge, 1990.

Brix, Hans. *– hurtig svandt den lyse Sommer! Kaj Munk 1924-1944*. Copenhagen: Westermann, 1946.

Carney, Raymond. *Speaking the Language of Desire: The Films of Carl Dreyer*. Cambridge: Cambridge University Press, 1989.

Cook, David. "Making Sense." *Film Criticism* 17, no. 2-3 (1993): 31-39.

Currie, Gregory. "The Film Theory That Never Was: A Nervous Manifesto." In *Film Theory and Philosophy*, edited by Richard Allen and Murray Smith, 42-59. Oxford: Clarendon Press, 1997.

Dahl, Henrik. "Kultur og videnskab: fra alliance til fjendskab." In *Det forkælede samfund*, edited by Carl Th. Pedersen, 145-60. Copenhagen: Akademisk Forlag, 2002.

Dreyer, Carl Th. "Dreyer vil skabe en ny filmtype midt imellem 'rene' film og teatret." Interview by Henrik Stangerup. *Information*, 27 June 1964.

——. "En instruktør overflødig." *Politiken*, 14 March 1955.

——. "Filmatiseringen af *Ordet*." In *Om filmen. Artikler og interviews*, edited by Erik Ulrichsen, 78-81. Copenhagen: Nyt Nordisk Forlag Arnold Busck, 1959.

——. "Filmen, der skal aflive myten om jødernes skyld." Interview. *Dagens Nyheder*, 21 February 1954.

——. "I dag ved vi alle, at der er mirakler til." Interview by Knud P. *Politiken*, 12 January 1955.

——. "Metaphysic of *Ordet*." *Film Culture* 2, no. 1 (1956): 24.

——. "Ordet." Typescript screenplay, [1954]. Acc. 2001/48, Håndskriftafdelingen, Det Kgl. Bibliotek, Copenhagen.

Drouzy, Maurice. *Carl Th. Dreyer, né Nilsson*. Paris: Éditions du Cerf, 1982.

——. "Carl Th. Dreyers *Ordet*." *Catholica* 12, no. 1 (1955): 23-26.

Dunne, John William. *Et Eksperiment med Tiden*. Translated by Finn Methling. Copenhagen, 1947.

——. *Intet dør*. Translated by Finn Methling. Copenhagen, 1947.

Easthope, Antony. *Literary into Cultural Studies*. London: Routledge, 1991.

Editors of *Lingua Franca*, The, ed. *The Sokal Hoax: The Sham That Shook the Academy*. Lincoln, Neb.: University of Nebraska Press, 2000.

Gallagher, Tag. "Chain of Dreams: Carl Th. Dreyer." *Filmhäftet*, forthcoming.

Gaut, Berys. "Making Sense of Films: Neoformalism and Its Limits." *Forum for Modern Language Studies* 31, no. 1 (1995): 8-23.

Grodal, Torben. "Art Film, the Transient Body, and the Permanent Soul." *Aura* 6, no. 3 (2000): 33-53.

——. "Die Elemente des Gefühls: Kognitive Filmtheorie und Lars von Trier." *Montage/AV* 9, no. 1 (2000): 63-96.

Gross, Sabine. "Cognitive Readings; or, The Disappearance of Literature in the Mind." Review of Mark Turner, *Reading Minds*. *Poetics Today* 18, no. 2 (1997): 271-97.

Guillory, John. "The Sokal Affair and the History of Criticism." *Critical Inquiry* 28, no. 2 (2002): 470-508.

Hollows, Joanne, Peter Hutchings, and Mark Jancovich, eds. *The Film Studies Reader*. London: Arnold, 2000.

Huxley, Aldous. *Den evige filosofi*. Translated by Mogens Boisen. Copenhagen: Aschehoug, 1950.

Jackson, Tony E. "Questioning Interdisciplinarity: Cognitive Science, Evolutionary Psychology, and Literary Criticism." *Poetics Today* 21, no. 2 (2000): 319-47.

Jenkins, Henry. "Historical Poetics." In *Approaches to Popular Film*, edited by Joanne Hollows and Mark Jancovich, 99-122. Manchester: Manchester University Press, 1995.

Jørholt, Eva. "Verden ifølge Grodal: Den filmiske oplevelse i øko-biologisk perspektiv." Review of Torben Grodal, *Moving Pictures*. *Kosmorama*, no. 219 (1997): 110-15.

Kaston, Carren O. "Faith, Love, and Art: The Metaphysical Triangle in *Ordet*." In *Carl Th. Dreyer*, edited by Jytte Jensen, 67-77. New York: Museum of Modern Art, 1988.

Kvam, Kela, Janne Risum, and Jytte Wiingaard, eds. *Dansk teaterhistorie*. 2 vols. Vol. 1: *Kirkens og kongens teater*. Copenhagen: Gyldendal, 1992.

Mayne, Judith. *Cinema and Spectatorship*. London: Routledge, 1993.

"miracle play." *Encylopædia Britannica* [online] ([cited 18 September 2002]. Available from http://search.eb.com/eb/article?eu=54246.

Munk, Kaj. "Om Miraklet." In *Himmel og Jord*, 28-31. Copenhagen: Nyt Nordisk Forlag / Arnold Busck, 1938.

——. "Omkring 'En Idealist's Urpremiere." In *Himmel og Jord*, 220-23. Copenhagen: Nyt Nordisk Forlag / Arnold Busck, 1938.

Nash, Mark. *Dreyer*. London: British Film Institute, 1977.

Nowell-Smith, Geoffrey. Review of David Bordwell, *Making Meaning*. *Screen* 34, no. 3 (1993): 293-98.

Ouspensky, Peter Demianovich. *Tertium Organum: En Nøgle til Verdensgaaderne*. Translated by Finn Methling. 3rd ed. Copenhagen: Hagerup, 1949.

Perez, Gilberto. "Toward a Rhetoric of Film: Identification and the Spectator." *Senses of Cinema* [online], no. 5 (April 2000 2000) [cited 31 May 2002]. Available from http://www.sensesofcinema.com/contents/00/5/rhetoric2.html.

Rhine, Joseph Banks. *Sjælens Evner*. Translated by Torkil Lund. Copenhagen, 1949.

Sémoulé, Jean. *Dreyer*. Paris: Éditions universitaires, 1962.

Snow, Edward A. *A Study of Vermeer*. Berkeley & Los Angeles: University of California Press, 1979.

Sønderby, Knud. "Dreyers *Ordet* og Kaj Munk." *Politiken*, 13 March 1955.

Turner, Mark. *Reading Minds: The Study of English in the Age of Cognitive Science*. Princeton, N.J.: Princeton University Press, 1991.

Warshow, Robert. "*Day of Wrath*: The Enclosed Image." In *The Immediate Experience: Movies, Comics, Theatre & Other Aspects of Popular Culture*, 261-67. New York: Atheneum, 1970 [1952].

Peter Wuss

The Documentary Style of Fiction Film in Eastern Europe
Narration and Visual Style

A Neglected Stylistic Movement

In the sixties, a number of films sharing common characteristics and thus making up a group style appeared in the cinemas of the then still socialist countries in Eastern Europe. Among these films are the works of Miloš Forman, Věra Chytilová, and Jaromil Jireš in Czechoslovakia, Marlen Khutsiyev, Andrei Mikhalkov-Konchalovsky, Vasily Shukshin, and Otar Ioseliani in the Soviet Union, Jerzy Skolimowski and Krzysztof Zanussi in Poland, and Gerhard Klein, Jürgen Böttcher, Lothar Warneke, and Rainer Simon in the GDR.[1]

These films, though they did not deny their fictionality, developed cinematic forms of the representation of reality that approached documentary films both in their formal qualities and the type of reception they elicited. Thus the term "Documentary Style" came to be used in Eastern Germany to describe these fiction films.[2]

The term was used, however, only among a small circle of filmmakers and in the articles of a few approving critics. As strange as it may seem, this style never existed officially, and one can search for it in vain in most film history books. The term is missing in the historiography of both the East and the West. The reason this style was ignored in the East is most likely to be found in the fact that such films did not correspond to the official cultural policy. When they were produced, usually under the hand and against the interests of the administration, it was thought to be better not to mention them. Quite accurately, the political leadership recognized that they tended to try to avoid the doctrine of Socialist Realism, not through open confrontation, but in the name of a fundamen-

tally realistic approach, on which the socialist politics of art was also based. Since the filmmakers viewed their work as the search for truth, but refused to submit themselves to pragmatic politics, it is no wonder that their work was taken amiss.

In the West it seems that this stylistic movement simply was not recognized as such, probably because it was intentionally unspectacular and thus did not lend itself to journalistic popularization. Neither its politics nor its aesthetics made it into a sellable topic. Furthermore, in order to recognize it, Western critics would have had to be competent in understanding the cinematic cultures of many countries, most of which they could not even visit without great difficulty. Back then, film history was also generally concerned with national developments and hardly looked at questions of style. Even if individual films or directors were praised for their accomplishments within a national cinema, the international aspects of this stylistic development were not recognized or were considered irrelevant from a Western viewpoint.

However, they were anything but that, and even today the phenomenon is well worth a closer look, which I would like to encourage with the following remarks. The decisive artistic accomplishment of the Documentary Style was that it permitted a very exact and finely graded depiction of human life by means of a new form of filmic perception. By using open narrative structures and active strategies of perception, it was able to show and describe psychological behavior in new ways that brought the Eastern European cinema much closer to modernism. Fiction films were made that – in terms of their truth to life and their attention to details – were not only able to meet up to documentary criteria, but also based themselves on specifically cinematic kinds of reality effects. In this way, eastern-central Europe caught up with and carried on the aesthetic efforts of neo-realism, and it did so in a multinational way. This movement gave international art film a new impulse to concern itself more closely with certain forms of cinematic expression, particularly regarding aspects of the representation of reality.

Describing Group Styles

In trying to determine the characteristics of group styles, it seems sensible to look as broadly as possible at the question of which aesthetic means the group uses in common over a longer time. The characteristics that determine a style can potentially be drawn from very different forms and intentions. Furthermore, they are often linked closely to concrete social and cultural frameworks and conditions. A narrow concept of style, which only relates to the cinematic techniques that shape a "visual style", is not adequate here. Instead, we must also include aspects of "film form" that include narrative relationships and other dramaturgical categories and also deal with genres and modes. Complex studies, such as Bordwell, Staiger, and Thompson carried out in *The Classical Hollywood Cinema*[3], also demonstrate how paying attention to non-artistic factors can be of great value for understanding a style. One problem is certainly that of how one can make use of these multiple aspects not only in a standard hermeneutic approach, but also in a structural and functional analysis, which could enable systematical comparison of styles at the level of cognitive theory. Currently we are still at the beginning of such endeavors, and I can only report on some first steps in this direction.

A starting point for such an analysis may be to discern the common use of specific artistic means over a certain period, that is, the invariance of certain formal characteristics that shape a style. Torben Grodal has drawn on Karl Pribram's psycho-physiological studies[4] to point out an interesting possibility of grasping style theoretically, in that he refers to the principle of repetition: "Style may be a type of organization of patterns of repetition that mediate aesthetics and associative meaning, and which combines fields of space with repetitive fields in time"[5]. This statement corresponds closely to Umberto Eco's model: "What could it mean to speak of the unity of content and form in a successful work other than that the same structural scheme governs the different levels of organization? A network of homologous forms is established, which makes up the special code of this work."[6] In trying to describe a style it is helpful to look for the structural schemes throughout a work by first analyzing similarities at the formal

level and describing them as a series of homologous forms. Evidently, stylistic unity can be produced by the repetition of similar forms of expression, which then function as key stimuli for complex processes of reception.

Isolating such series of similar forms, however, is not sufficient for a concrete analysis of style, since such a formalized description can only relate to a limited part of composition. The structure of a film, though, always involves many different formal levels, which are not necessarily commensurable with one another and which can only be related to each other through the work of interpretation. Therefore, it is necessary to look for stable functional relationships between the various homologous forms at different levels of film form in order to grasp a stylistic principle structurally. It is possible to determine such relationships empirically. Experience shows that certain visual forms tend to be connected with specific forms of narration and vice versa. Thus the interaction of formal and narrative factors tends in each case to produce a system of conditions leading to optimal effects. Drawing on thoughts from the Formalist School, I would like to refer to this system of conditions as the functional core or the dominant[7] of a stylistic system. Artistic systems of style generally seem to be based on an at least temporarily stable cooperation among formal techniques at various levels, whose series of homologous forms thus can be optimized in terms of their effects. One level works for the other.

All the usual aspects that film theory has thus far worked out to describe a single work can also be used to describe the interacting elements of such complex formal systems. These aspects can be gathered together in a descriptive system[8] that, following German aesthetics and film theory, can be divided into the following levels:

A) Artistic Relationships:
- Dramaturgy and form, with the subsections:
 composition, narration, conflict, character, mise-en-scène, image, sound, editing.
- Morphology, with the subsections:
 mode, genre, style.
- Reception theory, with the subsections:
 cultural theory, film sociology, film psychology.

Every film style and the specific aesthetic qualities that differentiate it from others can potentially be described quite accurately by drawing on all these formal aspects. This can aim at formalization and systematic comparison as well as at interpretation. Generally, however, even a few of these characteristics are adequate to determine a style, that is, those that stand for its functional dominant.

It is useful to extend the descriptive system by including characteristics of the social and cultural context, which I here refer to as:

B) Extra-artistic Relationships:
– These include systems of:
 technology, economy, politics, ideology, social psychology, culture, other art forms, and also personal factors.

Trying to formalize these relationships may not always be very helpful, but still, these factors can be of fundamental importance to the existence of some group styles. That is the case here.

Historical Prerequisites for the Documentary Style

A number of extra-artistic factors were most likely decisive for the origin of the Documentary Style of fiction film. These resulted from the contradictory historical situation that had arisen in eastern Central Europe in 1956. In February of that year, the 20th Party convention of the Soviet CP met and admitted that the Communist movement had committed fundamental errors, culminating in the crimes of Stalin. In autumn of 1956, reform movements inspired by the criticism of Stalinism and even popular uprisings against the political dictatorship appeared in Poland and Hungary. When they were brutally suppressed, it meant that all impulses toward political opposition were stifled in the other Eastern Block countries, as well.

The young filmmakers who started out during those years had to live with a fundamental conflict. On the one hand, they wished to distance themselves from the ideological clichés of the past and to achieve an authentic depiction of social reality. Thus in their films they attempted to show only events that were based on their

own observations and that the viewers could judge against their own experience. On the other hand, the official cultural policy put limits on their portrayal of the life world of "really existing socialism" and their desire for truth before they even began. Any unprejudiced depiction of contradictions and conflicts within social relations was in danger of being attacked and suppressed as counterrevolutionary. That included many films that were not even intended to be a criticism of the system, but rather a positive contribution to the new (socialist) society and its self-awareness of problems.

The official film policy was correspondingly schizoid: on the one hand, Marxism suggested that one should show life in its contradictoriness and use film to make people aware of these contradictions. On the other hand, there was a fear that portraying conflicts could also lay bare social contradictions that were unsolved or even unsolvable for the system and thus even aid the enemy by carrying out a so-called "discussion of errors". When filmmakers did decide to take on such controversial topics, this regularly led to the films being banned. Despite Khrushchev's alleged reform course in the Soviet Union, for example, Khutsiyev's film *I am Twenty* was made in 1961, but was not allowed to be released until 1965. This was no isolated case. At the infamous Eleventh Plenary Meeting of the Central Committee of the SED, the party leadership in the GDR banned around a dozen films that were already finished or were being shot in December 1965. After the tanks of the Warsaw Pact nations put an end to the "Prague Spring" in 1968, similar restrictions on film production went into effect in Czechoslovakia.

For their part, the filmmakers also followed an ambivalent program under these conditions. They took up the impetus of the politics of De-Stalinization, which was certainly legal to do, and resisted schematic ideology and palliation. However, if they wished to continue working in their field, they also had to avoid any stories that involved sharp social conflicts, and at the same time had to try to keep from losing their own credibility and their moral principles. Some of them, the representatives of the Documentary Style, saw a way out of this dilemma in detailed and true-to-life depiction of everyday personal experience. The Czech critic

Jan Žalmann described in 1968 the basic attitude of the young film-makers in his country as follows: "Ten years, filled on the one hand with the messianic belief in socialism and the fever to build a new society, on the other hand shaped by the Cold War, isolation, the threat of a nuclear catastrophe and the practice of dogmatism, brought with them a 'shock about the loss of values' … The old forms had become shaky. For the most part, the normative aesthetics of the past codified artistic lies and compromised realistic art instead of helping it succeed. Eye to eye with this art, which was helpless and unable to move forward, the young artists looked for other norms. They are enraptured by 'life as it is' … Personal experience is rehabilitated. It becomes an indispensable criterion in the sea of uncertainties that surround us …"[9].

The filmmakers kept to a basic stylistic tendency of realism in that they took up an attitude toward reality that began with the works of the Lumière brothers and had found its provisional culmination in Neo-realism. In Bazin's terminology, they believed more in "realité" than in "image". But they also clearly differentiated their own style, in that they came close to documentary film forms, at times even overstepping the boundaries. They integrated real everyday occurrences, social events, or authentic persons, as well as real locations, into the films, and even went so far as to experiment with semi-documentary depictions[10]. Referring to her early work, *A Bagful of Fleas*, a story that took place among apprentices, the young Czech director Věra Chytilová stated: "At first I investigated the problems in their dormitories at length, in order to provoke them in specific situations while filming. The girls, who played themselves here, were supposed to improvise freely on their own within the directions I set."[11] This corresponded to the director's wish that the film might help the spectators to "separate the authentic things from the unauthentic ones", since "Lies in art should be legally banned."[12]

Whatever the filmmakers showed on screen about everyday life was supposed to correspond to the truth, no more and no less. The audience should be able to test the film's authenticity against their own personal experience, both regarding the whole and all its details. In regard to the filmmakers' understanding of hard social contradictions, however, this again and again ended in comprom-

ises. Still, the outward appearance of everyday life in the socialist countries did conform to the pressure not to show deep social conflicts on screen, since these were intentionally hidden or repressed in public life as well, in order to present the illusion of harmony. If the film neglected them, too, then this did not immediately appear to be a lie.

Although a certain political thaw began to ease up the "cold war" between the major powers at the beginning of the 60s and the East was able to take a more relaxed view of its own problems, hopes for substantial changes within the system gave way to the feeling that any progress would have to occur in very small steps. It appeared that the social and political status quo would last for some time and that one would have to live with it. Brecht's line, "The difficulties of the mountains lie behind us, now we face the difficulties of the plains,"[13] was often quoted in this period. Thus the Czechoslovakian filmmaker Evald Schorm titled a film of his *Courage for Every Day/Everyday Courage* (1964).

This feeling was the starting point for the Documentary Style. These films were based in the present and usually showed undramatic, everyday situations that were shaped by the immobility of social relations. The main characters were almost always young people. The film authors were well acquainted with their ways of life and were able to observe them and their milieu apparently offhandedly, but very precisely with the camera.

Since the protagonists were chosen from a generation that had already grown up in the new social reality, it seemed at first sight quite legitimate to view them in a way that did not deal with the class conflicts of the transition period. These characters were not situated in politically motivated conflicts that made them *a priori* into positive or negative heroes, as had been the usual pattern. Therefore they came closer to the kind of representation of people that the contemporary international exhibit of photographs, *Family of Man*[14] propagated. This exhibit was the first large-scale attempt to portray a picture of average people and the beauty of the everyday. Even ordinary everyday occurrences were shown there as something meaningful, as something that shaped life, and the Eastern European filmmakers saw it as confirming their attempts to observe their life-world closely. In their visual style and ap-

proach to reality, the documentary fiction films followed the broadly humanistic concept of the exhibit, which might be described as democratic and pluralistic and which intentionally avoided ideological models. That was reason enough for the Party ideologues to obstruct this style or at least to reject it as artistically worthless, and that, of course, had immediate consequences for the films' distribution.

Even though the characters portrayed in the films showed an obvious disaffection with ideology, the filmmakers were anything but politically disinterested. They attempted to show social contradictions in detail, to make them clearly visible, and thus make the viewers conscious of them. If it was impossible to show major conflicts, then at least certain discrepancies in social reality should be named. This had far-reaching consequences for the structure of the films' composition and narration.

Problems of Narration and their Theoretical Description

Along with the central dramatic conflicts, these films also generally gave up their plots. The stories lacked the classic narrative structure oriented around a dramatic action with a beginning, middle, and ending, linking significant events through the principle of causality. Instead, the action took place in a thoroughly undramatic way. Amorphous everyday happenings followed one another in a loose way. They were arranged in small, episodic actions – "menues actions" in Barthes's[15] sense – and the links between them seemed rather coincidental.

This certainly handicapped the films in regard to the administration and the public, since cultural policy in the East was based on clear, unequivocal connections between form and content. The lack of a clear-cut narrative was taken to indicate that an unambiguous political message was also missing. Thus, in trying to defend this style, critics and even the filmmakers themselves had trouble in working out the internal principles of this form of narration.

People acquainted with the film profession almost intuitively recognized that the best films of this movement were by no means composed by random and that they did indeed tell coherent stories

and carry a message. Still, it took years to find adequate ways to describe and explain these narrative strategies. Drawing on concepts from Hegel's aesthetics, critics first spoke of the film stories as being episodic, epic, or even lyric, but this could not explain where the non-narrative films got their inner coherence. In Russia, they were called "films without an intrigue"[16] or a "syuzhet"-less form; this gave the phenomenon a name, but only described what the narrative structure was not, and thus could not explain what made the stories hold together. More differentiated studies of the inner structure of "syuzhet"-less forms, for example Yuri Lotman's semiological analyses of film[17], helped define positive formal characteristics like the static character of these texts, in which only uniform, repetitive movements are possible, which construct functionally similar elements that are relatively independent of one another and add up to potentially endless, cumulative chains.

Furthermore, some of the filmmakers also developed models for this form of construction, for example by looking to music for analogies to the composition of events in the films. The confrontation with "open works" was going on at the same time in Western Europe, too, where films were also being made with correspondingly open forms of narration and very similar characteristics, as Umberto Eco showed in regard to Antonioni's films in the sixties[18]. As already mentioned, the principle of the repetition of homologous forms provided a useful point of departure to analyze such open forms, and studies of this kind were begun in the East[19].

In the mean time, cognitive film theory has provided us new theoretical possibilities to describe open cinematic forms and the corresponding strategies of narration within a model of reception is based on differentiating the construction of cognitive schemata according to perceptual, conceptual, and stereotypical film structures. Open forms of narration such as the Documentary Style or in Western Europe the "cinéma du comportement" of Antonioni, Rivette, or Rohmer has been explained in analogy to perceptually led structures[20]. In the case of open narrative forms, we can assume that clusters of structural relations similar to a musical leitmotif are to be found throughout the entire film narrative. They make up series of invariant forms, so-called topic lines, which give the film meaning, even though the viewer usually only takes them in un-

consciously. In my opinion, such topic sequences work at the perceptual level and activate the viewer both cognitively and emotionally[21]. In analogy to Neisser's principle of the cycle of perception[22], this steers the viewer's expectations, and the invariant structures become more and more noticeable and conscious. The recurrence of analogous motifs, clusters, or topics thus links relatively independent events structurally. Topic lines can serve in this way as basic structures of film narration, which are able to replace the classical causal chains of events or the stereotypical plots that usually shape the narration of genre movies. In their own way, they create coherence, and the Documentary Style of fiction film was able to take advantage of this.

Two Examples of the Documentary Style

Miloš Forman's *Black Peter* (1963) tells about the everyday life of an adolescent apprentice in a general store in Prague, and the film does this in a relaxed way. The camera follows the boy unobtrusively; it lets the viewer in on his life, which is average and goes on without any unusual occurrences. The film shows his work in the store, his first advances towards a girl, his meetings with friends and his peer group, his relationship to his parents. The events seem to occur almost randomly. With the exception of one episode in which Peter somewhat half-heartedly tries to clear up a case of shoplifting, there is hardly anything sensational to experience and no necessary causal relation of the events.

Nonetheless, the film shows an unbroken series of contradictory situations of the same kind: instruction is given. His environment, especially his parents, continually confronts Peter with norms and standards. The protagonist endures this; he does not even try to resist these continuous reproaches, but it soon becomes clear that the guidelines and advice are no good. The older people's standards of how one should live continually collapse on themselves. Peter's father takes back in one sentence what he just said in the one before. Thus the film indirectly passes a scathing judgment on society, which loudly propagates norms but cannot provide any workable concept of how to live. The motif of values breaking

down in everyday life is a casual observation, particularly since it is not employed politically. However, presented again and again, it can create a social-psychological argument that is quite harsh: it denies the society the ability to do what it constantly presumes itself able to do, that is, to judge and guide social processes. The periodic recurrence of the same contradictory element may not be able to strengthen a dramatic conflict or involve the viewer in the process of solving a problem, but it does ensure that a problem is found and identified. Thus, it marks the beginning of problem solving and it creates a field of conflict, which in its own way moves the events forward[23]. Thus a series of common topics becomes evident in the course of the film, and these direct the viewer's attention to a certain coherence of meaning and at the same time link the events, since they activate the viewer's expectations and point them in a certain direction.

The best-made films of the Documentary Style are able to use such series of topics to create a coherent narrative. This is the case with Otar Ioseliani's *There Was a Singing Blackbird*, which was screened in 1971 in the USSR, that is, in the late period of this stylistic development. The film begins by showing how the members of a large orchestra playing in the Georgian capital Tiflis are worried and waiting in suspense about whether or not the young musician will arrive in time, who has to give the kettle drums a couple of beats towards the end of the piece. Gija, the likeable hero of the film, does manage to sprint in and get there in the nick of time.

This occurrence is, as it turns out, no exception, but rather characteristic of the young Georgian, whose everyday life we are shown in the film. Gija's work is not very demanding, and thus he pays more attention to the little things of life and he is constantly fighting the clock. When, at the end of the film, he is coincidentally killed in a car accident – he turned around to look at a pretty girl – he seems not to have left anything behind more than a nail that he helpfully and attentively hammered into the wall of a clockmaker's room so that the man could hang up his cap. Here, too, the succession of events seems to be coincidental; in any case, there is no causal chain or plot.

However, the film continually varies situations that show a contradiction: the young man is a good-for-nothing, since he does not

try to reach any recognizable goal. He abandons the composition he began just as quickly as the book he borrowed from the library, but in his friendly and considerate way, he is constantly involved in things that make everyday life in his surroundings more pleasant. He uses his connections to bring a friend to a well-known and very exclusive doctor, he organizes a serenade for his aunt's birthday, and he is always willing to take on little tasks without a fuss. On the one hand, the film emphasizes how the hero loses himself in trivialities, on the other hand, it also becomes evident that his development, as aimless as it seems, constantly serves one of the most sensible aims there is, namely making life friendlier and more pleasant for other people[24].

Here, too, repetition makes the contradictoriness of behavior become more and more apparent for the spectator, and the protagonist's conflict is also a thoroughly social one, since it reflects the situation of his generation and its turning away from the norms of what pretended to be an achievement-oriented society, but did not offer the advantages of one. Ioselani stated that, in constructing his film narrative, he did not stick to the usual dramatic construction, but rather oriented himself toward the compositional techniques of musical works with their recurring motifs[25]. Although this kind of form demands very precise artistic organization, the film narrative makes it appear as though the contingencies of pulsing everyday life of the Georgian capital and the moods of the protagonist determine the sequence of actions. However, the strict composition rhythmically directs the audience's attention to concrete situations, which seem very authentic, and thus causes it to think over the values depicted in the film.

This form of narration did face a real problem, in that the unremarkable everyday stories could easily become boring and unattractive. Particularly the young audience that the films were primarily aimed at often found it difficult to become emotionally involved or to identify with the characters, who were viewed from a distance and who often showed inner contradictions and their own ordinariness instead of youthful attractiveness or self-control. The audience's reserved reaction often caused the filmmakers more insecurity than did the hostility of the politicians.

This style did receive encouragement from other sides, however: from the British Free Cinema and from American independent film, and particularly from modern documentary filmmaking, i.e. from *Cinéma vérité* in France and Direct Cinema in the USA, which developed at this time. In their way of thinking, the young filmmakers in Eastern Europe felt themselves close to these schools and their rigorous demands for truthfulness. Certain characteristics of their visual style also provided a decisive impulse.

The distinctiveness of camera work in the new documentaries was a direct result of advances in film technology at that time. The new formal possibilities of both schools of documentary filming were based to a large degree on a qualitative leap in film technology at the beginning of the sixties[26]. Essentially, the new situation for documentary filmmaking resulted from the development of light-weight 16mm hand-held cameras. Even without a blimp they were quiet enough to permit synchronized sound recording even with close-up or extreme close-up shots. Portable tape recorders that allowed wireless synchronized sound recording came into use at the same time. The conditions for shooting documentaries were further improved by the concurrent use of zoom lenses, improved view-finders, and considerably more sensitive black and white film stock.

Speaking of how he had filmed *Louisiana Story* for Flaherty, Richard Leacock complained about how traditional technology had limited filming. He said the traditional equipment caused people to change their behavior and stiffen up whenever sound recording was used[27]. At the beginning of the sixties, Leacock had devised new camera equipment that allowed a two-person team to use synchronized camera and sound recording while following their interview partners almost anywhere without bothering them[28]. The new technology not only improved mobility and made filming less intrusive, it also provided unexpected possibilities to depict natural human behavior in psychologically sophisticated ways on the screen. This was fascinating not only for documentaries, but for fictional films, as well, since filmmakers discovered a multitude of details in human expression that had previously gone unnoticed.

However, the young filmmakers in Eastern Europe had no access whatsoever to the new 16mm synchronized sound equipment. They usually used the standard 35mm studio cameras for their early films and dubbed them during post-production. The new documentaries did not have an immediate influence through the use of the new technology, but rather worked indirectly by stimulating a process of rethinking ways of working. The documentaries showed how extremely differentiated human behavior is and how cinematography could be used to register its nuances. Walter Benjamin compared film to Freud's *Psychopathology of Everyday Life*, which "isolated and made analyzable things which had heretofore floated along unnoticed in the broad stream of perception"[29]. In this sense, the new technology made it possible for filmmakers to use the camera to scrutinize and emphasize certain small human reactions much more than had been possible previously. These were not just faulty reactions, inappropriate conduct, or psychological shortcomings, but contradictory human behavior in general. The everyday actions of individuals as well as whole groups could be used to show a contradictory mixture of inner and external activities, of physical actions and communication, both verbal and nonverbal. The friction between the conscious and the unconscious, between planned and spontaneous actions became a focus of interest. Thus documentary films were able to help discover many nuances in people's spontaneous reactions and make them available for use in movies, which then could make more wide-ranging psychic processes visible.

When the camera captures this kind of contradictory and unpredictable moments of spontaneous human behavior on film, it is generally able to grab and hold the viewer's attention. This is also true for fiction films, and classical cinema certainly made use of such micro-conflicts as well; many actors in mainstream cinema probably became stars because of their unmistakable and unique form of acting spontaneously in front of the camera. The Documentary Style of fiction film was based to a very large degree on the observation of this kind of unplanned behavior, which gained a value of its own in the films and often permitted the audience new and interesting social-psychological insights. This helped articulate social problems and provided an aesthetic attraction of its

own for films that were not based on a suspenseful plot. Along with the true-to-life performance of the actors, often even replaced by amateurs, who provided further authenticity through their own unmistakable and natural way of behaving and reacting, a camera style had to be developed that was oriented toward real, factual images, "image-faits" in Bazin's sense. The cinematographic style of these films often seemed at first to resemble news coverage; the images seemed to be unplanned or even unprofessional. However, exact reproduction of reality was more important for this style than well-composed pictures. This led to a new way of observing reality. At the same time, the Documentary Style also tended to create a reality effect through its form of cinematic perception. Spectators viewed these effects as interesting and meaningful, as an attraction that also made sense. At their best, the documentary fiction films could arouse the impression that the viewers were seeing something, for example a psychologically precise and subtle depiction of behavior or a particular milieu, that they could never experience as closely and realistically in real life as here on the screen. The observation of uncontrolled, spontaneous behavior and the portrayal of reality worked together to define the Documentary Style.

The reality effect in cinema has its own structure and effects and its own history, which has in recent time led to phenomena like *Dogma 95*[30]. At that time, Kracauer's just published *Theory of Film*[31], with its concept of the "redemption of physical reality" in film art, seemed to confirm the reality effect. The Documentary Style gladly embraced slogans such as "unposed reality," "coincidence," "endlessness," "uncertainty," and the "flow of life" as points of orientation, and it is possible to find examples of all these characteristics in the films of this movement.

The contemporary documentary films also showed that it was not only important to catch certain observations and fix them in a documentary image, but also to make them noticeable and conscious through repetition and the cycle of perception. According to Dziga-Vertov, the "camera eye" demands a certain amount of effort[32]. The reality effect is not a point of departure, but rather the result of the viewer's confrontation with reality; thus it is the consequence of active perception. When the threshold of consciousness between perception and conceptualization is crossed, this

produces a reality effect, which suddenly makes what is portrayed on the screen seem to be a valuable discovery of a piece of life, of something particularly true-to-life and authentic, even if the material shown is fictional. Practically, this meant that certain structures of reality, for instance discrepancies in a person's behavior, had to be regularly repeated on screen in order for them to become conscious for the viewer and to create the effect of authenticity. This then meant that the Documentary Style developed a new relationship to editing.

It is no coincidence that at that time an intuitive understanding of editing developed among Mikhail Romm's former Moscow directing students, including Tarkovsky, Mikhalkov-Konchalovsky, and Shukshin. Their colleague Artavazd Peleshyan later referred to this as distance-montage and montage of the contexts[33]. This method assumes that not only the connections between immediately adjacent shots need to be considered, but also the arrangement of structurally or thematically similar shots over a longer stretch of time in the film. Specific key images and whole complexes of images can then be used to steer the viewer's expectations through stimuli arranged in intervals. This principle of editing corresponds not only to the cycle of perception, in which a cognitive schema is periodically perceptually tested against reality and thus gradually stabilized, but also to the basic narrative form of topic lines with its cyclical repetition of similar plot motifs.

The stylistic dominant of this form then turns out to be an interacting system made up of atomized elements of conflict, the characters' contradictory behavior patterns and the corresponding spontaneous reactions of the actors, realistic images and their tendency to produce reality effects, distance montage, and an open, generally episodic narrative structure.

Problems and Perspectives in the Development of the Style

Like any other stylistic movement, the Documentary Style represented not only an extension of formal possibilities, but also marked a possible dead end. The attempt to reproduce everyday occurrences and the ordinariness of the film action often caused

the situations shown in the film to appear to lack form and contours. The stories were in danger of falling apart, their descriptive approach tended to make them be short of emotional impact and become boring, and many viewers felt that their unarticulated conflicts were trivial and their ambiguous messages too demanding.

Many of the filmmakers tried to use formal tricks to avoid this flattening out of the form by using stronger stimuli and inner contrasts in the film form. One such way to intensify the film composition was to use the motif of death, which played a role in many of the films. In *There Was a Singing Blackbird*, the conflicts that Gija, the musician, is involved in become more emotional and easier to judge when the viewers are made aware that his life is one that could easily come to a sudden end. In many other documentary style films, as well, a sudden, random, and dramatically well-placed death often sets up a sharp contrast to the constant flow of the rest of the minor actions and thus intensifies the meaningfulness of the story. The fatal traffic accident in Egon Günther's *Die Schlüssel* (The Keys) can be viewed this way, as can the threat of fatal cancer in Lothar Warneke's *Die Beunruhigung* (Anxiety), a young scientist's experiences with death in Zanussi's *Illumination*, or the accidental death in his film, *The Constant Factor*. The rebirth of the dead father in *I am Twenty* and the life-threatening situation of the woman giving birth at the end of Mikhalkov-Konchalovsky's *Asya's Happiness* fulfilled a similar function. In the same way, almost all of Antonioni's movies up to the mid-sixties used a death in the background or the sidelines of the plot to create an artificial contrast and create new relationships within the evolutionary process in which the protagonist was involved.

The titles of many of the films also helped viewers form an opinion about the action by conceptualizing the basic situation. Examples are Zanussi's *The Structure of Crystals*, *Illumination*, and *The Constant Factor*, Khutsiyev's *I am Twenty*, and Konrad Wolf's *Ich war 19* (I Was 19). As far as I know, Mikhalkov-Konchalovsky originally planned to give away the central line of action in the title of his second film, which was to be: *The Story of Asya, Who Was Lame and Did Not Want to Marry Because She Was Proud*.

Another typical way to set up contrasts in the plot and to create critical distance was to comically exaggerate situations and make

use of corresponding genre characteristics. This is to some extent paradoxical, since the intention of getting as close to real life as possible should have excluded the use of genre stereotypes for the Documentary Style. In the end, however, genre seemed to present a viable alternative to the threat of a "dramaturgy of boredom". This became most clearly apparent in films made in the ČSSR. The loosening of cultural politics during the "Prague Spring" made it possible for a while to produce openly critical films using the forms of comedy, farce, satire, and burlesque. In them, contradictory elements of life are gradually made apparent through documentary observations as in Forman's *Loves of a Blonde*, break through in radically comical or farcical moments in his *The Fireman's Ball* or Menzel's *Closely Watched Trains* and *Larks on a String*, which, however, no longer reached the theaters during the Dubček era and remained banned for a long time.

These films, among the best made anywhere in the world at that time, avoided the danger of just observing everyday life, which was the ideal of some of the more orthodox proponents of the Documentary Style. However, just like Forman's *One Flew Over the Cukoo's Nest*, Tarkovsky's *The Mirror*, or other important works of filmmakers coming from Eastern Europe, it seems they would have been impossible without the professional experience of working within that style, which had tried out the possibilities and limits of specifically cinematic forms of expression. This style confirmed that it is a fundamental characteristic of film, as Tarkovsky put it, to insist on reaching "the truth of a unique, as it were immediately observed fact and its unrepeatable factuality" through the mise-en-scène[34].

Inconspicuously, but carefully watched over by mistrustful politicians, film art in Eastern Europe was able to achieve cinematic modernism in the sixties by shifting its production of meaning to the level of perception and by cultivating the tendency toward narrative openness.

Translated from the German by Stephen Lowry

Notes

1 Among the films belonging to this stylistic group are: Miloš Forman: *Black Peter* (*Černý Petr*, 1963) and *Loves of a Blonde* (*Lásky jedné plavovlásky*, 1964); Věra Chytilová: *Ceiling* (*Strop*, 1961), *A Bagful of Fleas* (*Pytel blech*, 1962) and *Something Different/Another Way of Life* (*O něčem jiném*, 1963); Jaromil Jireš: *The Cry/The First Cry* (*Krik*, 1963); Marlen Khutsiyev: *I am Twenty/Zastava Ilijcha* (*Mne dwadzat' let*, 1961/65), *Ilyulskij Dozhd* (*July Rain*, 1966), Andrei Mikhalkov-Konchalovsky: *Asya's Happiness* (1967/released 1988); Vasily Shukshin: *There Was A Lad* (*Shivjot takoj paren'*, 1964), *Your Son and Brother* (*Vasch syn i brat*, 1966), *Strange People* (*Strannye ljudi*, 1970); Otar Ioseliani: *Falling Leaves/When Leaves Fall* (*Listopad*, 1967), *There Was a Singing Blackbird* (*Shil pevči drosd*, 1971); Jerzy Skolomowski: *Walkover* (1965), Krzyzstof Zanussi: *The Structure of Crystals* (1969), *Illumination*; Gerhard Klein: *Berlin um die Ecke* (Berlin Around the Corner, 1965), Jürgen Böttcher: *Jahrgang 45* (1966/ 89), Lothar Warneke: *Dr. med Sommer II* (Medical Doctor Sommer, the Second, 1970), Rainer Simon: *Gewöhnliche Leute* (*Ordinary People*, an episode of *Aus Unserer Zeit* [*From Our Times*, 1970]).

2 Cf. Warneke, Lothar: Der dokumentare Spielfilm. In: *Film – Wissenschaftliche Mitteilungen*, Vol. 5, special issue, October 1964, 229-258.

3 Cf. Bordwell, David / Staiger, Janet / Thompson, Kristin: *The Classical Hollywood Cinema. Film Style & Mode of Production to 1960*. London: Routledge, 1988.

4 Cf. Pribram, Karl: Brain Mechanism in Music. In: Clynes, M. (Ed.) *Music, Mind and Brain: The Neuropsychology of Music*. New York: Plenum Press, 21-35.

5 Cf. Grodal, Torben: *Moving Pictures. A New Theory of Film Genres, Feelings, and Cognition*. Oxford: Clarendon Press 1997, 55.

6 Transl. from Eco, Umberto: *Einführung in die Semiotik*. München: Fink 1972, 151.

7 Cf. Jakobson, Roman: Die Dominante. In: Poetik. Frankfurt am Main: Suhrkamp 1993, 212-219.

8 Cf. Wuss, Peter: Originalität und Stil. Zu einigen Anregungen der Formalen Schule für die Analyse von Filmstilen. In: *Montage/AV 7/ 1 / 1998*, 145-167.

9 Žalman, Jan: Die Wahrheit des Individuums / Über die Filme des „Prager Frühlings". In: *Kinemathek* Vol. 29., no. 79, 1992, 21.

10 Cf. in particular Khutsiyev: *I am Twenty/Zastava Ilijcha*, Chytilová: *A Bagful of Fleas*, Mikhalkov-Konchalovsky: *Asya's Happiness*.

11 Chytilová, Věra, qtd. in: Bulgakowa, Oksana: Von nichts anderem – die drei Trilogien der Vera Chytilová. In: Gehler, Fred (Ed.): *Regiestühle international*. Berlin: Henschelverlag 1987, 61.

12 Ibid., 57.

13 Brecht, Bertolt: Wahrnehmung (1949). In *Werke* (Große kommentierte Berliner und Frankfurter Ausgabe), vol. 15 (Gedichte, vol. 5), Berlin/ Weimar, Frankfurt a.M.: Aufbau & Suhrkamp 1993, 205.

14 Cf. Edward Steichen: *The Family of Man*. New York: Museum of Modern Art, 1955.

15 Barthes, Roland: Les suites d'actions (1969). In: L'aventures sémiologiques. Paris: Éditions du Seuil, 1985, 208.

16 Cf. Djomin, Victor: Film ohne Intrige (Excerpts translated from the Russian.) In: *Aus Theorie und* Praxis. Potsdam-Babelsberg: Betriebsakademie des DEFA-Studios für Spielfilme, 1972.

17 Cf. Lotman, Jurij: *Probleme der Kinoästhetik. Einführung in die Semiotik des Films*. Frankfurt am Main: Syndikat 1977, 96ff.

18 Eco, Umberto: *Das offene Kunstwerk*. Frankfurt a. Main 1977, 204ff. (*Opera aperta*. Milan: Bompiani, 1962).

19 Cf. Wuss, Peter: Narration and the Film Structures for Three Learning Phases. In: *Poetics*, 19, 1990, 549-570.

20 Cf. Wuss, Peter: Narration and the Film Structures for Three Learning Phases. In: *Poetics*, 19, 1990, 549-570.

21 Cf. Wuss, Peter: Structures narratives du film et mémoire du spectateur. In: *Iris* (Paris) 19, 1995, 31-54.

22 Cf. Neisser, Ulric: *Kognition und Wirklichkeit. Prinzipien und Implikationen der kognitiven Psychologie*. Stuttgart: Klett-Cotta, 1979, 105ff.

23 Cf. Wuss, Peter: Cinematic Narration, Conflict and Problem Solving. In: *Moving Images, Culture* & Mind. Ed. by Ib Bondebjerg. Luton: University of Luton Press, 2000, 105-116.

24 Cf. Ioseliani, Otar: Interview by Margit Voss: Alles hineinlegen und nichts erfinden. In: *Sonntag*, 1972, 47, 9.

25 Cf. Ioseliani, Otar: TV-Interview by Marcel Bluwal, arte: 27.04.1994.

26 Cf. Mamber, Stephen: *cinéma verité in America: Studies in Uncontrolled Documentary*. Cambridge, Mass. / London: MIT Press, 1974; Salt, Barry: *Film Style and Technology: History and Analysis*, 2nd Edition, London: Starword, 1992, 253ff.

27 Cf. Leacock, Richard. Interviewed. *Film Culture*, 22-23, Summer 1961.

28 Cf. Cameron, Ian & Shivas, Mark: Interviews. Richard Leacock, *Movie* 8 (April 1963).

29 Benjamin, Walter; the Work of Art in the Age of Mechanical Reproduction. In: *Illuminations*. New York: Schocken Books, 1969, 235.

30 Cf. Wuss, Peter: Analyzing the Reality Effect. In: One-line journal *The Journal of Moving Image Studies*, Vol. I, Issue 2 (Spring 2002): http://www.uca.edu/org/ccsmi/journal2/index.htm.

31 Cf. Kracauer, Siegfried: *Theory of Film. The Redemption of Physical Reality.* New York: Oxford University Press, 1960.

32 Cf. Wertow, Dsiga: *Dsiga Wertow – Publizist und Poet des Dokumentarfilms.* Ed. by Herman Herlinghaus. Leipzig: Leipziger Dokumentarfilmwoche, 1960, 54.

33 Peleshyan, Artavazd: Distance Montage, or The Theory of Distance. In: *Die Dokumentarfilme der* armenischen Sowjetrepublik. Eine Retrospektive des 21. Internationalen Dokumentarfilmfestivals Nyon; Schweiz. Nyon / Berlin 1989, 79-102.

34 Tarkowski, Andrej: *Die versiegelte Zeit. Gedanken zur Kunst, zur Ästhetik und Poetik des Films.* Leipzig / Weimar: Kiepenheuer, 1989, 82.

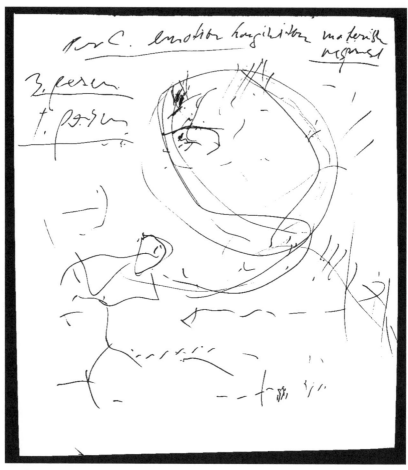

Torben Grodal's illustration on a flipover of the processing of a narrative in the human brain (scholar seminar at Aalborg University, January 2002)

35 Years in Print
Torben Grodal: List of publications 1968-2003

Edited by Peter Schepelern

1968

"Mellem litteraturvidenskab og filosofi. Debat om Knut Hanneborg: "The Study of Literature"," *Poetik* (1:4). Copenhagen: Arena, 1968, pp. 36-39. [Comment on Knut Hanneborg: *The Study of Literature*].

1969

"Kohærens sandsynlighed vurdering," *Poetik* (2:2). Copenhagen: Arena, 1969, pp. 67-72. [Birgit Grodal is uncredited co-writer].

1970

"Pontoppidans sexualøkonomi. Karaktereologien i P.'s romaner med særlig henblik på "Lykke-Per"," *Poetik* (3:4). Copenhagen: Arena, 1970, pp. 329-342.

1971

"Tilpasning eller fremmedgørelse. "Erasmus Montanus" og "Den 11. juni" som ideologiske afgrænsninger af enevælden i forhold til feudalisme og liberalisme," *Poetik* (4:2-3). *Tekstanalyser*, ed. Jørgen Holmgaard. Copenhagen: Arena, 1971, pp. 21-34.

"Den eventyrlige nekrolatri. Dødstematikken i nogle H. C. Andersen-texter og relationen til de sociale, sexuelle og skripturelle traumer," *Poetik* (4:2-3), *Tekstanalyser*, ed. Jørgen Holmgaard. Copenhagen: Arena, 1971, pp. 74-94.

"Ælling og ørn. Handlingsopbygning og værdiunivers i "Den grimme Ælling" og "Ørneflugt"," *Poetik* (4:2-3), *Tekstanalyser*, ed. Jørgen Holmgaard. Copenhagen: Arena, 1971, pp. 95-105.

"Klassestruktur og historiesyn i nogle Pontoppidan-texter," *Poetik* (4:2-3), *Tekstanalyser*, ed. Jørgen Holmgaard. Copenhagen: Arena, 1971, pp. 182-190.

"Tematisk tekstanalyse. En skitsering af tekstanalytisk emneområde," *Poetik* (4:4). Copenhagen: Arena, 1971, pp. 40-55.

"Den sociale sult og den existentielle kvalme. Herman Bang Franz Pander," in *Analyser af dansk kortprosa I*, ed. Jørgen Dines Johansen. Copenhagen: Borgen, 1971, pp. 267-289.

1972
"Sælens lyst og sjælens ubodelige ensomhed. En analyse af Martin A. Hansens "Løgneren"," *Poetik* 17 (5:1), 1972, pp. 1-24. Reprinted in *Analyser af danske romaner 3*, ed. Jørgen Holmgaard. Copenhagen: Borgen, 1977, pp. 235-266.

"Asdiwal-sagnet. Strukturautonomisme og samfundsanalyse i Lévi-Strauss' betydningsfilosofi og myteanalyse," in *Tegn, Tekst, Betydning. Introduktioner til nyere fransk filosofi*, eds. Torben Ditlevsen, Jørgen Mønster Pedersen, Bruno Svindborg. Copenhagen: Borgen, 1972, pp. 9-33.

1973
"Holberg og historien," *Kritik 26* (7:2). Copenhagen: Fremad, 1973, pp. 130-136.

"Aspekter af nyere fransk litteraturkritik," *Vindrosen* 1, 1973 (19:1). Copenhagen: Gyldendal, pp. 76-78. [Review of Niels Egebak: *Aspekter af nyere fransk litteraturkritik*].

1974
"Nattevagt" og den socialhistoriske analyse," *Poetik 21* (6:1). Copenhagen: Arena, 1974, pp. 69-88.

"Hierarki, ægteskab og social forandring i Shakespeares "Som man behager", "Stormen" og "Pericles"," *Poetik 22* (6, 2). Copenhagen: Arena, 1974, pp. 45-74.

Tekststrukturer. En indføring i tematisk og narratologisk tekstanalyse, eds. Torben Kragh Grodal, Peter Madsen, Viggo Røder. Grodal has written chapters VII-XII, pp. 139-229. Copenhagen: Borgen, 1974. [2nd, revised edition, 1976; reprinted 1978].

"Familien som samfundsmodel. *The Godfather* (1971)," in *Filmanalyser. Historien i filmen*, eds. Michael Bruun Andersen, Torben K. Grodal, Søren Kjørup, Peter Larsen, Peter Madsen, Jørgen Poulsen. Copenhagen: Borgen, 1974, pp. 359-367.

"Claude Lévi-Strauss og litteraturanalyse eksemplificeret på "Tommeliden" og "Løgneren",", *Meddelelser fra Dansklærerforeningen* 1974 (12:1). Copenhagen: Dansklærerforeningen, pp. 22-34.

1975
"Slikkepind og marcipanbrød", *Dansk Grafia*, 1975, nr. 26. Copenhagen: Grafisk Kartel, 1975, pp. 20-21. [Co-written with Alf Holter, published under the pseudonym Unikol].

1976
"Konjunktur, klasse og intim fallit i Herman Bangs Stuk," *Analyser af danske romaner 1*, ed. Jørgen Holmgaard. Copenhagen: Borgen, 1976, pp. 15-120.

1977
"Mellem borgerskab og arbejderklasse. En analyse af Rifbjergs prosaforfatterskab," in *Linjer i nordisk prosa. Danmark 1965-1975*, ed. Peter Madsen. Lund: Bo Cavefors, 1977, pp. 253 313.

1978
"Skitse til en litteratur- og bevidsthedshistorisk beskrivelse af perioden 1848-1901 i Danmark," *Kultur & Klasse 32* (8:4). Copenhagen: Medusa, 1978, pp. 60-114. [Co-written with Jørgen Holmgaard].

"Efterskrift," *Kultur & Klasse 32* (8:4). Copenhagen: Medusa, 1978, pp. 115-128.

1979

"Tematisk og strukturel litteraturanalyse i Frankrig i efterkrigstiden," in *Litteraturkritik. Aspekter af det 20. århundredes litteraturkritik*, eds. Morten Giersing, Ralf Pittelkow. Copenhagen: Borgen, 1979, pp. 94-135.

"Udviklingstendenser og problemer i fremtidens mediestruktur," *Kultur & Klasse 36* (9:4). Copenhagen: Medusa, 1979, pp. 7-18.

1980

"Frihed og nødvendighed," *Kultur & Klasse 38* (10:2). Copenhagen: Medusa, 1980, pp. 97 109.

1984

"Sherlock Holmes. En professionel voyeur," in *Lystmord. Studier i kriminallitteraturen fra Poe til Sjöwall/Wahlöö*, eds. Jørgen Holmgaard, Bo Tao Michaëlis. Copenhagen: Medusa, 1984, pp. 113-179.

"Det moderne gennembruds kvinder," *Kultur & Klasse 49* (13:1). Copenhagen: Medusa, 1984, pp. 116-126. [Review of Pil Dahlerup: *Det moderne gennembruds kvinder*].

"Gennembrudskvinder og dolkestødslegender," *Litteratur/85, en almanak*, ed. Karen Syberg, Asger Schnack. Copenhagen: Tiderne Skifter, Dansklærerforeningen, 1984, pp. 51-53. [Review of Pil Dahlerup: *Det moderne gennembruds kvinder*].

1985

Dansk Litteraturhistorie, vol. 6: *Dannelse, folkelighed, individualisme 1848-1901*, pp. 269-316, 333-425, 471-540, 568-614, notes in vol. 9, pp. 118-122, 124-126. Copenhagen: Gyldendal, 1985. [The other writers of this volume are Lise Busk-Jensen, Per Dahl, Anker Gemzøe, Jørgen Holmgaard, Martin Zerlang; reprinted 1990].

1987

"Melankoliens potens – Miami Vice," *Kultur & Klasse 56* (14:4). Copenhagen: Medusa, 1987, pp. 36-52. [English version: "The Postmodern Melancholia of Miami Vice," 1989].

"Arbejds-lyst eller Back to the Future. Visuelle studier i Reagan-Amerika," *Kultur & Klasse 57* (15:1). Copenhagen: Medusa, 1987, pp. 41-75. [Reprinted in *Ind i Filmen*, ed. Eva Jørholt. Copenhagen: Medusa, 1995, pp. 57-90].

"Fiktionsteori og underholdningens genrer," *Kultur & Klasse 58* (15:2). Copenhagen: Medusa, 1987, pp. 7-25.

"Skam, latter og kønskamp. En analyse af Hawks' Bringing Up Baby," *Kultur & Klasse 58* (15:2). Copenhagen: Medusa, 1987, pp. 63-78. [Reprinted in *Ind i Filmen*, ed. Eva Jørholt. Copenhagen: Medusa, 1995, pp. 269-84].

1988

"Det moderne gennembruds fremstillingsformer i socialhistorisk lys," in *The Modern Breakthrough in Scandinavian Literature 1870-1905,* ed. Bertil Nolin, Peter Forsgren. Gothenburg: Göteborgs universitet, 1988, pp. 43-51.

"Emotion, narration, illusion og distance," *Kultur & Klasse 60* (15:4). Copenhagen: Medusa, 1988, pp. 7-32.

"Tendenser i nyere fiktionsanalyse. Kommunikation, ekspression og historisering," *Kultur & Klasse 61* (16:1). Copenhagen: Medusa, 1988, pp. 76-92.

"Det synlige og det usynlige. Fortrængning, konstruktion og *Keiserens nye Klæder*," *Kultur & Klasse 62* (16:2). Copenhagen: Medusa, 1988, pp. 65-85.

1989

"Fiktion som moderne mentalt software," *Kultur & Klasse 64* (16:4). Copenhagen: Medusa, 1989, pp. 65-85.

"The Postmodern Melancholia of Miami Vice," *Dolphin 17, Media Fictions,* ed. Michael Skovmand. Aarhus: Aarhus university Press, [1989], pp. 52-75. [English version of "Melankoliens potens – Miami Vice," 1987].

"Stephen King," *Levende Billeder*, november 1989 (5:9). Copenhagen, 1989, pp. 23-25.

1990

"Indramning, intertekst og TV-fiktion", *MedieKultur 14.* Copenhagen: SMID, 1990, pp. 80 105.

"Framing, Intertext, Metatext and Television Fiction," in *Strategier för tv-analys*, ed. Peter Dahlgren, Klaus Bruhn Jensen, Søren Kjørup. Stockholm: Stockholms universitet, 1990, pp. 102-117. [English version of "Indramning, intertekst og TV-fiktion", 1990].

"Biografi, psykoanalyse og fiktionsanalyse," in *Historie, tolkning, tekst og tekst, tolkning, historie*, eds. Jørgen Dines Johansen, Finn Hauberg Mortensen, Horst Nägele. Odense: Odense Universitetsforlag, 1990, pp. 41-56.

"Melodrama, vilje og hengivelse i "Borte med blæsten"," *Sekvens 90.* Copenhagen: Institut for Film- og Medievidenskab, 1990, pp. 99-114.

"Tid, rum, passion og melodrama. Med et analytisk nærbillede af *Vertigo*", *Sekvens 90.* Copenhagen: Institut for Film- og Medievidenskab, 1990, pp. 115-148.

"Kognition, emotion og neurale modeller," *Kultur & Klasse 68* (17:4). Copenhagen: Medusa, 1990, pp. 93-111.

"Allegori eller software?," *Kultur & Klasse 68* (17:4). Copenhagen: Medusa, 1990, pp. 134 140.

1991
"Individ, samfund og passion. Om historisk melodrama på tv," in *Analyser af tv og tv-kultur*, ed. Jens F. Jensen. Copenhagen: Medusa, 1991, pp. 199-214.

"Drømme og visuelle medier," *Psyke og Logos* (12:1), 1991. Copenhagen: Dansk Psykologisk Forlag, pp. 173-187, 254.

1992
"Videnskabelig fiktion om krop og sjæl. Stanley Kubricks og Ridley Scotts Science Fiction," in *Film på strimler. Om moderne film*, ed. Lone Erritzøe. Copenhagen: Amanda, 1992, pp. 171 188.

"Romanticism, Postmodernism and Irrationalism," *Sekvens 92, Postmodernism and the Visual Media*, eds. Eva Jørholt, Peter Schepelern. Copenhagen: Department of Film and Media Studies, University of Copenhagen, 1992 pp. 9-27.

1993
"Subjektiv og objektiv tid i visuel fiktion. En kritik af Genettes og Bordwells modeller for narrativ tid," *Sekvens 93. Visse tendenser i filmvidenskaben, Festskrift til Martin Drouzy*, ed. Anne Jerslev. Copenhagen: Institut for Film- og Medievidenskab, 1993, pp. 209-231.

"Ømhed, væmmelse og manisk kontrol. Steve Martin som komisk type," in *Mediegleder. Et festskrift til Peter Larsen*, ed. Jostein Gripsrud. Oslo: Ad notam/Gyldendal, 1993, pp. 61-70.

1994
Cognition, Emotion, and Visual Fiction. Theory and typology of affective patterns and genres in film and television. Copenhagen: Department of Film and Media Studies, 1994, 312 pp. [Doctoral dissertation; new version: *Moving Pictures*, 1997]

"Kognitiv medieanalyse," *MedieKultur 22*. Copenhagen: SMID, 1994, pp. 5-19.

"Stil og narration i visuel fiktion," *Sekvens 94, Fortælleteori & levende billeder,* ed. Lennard Højbjerg. Copenhagen: Institut for Film- og Medievidenskab, 1994, pp. 167-185.

1996
"Glamour, Ghetto, and Wasteland: Los Angeles as Film Backdrop," *Sekvens 95/96, A Century of Cinema*, eds. Peter Schepelern, Casper Tybjerg. Copenhagen: Department of Film and Media Studies, University of Copenhagen, 1996 pp. 103-126.

1997
"Audiovisuel virkelighedsfremstilling," *Sekvens 97, Filmæstetik og billedhistorie*, eds. Helle Kannik Haastrup, Torben Grodal. Copenhagen: Institut for Film- og Medievidenskab, 1997, pp. 35-50.

"Visuelle metaforer og mentale modeller i film," in *Metaforer i Kultur og Samfund*, ed. Carsten Hansen. Copenhagen: Netværk for metaforer, kultur og kognition, 1997, pp. 47-59.

Moving Pictures. A New Theory of Film Genres, Feelings, and Cognition. Oxford: Oxford Univerrsity Press/Clarendon, 1997 206 pp. [Revised edition of *Cognition, Emotion, and Visual Fiction. Theory and typology of affective patterns and genres in film and television*, 1994; paperback edition 1999, reprinted 2002].

"Kropssprog i medieret form," *MedieKultur 26*, 1997. Copenhagen: SMID, pp. 18-26.

"Fortolkning og intelligente processer set i et kognitionsvidenskabeligt og økologisk perspektiv," *Fortolkningens rum*, ed. Ove Christensen. Aarhus: NSU Press, 1997, pp. 87-101.

"Round up the Usual Suspects. 90'ernes filmgenrer," *Kosmorama 219* (43:1), special issue: *Genre i 90'erne*. Copenhagen: Det Danske Filminstitut, 1997 pp. 6-15.

"Levende billeder til alle," in *Dansk Mediehistorie 2*, ed. Klaus Bruhn Jensen. Copenhagen: Samleren, 1999, pp. 219-238. [Reprinted 2003].

"Film Aesthetics and Parkinson's Nostalgia for Psychologisms", *Film-Philosophy* [www.film philosophy.com] (1:11), October 1997, 3 pp. [Reply to Eric Parkinson "Project for a Scientific Film Theory"].

1998
"Triers Lagkagefråde," in *Din store idiot*, eds. Jeanne Betak, Caroline Sacha Cogez, Knud Romer Jørgensen. Copenhagen: Rhodos, 1998 pp. 268-273.

"Følelser, tanker og narrative mønstre i film," *Kosmorama 221* (44:1), special issue: *De nye filmteorier*. Copenhagen: Det Danske Filminstitut, 1998 pp. 6-22.

"Filmfortæling og Computerspil," in *Multimedier, Hypermedier, Interaktive Medier*, ed. Jens F. Jensen. Ålborg: Ålborg Universitetsforlag, 1998, pp. 239-251.

"Berlin fra himlen og på jorden. I film af Ruttmann, Wenders og andre billedmagere," in *Filmbyer*, ed. Palle Schantz Lauridsen. Copenhagen: Forlaget Spring, 1998 pp. 26-44.

1999
"Emotions, Cognition and Narrative Patterns in Film," in *Passionate Views*, eds. Carl Plantinga, Greg M. Smith. Baltimore: Johns Hopkins Press, 1999, pp. 127-145. [English version of "Følelser, tanker og narrative mønstre i film," 1998].

"Æstetik, film og neuroner," *Kritik 141* (32:5). Copenhagen: Gyldendal, 1999, pp. 70-73. [Reply to Rasmus Helles and Simo Køppe: "Æstetikken der forsvandt. En filmteori for aber?", *Kritik 140*, pp. 61-72].

"Intertextuality in a Cognitive Perspective," *Sekvens 99, Intertextuality & Visual Media*, eds. Ib Bondebjerg, Helle Kannik Haastrup, Copenhagen: Department of Film and Media Studies, 1999, pp. 47-61.

"Melodrama, seksualitet og altruisme. Stil og følelser i film noir," *Kosmorama 223* (45:1), special issue: *Film noir*, Copenhagen: Det Danske Filminstitut, 1999, pp. 44-60.

"Fortællingens frie spil. Film, computerspil og interaktionens æstetik," *Kosmorama 224* (45:2), special issue: *Filmens ny verden*. Copenhagen: Det Danske Filminstitut, 1999, pp. 44 60.

"A fikció müfajtipológiája," *Metropolis* (3:3), 1999, pp. 52-72 [Hungarian translation of *Moving Pictures*, Chapter 7].

2000
Filmoplevelse. En indføring i filmteori. Copenhagen: Institut for Film- og Medievidenskab, 2000. 196 pp. [Reprinted 2002; new edition 2003].

"Subjectivity, Realism and Narrative Structures in Film," in *Moving Images, Culture & the Mind*, ed. Ib Bondebjerg, Luton: University of Luton Press, 2000, pp. 87-104.

"Art Film, the Transient Body, and the Permanent Soul," *Aura* (4:3), Stockholm: Stockholm University, 2000, pp. 33-53.

"Die Elemente des Gefühls. Kognitive Filmtheorie und Lars von Trier," *Montage/av* 9/1/2000 (9:1), Marburg: Schüren Verlag, pp. 63-98.

"Lars Konzack: Software genrer," *MedieKultur 31*, Copenhagen: SMID, 2000 pp. 133-135. [Review of Lars Konzack: *Software genrer*].

"Video Games and the Pleasures of Control," in *Media Entertainment: The Psychology of its Appeal,* eds. Dolf Zillmann, Peter Vorderer. Mahwah, N.J.: Lawrence Erlbaum, 2000, pp. 197 213.

2001
"Film, Character Simulation, and Emotion," in *Nicht allein das Laufbild auf der Leinwand ... Strukturen des Films als Erlebnispotentiale,* eds. Jörg Friess, Britta Hartmann, Eggo Müller. Berlin: Vistas Verlag, 2001 pp. 115-127.

"Lars Qvortrup: Virtual Interaction," *MedieKultur 33.* Copenhagen: SMID, 2001, pp. 89-92. [Review of Lars Qvortrup: *Virtual Interaction*].

"Old Wine in Old Bottles," *Film-Philosophy* [www.film-philosophy.com] (5:12), April 2001, 12 pp. [Review of Warren Buckland: *The Cognitive Semiotics of Film*].

"Zhang Yimou," *Kosmorama 227/228* (47:1-2), special issue: *Filmkunstnere i tiden.* Copenhagen: Det Danske Filminstitut, 2001, pp. 323-327.

2002
"The Experience of Realism in Audiovisual Representation," Northern Lights. Film and Media Studies Yearbook, *Realism and 'Reality' in Film and Media,* ed. Anne Jerslev. Copenhagen: Museum Tusculanum, 2002, pp. 67-91.

"Grand teorija un pecteorija," *Kino raksti 7/2002.* Riga: Latvijas Kinematografistu savieniba, 2002, pp. 95-104. [Latvian translation of unpublished paper, "Grand Theory and Post Theory," 2000].

2003
Filmoplevelse. En indføring i audiovisuel teori og analyse. Copenhagen: Samfundslitteratur, 2003, 347s. [Revised edition of *Filmoplevelse. En indføring i filmteori,* 2000].

"De bløde følelser. Filmfortællinger og den nye danske film," in *Nationale spejlinger. Tendenser i ny dansk film*, eds. Anders Toftgaard, Ian Hawkesworth. Copenhagen: Museum Tusculanum, 2003. [In press].

"Realisme, abstraktion og synets evolutionshistorie," in *Fra verden til navlen*, eds. Simon Laumann Jørgensen, Thomas Haunstrup and Esben D. Jacobsen. Århus: Philosophia, 2003. [In press].

"Stille eksistenser finder lykken. Italiensk for begyndere," *Nøgne billeder. De danske dogmefilm*, ed. Ove Christensen. Copenhagen: Medusa, 2003. [In press].

"Stories for Eyes, Ears, and Muscles. Video Games, Media, and Embodied Experiences," in *Video Game Theory*, eds. Mark J.P. Wolf, Bernard Perron. London: Routledge, 2003. [In press].

"Film Lighting and Mood," in *Motion Picture Theory: Ecological Considerations*, eds. Joseph D. Anderson, Barbara Fisher Anderson. Carbondale: Southern Illinois University Press, 2003. [In press].

"Love and Desire in the Cinema. An evolutionary approach to romantic films and pornography," *Cinema Journal*, 2003 [In press].

A Note on the Cover Illustration

Michael Kvium: Untitled [The Grand Mal, 1985]. Watercolor 16 x 32 cm, private collection. (Signed in pencil with dedication to Lars von Trier). Reproduced with permission by the artist.

In 1984, after his successful debut film *The Element of Crime*, Lars von Trier made plans for a new film, *The Grand Mal*, which was to be shot in English with an international cast – and in more or less the same haunting style as his first feature. The manuscript, written by Trier and Niels Vørsel, was completed in October 1985.

The story takes place in contemporary West Berlin, where the Irish gangster families Mallett and O'Grady have established a casino as a cover for drug trading. The patriarch of the Mallett family, old Esmond, nicknamed The Grand Mal, is concerned that his family is losing influence. His granddaughter's husband, Dr. Mesmer, has no desire to enter the family business and, basically, old O'Grady's two mentally deranged sons now run it. The dramatic plot includes a blindfolded car race through the streets of Berlin in the dark of night, rape, sudden death, suicide in a bathtub, and culminates in a scene in which Mesmer crashes his car through the Berlin Wall.

Trier explains: "*The Grand Mal* is a family epic in the grand old style. The scene is Berlin – the divided city, or our dreams about it. Mesmer, the protagonist, is driven by a great love. He must fight a battle that is not of his own making, which ultimately leads to the downfall of the families. A melodrama revolving around the love of two young people. Pushy family members spin a web of complications and intrigues. Mesmer finds himself in a world of madness and is sucked into an inevitable maelstrom."[1] Unfortunately, the film project was also sucked into the maelstrom and aborted.

During the planning stages of the film, however, Trier approached the painter Michael Kvium for an illustration that could be used in the presentation of the project. Kvium painted this watercolor, depicting one of the dramatic scenes at the Berlin Wall.

It was never used or published, and it is the only visual remnant left of *The Grand Mal* project. We bring it here, an artistic vision of film style and story, with the kind permission of the artist – as a tribute to Torben Grodal who has written one of the essential texts on Trier's films and who is also an enthusiastic collector of Kvium's work.

P.S.

Notes

1 Quoted and translated from Peter Schepelern: *Lars von Triers film*. Copenhagen: Rosinante, 2000, pp. 111-112.

Film style and story